DISCARD

GILBERT STUART

For my own part, I will not follow any master. I wish to find out what nature is for myself, and see her with my own eyes. This appears to me the true road to excellence.

Gilbert Stuart

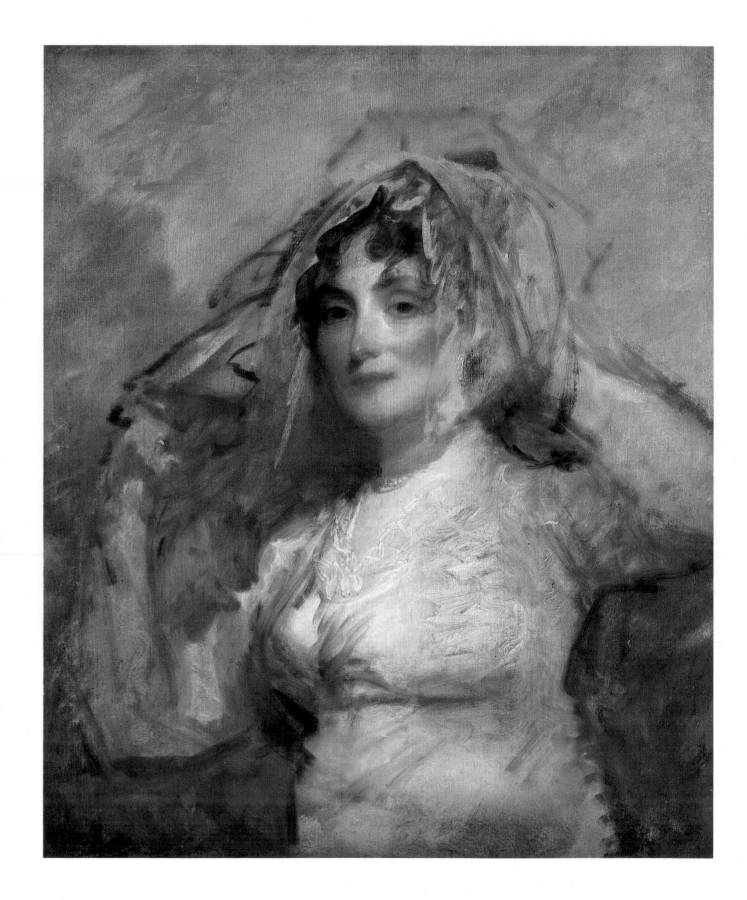

Gilbert Stuart

RICHARD McLANATHAN

Harry N. Abrams, Inc., Publishers, New York

IN ASSOCIATION WITH

The National Museum of American Art, Smithsonian Institution

*Dedicated to the memory
of Gilbert Stuart and of his many sitters,
all participants in the life of a period
of robust vitality and memorable achievement.*

Series Director: Margaret L. Kaplan
Project Director: Robert Morton
Editor: Teresa Egan
Designer: Michael Hentges
Photo Research: Barbara Lyons

Library of Congress Cataloging-in-Publication Data
McLanathan, Richard B. K.
 Gilbert Stuart:
 (The Library of American Art)
 Bibliography: p.
 Includes index.
 1. Stuart, Gilbert, 1755–1828. 2.Portrait
painters—United States—Biography. I. Title.
II. Series: Library of American art (Harry N. Abrams,
Inc.)
ND1329.S7M39 1986 759.13 [B] 86–1144
ISBN 0–8109–1501–4

Frontispiece: *Mrs. Perez Morton*, page 110

Published in 1986 by Harry N. Abrams, Incorporated, New York

Times Mirror Books

Printed and bound in Japan

Contents

Preface

AMONG THE MANY ARTISTS that America has produced, Gilbert Stuart must rank among those in the top echelon. Though he limited himself to the traditional field of portraiture, a category of art that seems today as obsolete as tiewigs and three-cornered hats, he enriched and enlarged it by his practice. No one knows how many pictures he painted, but the number of those that are known bulks amazingly large. Yet their artistic quality remains high, and their human quality, perhaps even higher. He lived, as do we all, in a period of change. The better to understand his accomplishment, both artistically and personally, I have tried to suggest something of the world in which he lived and worked, and of his often markedly idiosyncratic reactions to that world. He himself savored personality, and I hope that, knowing him a little more as a person rather than merely as a painter of icons who lived long ago, others may savor his complex personality as I have come to do in writing of him. In any event, the record is there—the many portraits painted over a long, productive life. If it accomplishes nothing more, I hope that this book will present to the latter-day reader a kind of visual who's who of a vital period, seen through the likenesses of those who lived in it and, often, profoundly influenced its course—and, thereby, the course of our lives even today—as observed and recorded through a personality as vivid as that of any of his many sitters.

Except for the file in the Frick Art Reference Library, which is periodically updated, the latest attempt to list Stuart's complete works appears in Mount's biography of 1964. Understandably, many lost or unrecorded pictures have come to light—and many others have changed hands—since its compilation.

Any such essay as this must rest on the foundation of the contributions of previous workers in the field, and, as always, there are certain key sources. Because of the lack of personal documents—since Stuart wrote few letters and almost everything else seems to have burned in the fire that consumed Jane Stuart's studio many years after her father's death—the paintings themselves remain the primary source. But there are also the accounts of Dunlap and Waterhouse, Jane's articles in *Scribner's*, Dowling's Irish reminiscences, and a few others that all of us who study Stuart have, of necessity, used extensively. Mason, Park, Morgan, Whitley, Flexner, and Mount have all made vitally important contributions, both in interpretation and in presenting additional material. All of these and more are listed in the brief Bibliography at the end of the book, and I hereby acknowledge my debt to them with pleasure and appreciation.

6

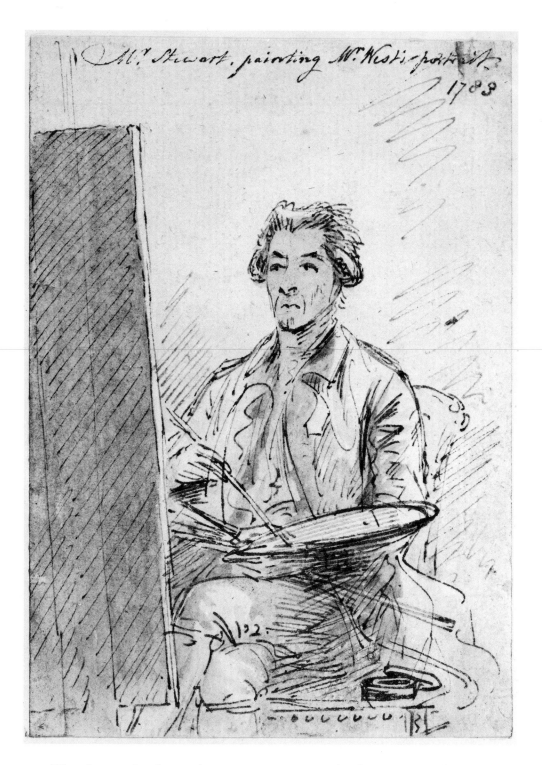

Mr. Stewart, painting Mr. West's portrait
1783

Benjamin West
Mr. Stewart, painting
Mr. West's portrait, 1783

Pencil on paper, 6⅞ × 4⅞"
British Museum, London

A swift sketch made by West while Stuart
was painting the canvas now in the Na-
tional Portrait Gallery, London. It sug-
gests the concentration with which Stuart
worked.

Thanks are also due to the many museums and private collections that have kindly supplied illustrations and background; to Robert Morton, Barbara Lyons, and others at the publisher's whose assistance was admirably professional but whose interest went far beyond that; to the staffs of the Frick, Bowdoin College, Fogg, and several other libraries for their patience and expertise; and to fellow art historians and interested friends whose information and suggestions were eminently helpful and generously given.

RICHARD McLANATHAN

The Stone School House
Phippsburg, Maine

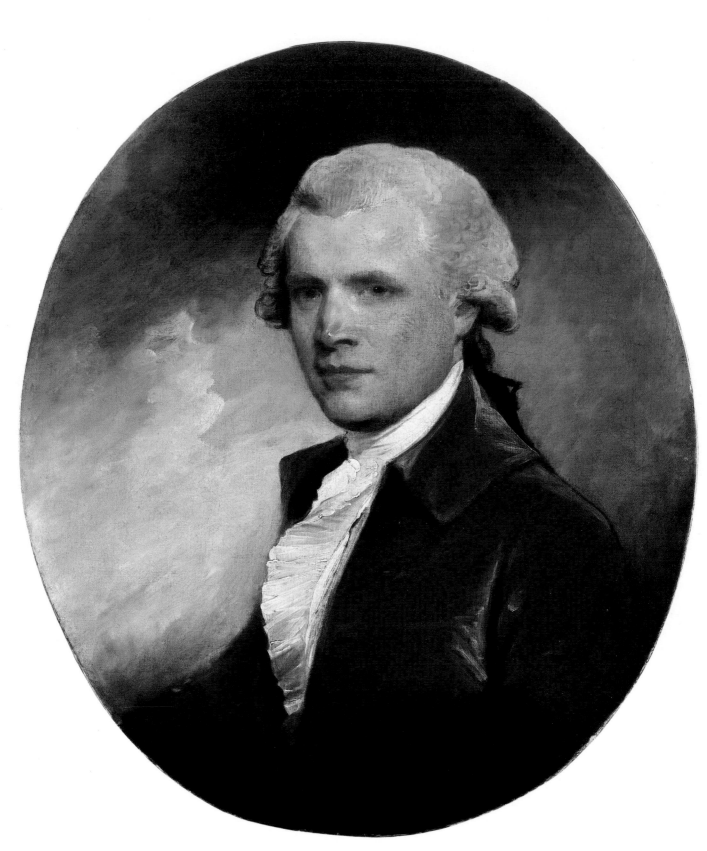

John Singleton Copley

INTRODUCTION
"Preserving the Resemblance"

THE EARLIEST KNOWN American paintings are portraits, produced by anonymous limners who had brought their craft with them across the seas. The predominantly Protestant societies of the American colonies, with their roots mainly in England, Scotland, the Netherlands, dissenting Germany, and Scandinavia, had little use for the fine arts, which they associated with the meretricious display of dissolute courts and the worldly trappings of papistry. But in the earlier years of settlement there were so few souls in so vast a wilderness that each individual took on an enhanced importance, and limners recorded the likenesses of men, women, and children—God's pilgrims all—with loving detail and realistic intent. Few seventeenth-century portraits have come down to us, but those few that have are precious documents of the early springtime of developing civilization in an America now unimaginably remote. They stand at the beginning of the practice of portraiture on these shores, to which Gilbert Stuart (1755–1828) later made such a brilliant contribution.

The portrait tradition was not only introduced but also maintained by artisans, handy individuals who "painted everything from houses to heraldic devices," including coaches and furniture and shop and inn signs, as effectively as they recorded a likeness. They learned their craft as artisans always have, by working with more experienced workmen and observing their methods and products. The resulting vernacular mode was influenced by academitism only remotely, primarily through engravings after the works of European masters and by the extremely small number of European pictures that were brought across the sea. But in 1729 came a significant change. That year saw the establishment in America of the first academically trained and professionally competent painter to reach these shores, a serious Scot named John Smibert (1688–1751). He had been persuaded to leave his minor but comfortable practice in London to follow the dream of George Berkeley, dean of Derry, who sought, with a promised parliamentary grant, to found a college in Bermuda for the Christian education of Indians. When, not surprisingly, the grant was not forthcoming, Berkeley sailed back to Ireland to become bishop of Cloyne and a distinguished philosopher, famous for his *Essays Towards a New Theory of Vision*. Smibert moved to Boston, and in 1730 opened, in his painting rooms there, the first art exhibition held in America. It included copies of old masters, casts from the antique, and, in flattering proximity, portraits he had just painted of such Boston worthies as Chief Justice Samuel Sewall and the Reverend Nathaniel Byfield.

John Singleton Copley

c. 1784. Oil on canvas, 26½ × 22¼"
National Portrait Gallery, London

The portrait was commissioned by Alderman Boydell in 1783, when both sitter and painter were recognized as leading artists of the day. Of the several portraits of Copley, including those by himself, "not one," in his family's opinion, "gives us as agreeable an impression of the artist as the one by Stuart."

Until his death just after the middle of the eighteenth century, Smibert was the leading artist in America. He had been preceded by other European-trained painters, such as the Swede Gustavus Hesselius (1682–1755), but none approached him in artistic ability. Smibert's painting rooms, where he also sold artists' supplies, were a place of pilgrimage for colonial painters, and of all the pictures there none was more influential than his copy of Van Dyck's portrait of Cardinal Bentivoglio, which he had made years earlier while studying in Italy. In its subtlety of modeling, painterly handling, and glowing color, the young Americans could glimpse the richness of the great tradition of which they dreamed. After Smibert's death, his nephew John Moffatt—brother of Dr. Thomas Moffatt of Newport, who was the partner of Stuart's father in a snuff mill—carried on the business of selling art supplies. Surely the young Gilbert Stuart, especially because of the Newport connection, saw Smibert's canvases, including the *Bentivoglio*.

Two American artists less than a generation older than Stuart exerted a profound influence on him, as they did on many others: Benjamin West (1738–1820), a precocious Pennsylvania Quaker, and John Singleton Copley (1738–1815), a New Englander born in Boston. Both started out as artisan painters, but both far transcended the vernacular tradition. At the age of nine, West met in Philadelphia an itinerant English limner named William Williams, who taught him the rudiments of the craft. He also studied the works of John Wollaston (fl. in America, 1749–1758), an English journeyman whose almond-shaped eyes appear in early West portraits, and of the far abler and tragically short-lived colonial painter Robert Feke (1705?–?1751), the only American artist of real quality before West and Copley. West developed a following at a very early age, and, with the assistance of generous Philadelphians, he went abroad to study in Italy. In 1763 he settled in London, where he made a great success.

Copley grew up on Long Wharf in Boston, where his widowed mother kept a tobacco shop that was patronized by sailors. After she married Peter Pelham, an engraver and painter, Copley studied with his stepfather, a jack-of-all-trades who advertised as a teacher of "Dancing, Writing, Painting upon Glass, and all kinds of needle work." Pelham gave music lessons and sold paints, brushes, and other artists' supplies. None of his paintings has been identified. Though he died when Copley was only thirteen, his influence upon the boy was strong. Copley studied Pelham's collection of engravings after European masters, the works of Smibert and Feke, the stiff and primitive efforts of Joseph Badger (1708–1765) and John Greenwood (1727–1792), both from New England, and of such British visitors as Joseph Blackburn (fl. in New England, 1753–1763), apparently a drapery painter—a specialist who worked on costumes and other such details in the studio of a more accomplished artist whose abilities brought him more work than he could handle alone. By the age of seventeen, Copley was an independent professional, painting as well as any of them and better than most. By his early twenties, he had surpassed them all and was indisputably the leading artist in America.

But Copley wanted to paint more than portraits. "A taste of painting is too much wanting," he wrote to West in London in 1766; "was it not for preserving

the resemblance of particular persons, painting would not be known in the place. The people generally regard it as no more than any other useful trade, like that of a Carpenter, a tailor or shew maker." Like West, who believed that "Painters could walk with Kings," Copley considered painting "one of the most Noble Arts in the World." Like West also, he longed to go to Europe to see the treasures of the world's art and to join the mainstream of Western art flowing out of a fabled past. On the eve of the Revolution, he went.

Stuart had no such ambitions. He wanted to become a part of that stream, but only as a portrait painter. Not for him the histories and mythologies that so captivated Copley and West. His overwhelming interest was in human faces and what they revealed of human nature. He had extraordinary natural gifts. When, despite the problems—caused by his stubborn and irresponsible nature—that complicated his life, he finally gained the skills to enable him to use his gifts, he equaled and sometimes surpassed the best. But in the completeness of his record of the likenesses of the leaders and prominent personalities of his time—in London, in Dublin, and in the United States—he remains unique. Thanks to Gilbert Stuart, our founding fathers and early heroes are not mere names in a history book. They are a part of our lives today, just as they were a part of his life. As the critic of *The World* of London wrote in 1787, Stuart could "secure the perpetual presence" of a sitter, "independent of time and place."

The high eighteenth century, the age in which Copley, West, and Stuart did much of their work, was a golden age of portraiture. The Enlightenment confirmed the conviction that the proper study of mankind was man, so the portrait reigned supreme. It had a long tradition behind it, stemming from the Renaissance and enriched by the Baroque of the seventeenth century. On both sides of the Atlantic it was the dominant category of painting. In the early nineteenth century, however, with the growing spirit of Romanticism, there was renewed interest in subjects from history and mythology, a movement in which the transplanted Americans, West and Copley, were leaders. But by the middle of the century, landscape ruled in an era ushered in in England by the picturesque views of the later Gainsborough, influenced by the Dutch; of Richard Wilson, influenced by the Italians; of Constable's airy skies and cloud-shadowed meadows and the atmospheric visions of J. M. W. Turner; and, in America, by the Romantic vision of Washington Allston and the rediscovery of nature in the canvases of Thomas Cole and other members of the Hudson River School.

Stuart, then, lived in a period of transition. Like Copley and West, he started out as a colonial primitive. But where they, by painstaking study, made their own way, Stuart needed instruction to enable him to develop his natural gifts, no matter how passionately his touchy independence resented it. He found it, first, with a visiting Scotsman, Cosmo Alexander, and, later, with Benjamin West in London. Stuart's artistic achievement was such that, years later, long after his return to America, West, by then president of the Royal Academy and full of years and honors, could tell the newly appointed British minister to the United States that there he would find "the best portrait painter in the world, and his name is Gilbert Stuart."

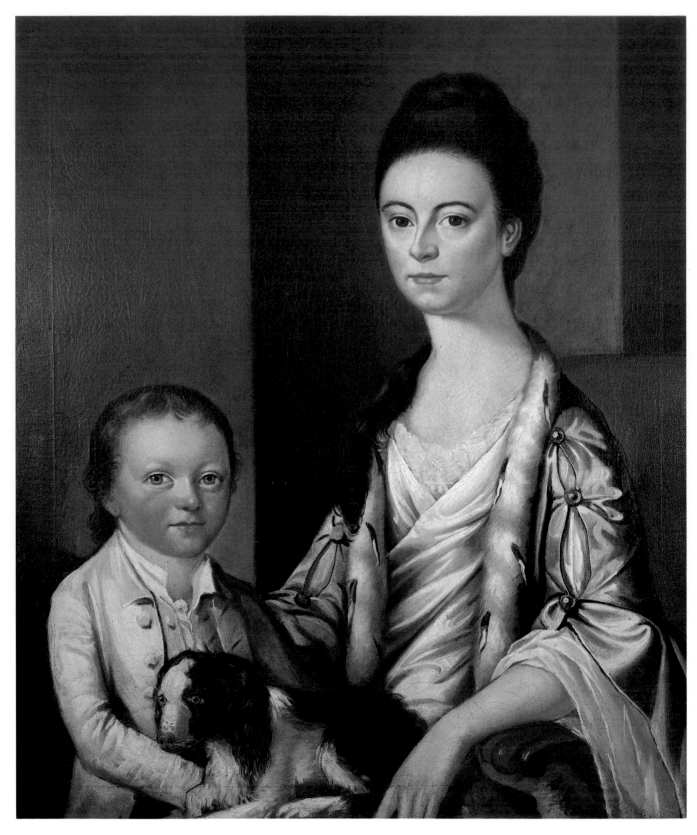

Mrs. John Bannister and Her Son

I. "An Only Son, Handsome and Forward"

W HEN THOMAS SULLY, the noted Philadelphia portrait painter, visited Boston in 1807, Gilbert Stuart was past fifty years of age. The tremor from which he suffered in later years was already noticeable, but when Sully came to the studio of his old master, he found him hard at work. Sully watched him charge his brush with paint, then hold it quivering for a moment before his hand darted forward to touch the canvas—with what seemed like miraculous precision—in the flickering, sure, but delicate stroke that is the hallmark of his distinctive style. "The privilege of standing by the artist's chair during a sitting was a situation I valued more, at that moment," Sully recalled in later years, "than I shall ever appreciate any station on earth." By that time Stuart was a legendary character. His eccentricities were well known and accepted. His outbursts of temper and dilatoriness in finishing commissions were condoned. He had won international fame, had mingled with the great in the capitals of Europe, and had been mentor to more than one generation of aspiring young American artists, thereby leaving his mark on the development of painting in this country for half a century. In artistic matters his judgment was considered to be infallible, and his status as the grand old man of American art was unquestioned.

Gilbert Stuart had traveled a long and arduous road to achieve this position. It had started fifty-two years earlier on the western shore of Narragansett Bay in the colony of Rhode Island. There, on a bitter cold night, the third of December, 1755, he was born in an upper chamber, above the rumbling waterwheel and massive gears and grindstones of a snuff mill built beside the runoff from Petaquanset Pond in the sparsely inhabited countryside of North Kingston County. Later, Stuart amused his friends in England and Ireland by describing his birthplace as "six miles from Pottawoone and ten miles from Pappasquash and about four miles from Conanicut and not far from the spot where the famous battle with the warlike Pequots was fought." When they jumped to the conclusion that he had come from India, he was delighted.

It was an unlikely birthplace for a world-famous artist, but there was a good bit of the unlikely in his life and career, and, appropriately, there is a mystery about his origins. Many have refused to credit the account of his daughter Jane that the artist's father was of a solid Scottish family from Perth and had been educated for the ministry but, because he was a Jacobite, had to flee the country after the defeat of Bonnie Prince Charlie's forces at Culloden in the ill-fated rising of 1745. It is true that, understandably, Jane tried to put the best face possible on

Mrs. John Bannister and Her Son

c. 1774. Oil on canvas, 36 × 30"
Redwood Library and Athenaeum,
Newport, Rhode Island
Gift of David Melville, before 1859

The Bannister house was one of the finest in Newport, a city of elegant mansions. During the Revolution it was commandeered by the British and occupied by Lord Percy. Later, as the duke of Northumberland, Percy commissioned Stuart to portray himself, the duchess, and their children, paintings the artist executed in a manner very different from that of the primitive works of his boyhood.

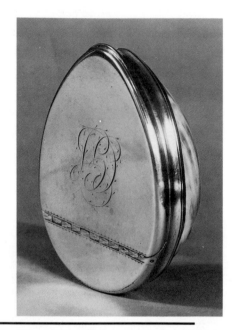

Silver Snuffbox

This is one of several snuffboxes owned by Gilbert Stuart. Once, while visiting his friend Isaac P. Davis, Stuart left without his snuffbox. It was so large that his host, as a joke, hired a porter with a barrow to return it.

the often somewhat questionable events of her father's career. Yet there is nothing inherently implausible about her story. According to what little is known of the elder Gilbert Stuart's departure from Scotland and arrival in America, the timing is right, and, given his ardent and impetuous temperament, it seems not unlikely. If he had been a refugee from Culloden, which was fought on April 16, 1745, and had fled to America, he would probably, like innumerable other emigrants, have indentured himself to pay the six or seven pounds necessary for his passage. His five years of indenture would have been up by 1751, the year in which he became a member of the considerable Scottish colony in Newport. There he was known as a carefree but entirely respectable young millwright; he may well have learned that trade during his indenture.

On May 31 of that year he married Elizabeth Anthony, the attractive daughter of a farmer who had considerable landholdings. He also entered into partnership with Thomas Moffatt, originally of Edinburgh, who in 1729 had accompanied his uncle, the painter John Smibert, when he came to America with Dean Berkeley. A Scottish physician who had attended the renowned Dutch medical school at the University of Leyden, Moffatt was a well-traveled and cultivated man. He was a friend and admirer of Robert Feke, the first native-born American painter of genius, who lived the greater part of his short life in Newport. There was also a third partner, Edward Cole, about whom little is known except his name and status as "gentleman." The purpose of the partnership was "to erect an engine for the manufacture of snuff," an endeavor that was more practical than it might seem today because almost everyone was addicted to snuff, which, because it was imported, was extremely expensive.

By November the mill was completed: a two-storied structure with a heavy frame and a gambrel roof, with quarters for the miller and his family above the lower floor, where the grinding was done. So young Gilbert Stuart spent his earliest years in an atmosphere redolent of tobacco. Throughout his maturity he was notorious for heavy consumption of snuff, dipping frequent pinches from a box "nearly as large round as the top of a small hat," as a wondering contemporary described it. "Snuff taking," Stuart admitted to John Neagle, a young Philadelphia painter visiting his Boston studio, "is a pernicious, vile, dirty habit, and, like all bad habits, to be carefully avoided."

"Your practice," his visitor observed, "contradicts your precept, Mr. Stuart."

"Sir, I cannot help it. Shall I tell you a story?"

Stuart then recounted an incident that occurred while he was traveling in Ireland in a coach "full within, loaded on the top, and an additional unfortunate stowed with the stuff in the basket.... In the dark night,...coachee contrived to overturn us all—or, as they say in New York, dump us—in a ditch. We scrambled up, felt our legs and arms to be convinced that they were not broken, and finding on examination that inside and outside passengers were tolerably whole (on the whole), someone thought of the poor devil who was shut up in the basket. He was found apparently senseless, and his neck twisted awry. One of the passengers, who had heard that any dislocation might be remedied if promptly attented to,

AN ONLY SON, HANDSOME AND FORWARD

seized on the corpse with a determination to untwist the man's neck and set his head straight on his shoulders. Accordingly, with an iron grasp he clutched him by the head, and began pulling and twisting by main force. He appeared to have succeeded miraculously in restoring life, for the dead man no sooner experienced the first wrench than he roared vociferously: 'Let me alone! Let me alone! I'm not hurt, I was born so!' "

"I, too, was born so," explained Stuart. "I was born in a snuff mill."

He was the third child in the family. James, the eldest, was born in the spring of 1752 but did not live the year out. Ann, who came the following year, survived to become a doting sister to young Gilbert, who entered the world with a healthy howl on that cold December night two years later. Like country families throughout the colonies, the Stuarts were largely self-sufficient, raising their own fruits and vegetables, chickens and other livestock. The nearest neighbors, farmers and fishermen, lived at some distance, and there were but few visitors. There were occasional trips to Kingston, the nearest town, a few miles to the west. Otherwise life was uneventful, lived to the accompaniment of the groaning waterwheel and the creaking of the machinery of the mill. From the windows of the family's living quarters on the second floor, they could look out at tall trees, the tumbling waters of the millrace, and the placid pond, extending far into the distance, where the elder Gilbert, no doubt often accompanied by his son, fished in the summer and skated in the winter. The boy had early shown himself to be bright. His parents were indulgent, but his mother was determined that he should begin his education properly, so she sent to Newport for a Latin grammar, and by keeping a page or two ahead of her pupil, taught herself and her son as well.

When young Gilbert was six, a shortage of the glass jars in which the snuff was shipped and sold brought the mill to a halt. The expedient of using animal bladders as a substitute proved unsuccessful, so the elder Stuart sold his share in the venture to Dr. Moffatt, and in 1761 the family moved across the bay to Newport, where a new world opened to the future artist.

By mid-century Newport, with a population of about six thousand, was an important colonial center. It was already famous for the mild island climate that had attracted southern and West Indian planters—who made it their headquarters—and many visitors as well, including George Berkeley, who spent three years there after his arrival in 1729, waiting for the parliamentary grant that never came. He enjoyed his stay and left his mark on Newport society. A friend of Jonathan Swift and the essayists Addison and Steele, Berkeley seems to have communicated his intellectual breadth and interest in arts and letters to the entire community. "A small but handsome town," a French visitor called it. "Its houses, though mostly of wood, are of an agreeable shape." It was a place of cobbled streets and paved squares, of weathered shingles and lilacs, of elms and butternuts casting shadows over lawns blooming with daffodils in the spring, of flower beds and rows of vegetables in dooryards defined by hedges and white-painted fences. A few minutes' walk took one beyond the town, out among open fields. "The face of the country was beautiful beyond description," Arthur

Trinity Church, Newport, Rhode Island

The triple-decked wineglass pulpit is that from which Bishop Berkeley preached. Stuart attended the parish school and was taught to play the organ by Herr Knotchell, the church organist. Designed by Richard Munday, the church was completed in 1726.

Browne, Stuart's boyhood companion, remembered. Of "beggars literally there were none.... Every man tilled his own field, the daughters spun, the sons delved, and competence and content were their companions."

Newport's wealth was based on maritime commerce, and by mid-century, its volume was greater than that of New York. More than three thousand seamen were said to have been employed in Newport-based vessels. Its connection with the sea was appropriately symbolized by the scallop shells that adorn the elegant secretary bookcases and other pieces of furniture to be found in many Newport houses. Made of Santo Domingo mahogany, they were produced by the Goddard and Townsend families in their shops on Easton's Point. Newport's broad expanse of sheltered anchorage, open throughout the winter when Boston's waterfront was often locked in ice, provided the home port for a large fleet, ranging from fishermen to merchantmen. There were also swift and rakish craft for trade in rum and slaves and the even more profitable venture of smuggling, to which the restrictions of the Navigation Acts provided an irresistible invitation to the independent-minded colonials. In those troubled times of almost continual war, fortunes could also be made—by those sufficiently daring and free of scruple—during a single voyage of a privateer.

The tradition of tolerance established by Roger Williams, the founder of "Rhode Island and Providence Plantations," was reflected in the mixture of English Anglicans, Baptists, and Quakers, Scots Presbyterians, and Sephardic Jews that made up Newport's society. The quality of the town's cultural life as well as its sobriety were expressed in the distinction of its architecture, whose assured dignity and reserve put to shame the nineteenth-century millionaires' "cottages," for which Newport is famous today, for being as ostentatious examples of conspicuous consumption as their nouveaux-riches owners no doubt desired. Only Williamsburg could match the genuine grandeur of the setting for Richard Munday's Colony House of 1742, with its balustraded roof deck and cupola, its mile-long approach up Queen Street, lined with handsome dwellings and shaded with trees, from Long Wharf, with its twenty-seven shops and warehouses, projecting almost a half mile into the harbor.

Before his death in 1739, Munday, an innkeeper and carpenter as well as an architect, had designed and built many of the town's more distinguished houses. By 1726 he had completed Trinity Church, whose steeple is still a landmark. There the Cranstons, Malbones, Pelhams, Wantons, and other leading families listened to lengthy and learned sermons delivered from the raised pulpit, which had a suspended sounding board. Dean Berkeley often preached there to a congregation that appreciated his urbanity of style and subtlety of mind. His baby daughter, Lucia, is buried in the graveyard nearby. He was the founder of the parish school of Trinity where, from the age of six, Gilbert Stuart was enrolled as a scholarship student. Along with the children of wealthier parishioners, he studied grammar, arithmetic, Latin, and history and learned the flowing style of penmanship that can be admired in the few letters that have come down to us. He was remembered as "a very capable, self-willed boy, who, perhaps on that account, was indulged in everything, being an only son, handsome and forward."

The Stuarts lived in what the artist later described as "a hovel on Bannister's Wharf." But life could not have been all bad, because Mrs. Stuart owned a female slave with a child old enough to be of help, and the family had enough land to grow a garden and keep some livestock. The elder Gilbert apparently continued in his trade, since he is listed in town records as a snuffmaker. Ever ingenious, he is said to have invented a device for lading and unlading vessels, though, typically, he seems to have had little profit from it. In 1761, the year the family moved to town from the shores of Petaquanset Pond, Stuart's name appears among the proprietors of another Newport, a plantation newly established in Nova Scotia. The new settlement was to be their refuge at the time of the Revolution. In the meantime there was much to entertain a lively boy: the fascinating bustle of the waterfront with its more than a mile of wharves, docks, and shipyards; the coming and going of craft of all sizes and their crews; the landing of exotic cargoes and sometimes of even more exotic people; and the constant activity of Brimley's ropewalks, where cordage for Newport's ships was made. In summer there were fishing and swimming off the beach.

Visitors to Newport during these years reported on the luxury of many of the houses, where Chinese or Indian tea was served in imported porcelain cups, and French, Italian, and Spanish wines were drunk from Dutch or English goblets. Many families received regular shipments of the latest books and periodicals from London and Edinburgh. Dress, drapery, and upholstery materials, articles of clothing, and even, rarely, coaches and carriages were imported. There were paintings purporting to be by such artists as Sir Godfrey Kneller and Van Dyck, including portraits of the sovereigns Charles I and Henrietta Maria, William and Mary, Peter the Great, and "the dying Cleopatra in an oval frame." There was great interest in music and an awareness of what was going on in the world across the seas. By constant reference, distant ports became familiar, and the very names of the great cities, particularly on the Continent and in the British Isles, stirred the memories of the elders and the imaginations of the young. Stuart's closest friends were Benjamin Waterhouse, of a wealthy Quaker family, who became a leading physician and brought vaccination to America, and Arthur Browne, son of an Anglican clergyman, who became a famous attorney in Dublin and represented the university in Parliament, where he was an eloquent speaker. They shared, as Waterhouse recalled, "the same ardent desire of visiting Europe."

All three boys, and doubtless their classmates, chafed under the discipline of their major teacher at the Trinity Parish School, a German pedagogue named Johann Ernst Knotchell. They thought more kindly of the Reverend George Bisset, the church's assistant minister, who oversaw their instruction and taught several subjects as well. Stuart, however, was enchanted by Knotchell's musical abilities, demonstrated by his performances on the organ that had been given to the church by Dean Berkeley. It was reputed to be "one of the best instruments in America," as Stuart later recalled. Recognizing the genuineness of the boy's enthusiasm, the stiff-necked German unbent enough to give him lessons and let him sit nearby while he played for services. It may have been Herr Knotchell who

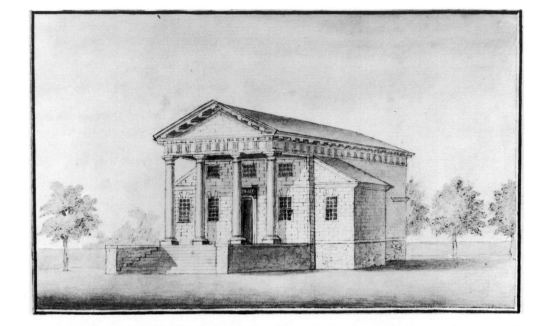

also taught him to play the harpsichord, the flute, the oboe, and other instruments. In any event, his love of music and his performing ability probably brought him greater satisfaction than anything else during his often troubled later life.

In 1766, when Stuart was eleven, the handsome Brick Market, with its arcaded ground floor and giant order of Ionic pilasters, was under construction in Newport, and he and his friends must have followed its building with interest. It was designed by Peter Harrison, a leading citizen and the outstanding architect in Pre-Revolution America. A Yorkshire Quaker turned Anglican, Harrison came to Newport at the age of seventeen. At twenty-three he was captain of one of the largest English merchant vessels in the Atlantic trade, and at thirty he retired from the sea to become a successful merchant, shipbuilder, engineer, surveyor, and farmer. In 1746, after what some considered a scandalous courtship, since it involved, not too unusually, a premature pregnancy, he married the charming Betty Pelham, one of the richest heiresses in the colony. Free to follow his interest in architecture, in 1748 he completed the Redwood Library, named in honor of Abraham Redwood—whom Stuart was later asked to paint—an Antiguan planter who had given a generous sum for the purchase of books for public benefit. It is the first example of pure Palladianism in the colonies, a building that Stuart remembered with admiration. It is fitting that a self-portrait and several other paintings by him hang permanently in its elegant interior.

By 1759 the construction of Touro Synagogue was under way. The oldest in the United States, built to Harrison's design, it was completed in the winter of 1763. The interior rivals that of King's Chapel in Boston, which was also designed by Harrison. Since, despite its importance, Newport was really a small town in the eighteenth century, such events were of great concern to the community and undoubtedly commanded the attention of Stuart and his companions. It was in Touro Synagogue in the summer of 1790, three years before Stuart re-

turned to America, that President Washington told the assembled Congregation Jeshuat Israel that "it is now no more that toleration is spoken of, as if it was by the indulgence of one class of people that another enjoyed the exercise of their inherent natural rights. For happily the Government of the United States ... gives to bigotry no sanction, to persecution no assistance." During a century when sectarianism prevailed throughout New England, Newport was an oasis of intellectual freedom, openness, and mutual respect. It was in such an atmosphere that Gilbert Stuart spent his early years.

In 1769 there occurred an event that changed the course of Stuart's life: the arrival in town of Cosmo Alexander, a Scottish painter. Alexander had been born in Edinburgh, the son of an artist who named him in honor of his own patron, Grand Duke Cosimo III of Tuscany. After the disaster of Culloden, Alexander, who had been a Jacobite, fled to the Continent, apparently studying in Italy before returning to London. There he became a member of the Society of Artists of Great Britain, a predecessor of the Royal Academy. He had also painted in Holland and was a member of the Painters' Guild of The Hague. He traveled to America with the expressed purpose of claiming certain tracts of land that were his by inheritance. Though it has been conjectured that Alexander was a British spy sent to report on seditious elements in the colonies, he seems to have been a highly respectable person who came well recommended. He had letters of introduction from William Strahan, the King's Printer, and others to people of the importance of William Franklin, the royal governor of New Jersey, at whose house he stayed for some time, painting portraits of the governor and his family and friends. In Newport his host was Dr. William Hunter, a physician who attended, primarily, the Scottish families of Newport, including the Stuarts, and who is credited with the first series of anatomical lectures given in the colonies.

According to family legend, Gilbert had early shown a marked visual acuity and a precocious ability to draw, but Dr. Hunter may have been the first outside the family to recognize his artistic talent. Hunter probably took care of him when, at some time during his boyhood, he either suffered an accident or had a disease that left him with one leg smaller than the other. Because of his athletic ability and activity, however, this was scarcely noticeable and seems to have caused him no inconvenience. It was probably when he had an eye affliction, which fortunately responded to treatment, that Hunter saw for the first time and recognized the promise of the sketches with which the boy had decorated the walls of his room in the small house on Bannister's Wharf. When Gilbert recovered, the doctor gave him a box of colors and commissioned a portrait of his two spaniels. Thus encouraged, Stuart copied engravings and developed a tight, provincial style of portraiture, perhaps derived in part from the son of an instrument maker, Samuel King, who painted as a sideline to his father's craft. Stuart's introduction to Cosmo Alexander was thus an event of great importance to him, and his first meeting with the fashionably dressed artist in his makeshift painting room in Dr. Hunter's house made a lasting impression. He always remembered Alexander, surrounded by his professional equipment, including, according to Ben-

Southeast Parlor of the Hunter House, Newport, Rhode Island

The painting of the two dogs has been recently identified as the earliest known work of Gilbert Stuart. It was commissioned by Dr. William Hunter, the physician who attended the Stuart family, when the artist was about twelve years old.

jamin Waterhouse, a camera obscura and "optical glasses for taking perspective views." At Hunter's request, Alexander agreed to give the boy instruction, and his determination as well as his ability soon led Alexander to take him on as an assistant. In this way, at age fourteen Stuart's artistic career was off to an auspicious start.

For all his study and experience—and his fine appearance and status as a gentleman—Cosmo Alexander was far from being a painter of the first rank. He has understandably been relegated to a minor position in the history of art. Though the dry, linear style learned in Florence and Rome shows him to have been somewhat uninspired, it also demonstrates his command of the principles of the painter's craft, which he passed on to his young protégé—what Waterhouse called "the grammar of art" and "the groundwork of the palette." So while Alexander was painting attractive but not outstanding portraits of various members of the Scottish community in Newport—of Grants, Fergusons, Keiths, and others—young Gilbert Stuart was learning how to grind and mix pigments, clean brushes, prepare panels and canvases, and lay out a palette with the colors arranged in neat dabs in the proper order. He also observed his master's technique and, in the process, learned something of the courtly manner of a person assured of his position and at ease in the company of others of birth and breeding.

The arrangement worked so well that Alexander proposed that Stuart accompany him on a journey through the southern colonies, during which he planned to paint portraits and pursue his inheritance. Seeing the advantages of the experience for their son, Stuart's parents agreed. Little is known of the travelers' itinerary, though portraits by Alexander have turned up in Philadelphia;

Newcastle, Delaware; and Norfolk, Virginia; and their route seems to have been determined by the presence of churches designed by or after the architect of the Radcliffe Library at Oxford and the beautiful churches of St. Martin-in-the-Fields and St. Mary-le-Strand in London: Sir James Gibbs, whose heir Alexander was. Whether or not it was originally so intended, the two seem not to have returned to Newport before departing for Scotland, probably in the fall or winter of 1770–71, perhaps sailing from a southern port.

Though Stuart had received the fundamentals of education under the tutelage of Herr Knotchell and the Reverend George Bisset in Newport, he evidently acquired his knowledge of the classics during study in Edinburgh, where educational standards were high. As he daily walked back and forth to school, he remembered, he passed James's Court, where the historian and philosopher David Hume lived and where, two years later, James Boswell entertained Dr. Johnson. Edinburgh's pungent smells from open sewers, the "evening effluvia," as Boswell called it, were a reminder that it was risky to walk at certain hours through the narrow closes of the medieval quarter, with its towering tenements, where the shouted warning, "Gardyloo!" scarcely gave time to dodge the contents of the slop jars emptied from above. The transformation of the city by the brothers Adam had recently begun, and the construction of the New Town to the Adams' superbly rational designs must have been fascinating to a youth who had seen the rise of Peter Harrison's Palladian buildings—though on a far smaller scale—in his native Newport. Edinburgh was a city of intellectual distinction as well, with writers and booksellers, poets, critics, musicians, learned symposia, and elegant receptions.

Stuart's experience in Edinburgh did much to prepare him for his later career, but he had far too little time to take proper advantage of his stay there. On August 25, 1772, Cosmo Alexander suddenly and unexpectedly died, leaving his young assistant to the care of his brother-in-law, Sir George Chalmers. Chalmers was also a painter and, though a baronet, was practically impecunious, his estate having been forfeited by a predecessor for Jacobite sympathies. There is no sure record of what happened during the next few months. Stuart seems to have painted portraits in an attempt to support himself, but, on his own at seventeen, he was too inexperienced to challenge the competition of the trained professionals already established there. After months of increasing hunger and despair, he signed on as a member of the crew of a small collier bound for Nova Scotia and finally turned up at home in Newport, thin, threadbare, and penniless. For weeks he saw no one but those closest to him, and nothing would induce him to say a word about his experiences in Edinburgh after Alexander's untimely death or about his voyage home. "What his treatment was," Waterhouse wrote, "I never could learn. I only know that it required a few weeks to equip him with suitable clothing to appear on the streets, or to allow any one of his former friends, save the writer, to know of his return home. Suffice it to say that it was such as neither Gilbert Stuart, father or son, ever thought proper to mention."

Despite the bitterness of this experience, which seems never to have entirely left him thereafter, the effect of the time spent with Alexander was decisive.

Through his influence, Stuart had tasted a kind of life and glimpsed a career that extended far beyond his provincial beginnings. He, too, would become a professional artist, living in a cultivated and graceful style. Portraiture would be the means by which he would achieve it. With the ferocious energy that so often throughout his life alternated with bouts of depressed lethargy, he set out to make a name for himself by painting portraits, at first of family and friends. Then he found sitters among the members of the congregation of Touro Synagogue, including the Portuguese Jews Aaron Lopez, who had made a fortune in spermaceti candles, and his brother-in-law, Jacob Rodriguez Ribera. Gradually, he acquired a reputation, and soon "our aspiring artist," Waterhouse proudly recorded, "had as much business as he could turn his hand to."

Stuart studied the works of Feke, Copley, Blackburn, and other painters whose canvases hung in Newport houses. He discovered, as had Copley some years earlier, the usefulness of engravings after European masters as a source of compositions, poses, and details. Gradually, he worked his way from the formulas of Cosmo Alexander toward the searching realism and reduction to essentials that inform his mature productions. But there were setbacks. "When," as Waterhouse wrote, "a committee of the Redwood Library . . . waited upon him to engage him to paint a full-length of its founder, Abraham Redwood, then living next door to the painter, for which the young artist would have had a generous reward, . . . he declined it in sullen silence, and by so doing turned the popular tide in some degree against him. . . . This occurrence cooled the zeal of many of his friends." Such an unexpected and capricious reaction seems inexplicable; the reason may lie hidden in his silence about his experiences after Alexander's death. He may have attempted a full-length in Edinburgh and failed miserably. In any event, the problem of the full-length portrait was to return to haunt him.

Perhaps it was this change of climate in Newport that led Stuart to go to Boston shortly after Copley's departure for Europe in June, 1774. According to Mather Brown, an American pupil of West's, Stuart lived for a time in Boston "near Mr. Whiting's, a print-seller near Mill Bridge," and was "the first person who learnt me to draw at about twelve years of age." But the climate in Boston was not favorable either, because of the growing tensions of the British blockade, the rising rebellion of the Patriots, and the stubborn resistance of the diminishing number of Loyalists. Leading Tories had taken refuge in Castle William in the harbor, and Sam Adams's Liberty Boys were on the rampage. As Henry Pelham, Copley's half brother, wrote, Boston was disturbed by "various and discordant Noises with which my ears are continually assailed in the day, passing of Carts and a constant throng of People, the shouting of an undisciplined Rabble, the ringing of bells and sounding of Horns in the night when it might be expected that an universal silence should reign but instead of that nothing but a confused medley of the ratlings of Carriages, the noise of drums, and the infernal yell of those who are fighting for the possession of the Devill."

The outbreak of war at Lexington in April, 1775, caught Stuart in an embattled Boston, and he fled back to Newport. A country at war has little use for artists, and he felt no particular loyalties either way. Benjamin Waterhouse had departed to study medicine in London, and when the elder Gilbert Stuart

John Bannister

c. 1774. Oil on canvas, 36 × 30″
Redwood Library and Athenaeum,
Newport, Rhode Island
Gift of David Melville, before 1859

A graduate of Harvard in 1764, Bannister inherited what was reputed to be the largest fortune in Newport, which he proceeded to multiply. The artist and his family, who lived "on Bannister's Wharf," as Stuart later recorded, knew the Bannisters well.

AN ONLY SON, HANDSOME AND FORWARD

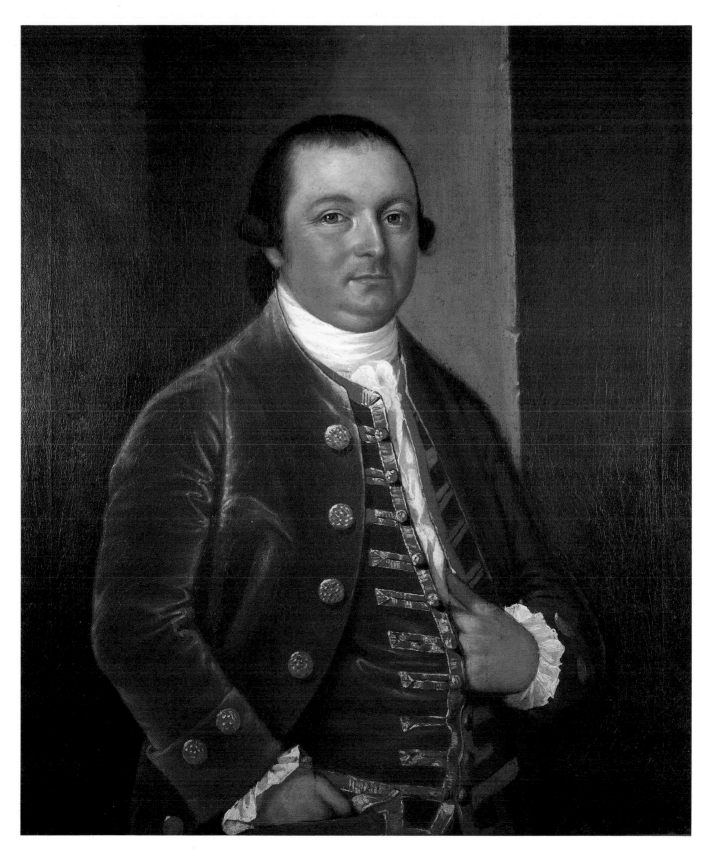

John Bannister

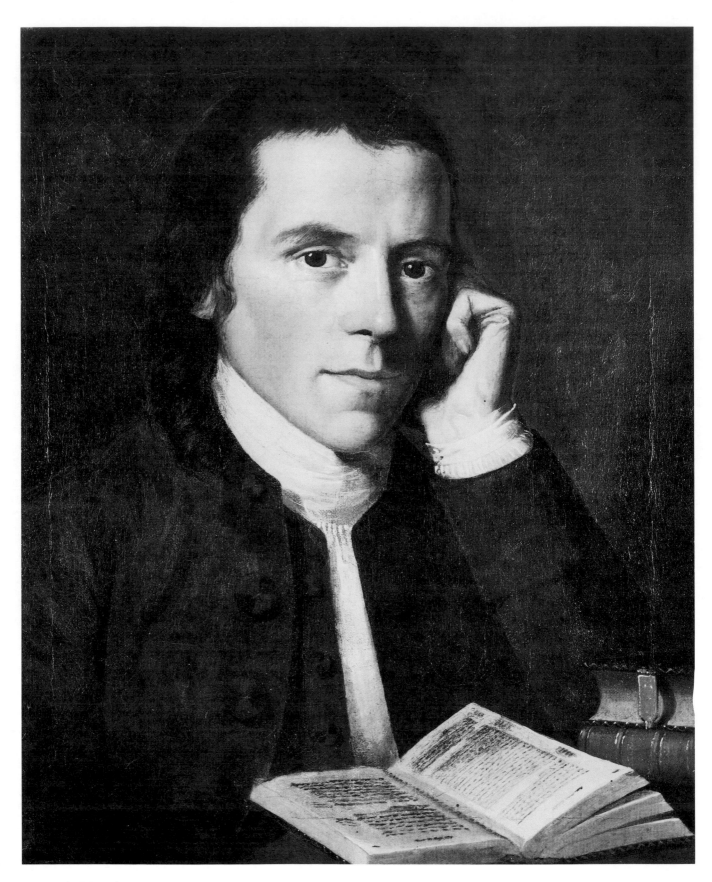

Benjamin Waterhouse

shipped quietly out to Nova Scotia, his son felt alone and without a future unless he, too, made his escape. If Copley could seek his fortune in London, so could he. He appealed to his uncle, Joseph Anthony, in Philadelphia, where he visited long enough to paint portraits of the family. Late in July, he went to Norfolk, where he stayed briefly with friends made during his previous visit with Cosmo Alexander. Probably, he painted a few portraits there before returning to Newport.

His spirits were so buoyed by his decision to go to England that he spent most of his last night in Newport playing the flute beneath the window of a young lady whose reaction to this unusual attention history has not recorded, though shortly afterward the young lady married a British officer.

Stuart planned to join Benjamin Waterhouse, who had family connections in London, because, as Benjamin's father pointed out to Stuart's worried parents, the two boys were "like David and Jonathan." As far as we know, Stuart had only one letter of introduction, to Sir Alexander Grant, a well-to-do Scot with relatives in Newport, whom Cosmo Alexander had painted. He had money enough, from portrait fees and from his uncle, to keep him with frugality for several weeks, but no other resources except his wits and his talent, still largely untried. Full of hope for the future, he embarked—as the *Newport Mercury* of September 11, 1775, reported—on September 8 on the *Flora*, bound for London, though the sailing was delayed until the fourteenth by the ominous presence off the Rhode Island coast of a British man-of-war.

Benjamin Waterhouse

c. 1775. Oil on canvas, 22 × 18″
Redwood Library and Athenaeum,
Newport, Rhode Island. Bequest of
Mrs. Louisa Lee Waterhouse, 1864

Waterhouse, who came from a prominent Quaker family in Newport, and Gilbert Stuart grew up together and became life-long friends. Stuart portrayed his friend just before they both went abroad. Waterhouse returned to become a leading physician and a professor at the Harvard Medical School, while Stuart came to be regarded as the leading painter in America.

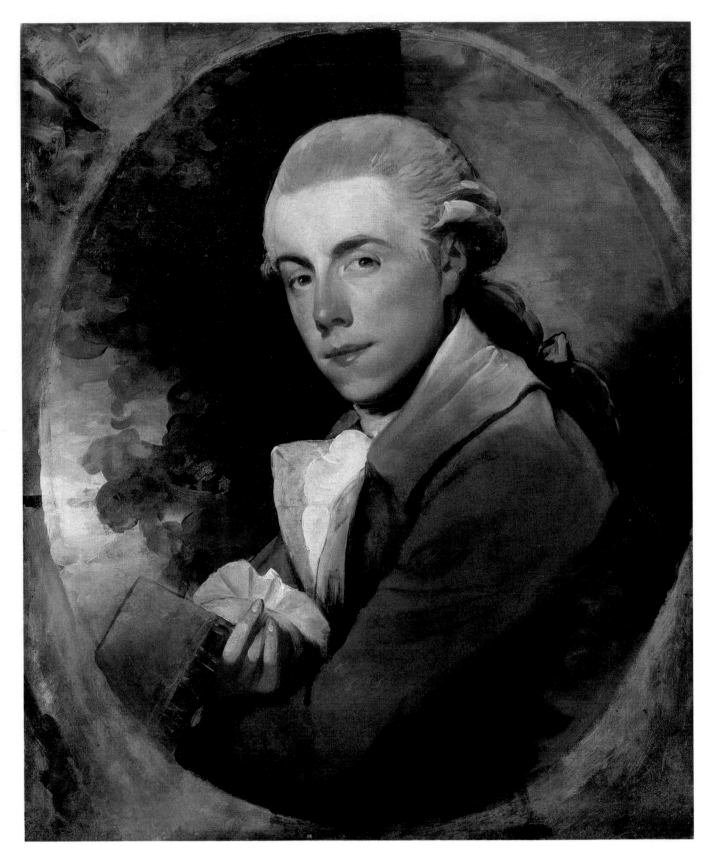

Man in a Green Coat

II. "Pitching Headlong into Misery"

AFTER A LONG AND ROUGH crossing, the *Flora* arrived in London, probably late in November, 1775. Relieved to have dry land under his feet after weeks at sea, Stuart hastened to look up his boyhood companion. To his dismay, he found that Waterhouse, unaware of his friend's imminent arrival, had departed for Edinburgh to study in the medical school there. If Edinburgh had seemed large and hostile to Stuart two years before, London, a dozen times larger, with perhaps three-quarters of a million inhabitants, must have appeared overwhelming in its restless activity and interminable sprawl. Though there were still open spaces and broad squares, as the eighteenth century progressed there had been an increasing amount of new building. Fashionable houses in rows and terraces were being developed in what had recently been fields and open common, and downriver, below the Tower, the port of London was fast becoming the greatest in the world. As it had been for centuries, the river was still a main highway, with ferries and the prams and wherries of the Thames watermen serving as aquatic buses and taxicabs.

Something of the Middle Ages remained in the maze of narrow streets and alleys and the occasional ancient church, inn, or house spared by the Great Fire of 1666. The skyline was picturesquely punctuated by the steeples of the city churches designed by that ingenious young inventor, astronomer, and mathematician, Sir Christopher Wren, to replace the fifty-one parish churches destroyed by the fire, and by the magnificent dome of Wren's St. Paul's Cathedral. The various guildhalls had been handsomely rebuilt in eighteenth-century style, though the Inns of Chancery, the Inns of Court, and the Temple still retained aspects of an earlier age, more dramatically symbolized by the White Tower, impregnable to change. Upriver to the west lay Westminster, the seat of the royal court and the government, of Parliament and the civil service; Westminster Abbey, with its venerable pomp; Inigo Jones's Banqueting House, with the ceiling of its great hall painted for Charles I by Rubens; and St. James's Palace, where the first three Georges lived and to which ambassadors are still accredited.

The drawings of Thomas Rowlandson, Stuart's contemporary, vividly record, with Hogarth's gusto but without his moralizing, that later-eighteenth-century London was a stage set for around-the-clock activity—in the open markets and the streets, the parks and commons, the alleys and docks, the churches and theaters, the taverns and pleasure gardens, the palaces of the aristocracy, the homes of the growing middle class, and the squalid tenements of the poor. There

Man in a Green Coat

c. 1785. Oil on canvas, 28½ × 23½"
The Metropolitan Museum of Art, New York City
Bequest of Mary Stillman Harkness

Though not all scholars agree, this has been identified as a portrait of the artist's great friend Benjamin Waterhouse. If this identification is correct, it was probably painted shortly after Waterhouse completed his medical studies in London, Edinburgh, and Leyden.

27

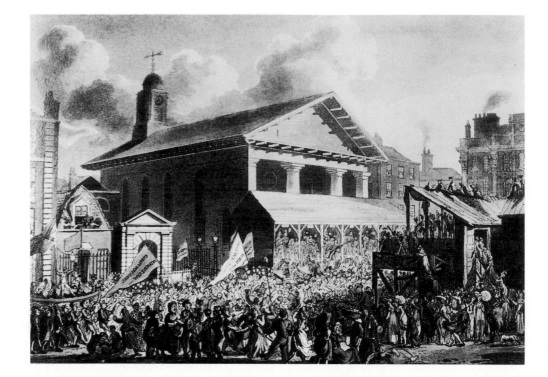

were parades and fireworks, concerts and operas, witty comedies and classical tragedies, often memorably performed. The streets were full of hawkers, pitchmen, and beggars, and they were infested with pickpockets and footpads, pimps and prostitutes. In the slums every fourth dwelling was a gin shop with the familiar sign: "Drunk for a Penny, Dead-Drunk for Twopence."

All classes enjoyed such robust entertainments as bull- and bearbaiting, dogfights, bare-knuckle boxing, viewing the antics of the insane in madhouses, and attending hangings at Tyburn. It was all a far cry from the idyllic peace of Newport, and the depression that had crushed Stuart two years earlier swept over him again. Yet he gathered himself and cast about for a place to stay. From a tailor named Palmer he rented a small room in a row of ancient houses known as York Buildings, on Buckingham Street between the Strand and the river, not far from Charing Cross. Evidently, he presented his letter of introduction to Sir Alexander Grant, because when Waterhouse returned from Scotland in the summer of 1776, he found, on an easel in Stuart's untidy room, an unfinished family group commissioned by that gentleman. "It remained long in his lodgings, and I am not sure that it ever was finished," confessed Waterhouse. In the meantime Stuart seems to have painted a few other pictures, enough to keep him alive. Considering his lack of experience, his youth, his inadequate training, and his colonial manners and wardrobe, it is amazing that he managed to find any work at all. Artists who were far better prepared than he had had to retreat to less fashionable but more favorable fields in the British provinces and as far away as the American colonies or even India. London had become a sophisticated and lively capital of the arts. A new age was flowering, but Gilbert Stuart was ill-prepared to play a part in it and was not about to recognize that fact.

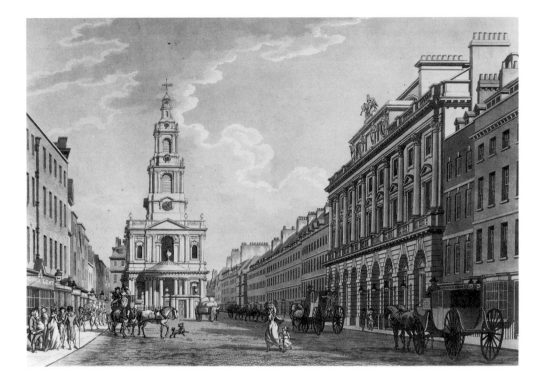

 The artistic world of London had developed dramatically since the acces-
sion of George III in 1760. The first British monarch since the Stuarts to show
any interest whatsoever in the arts, the king had been tutored while Prince of
Wales by Sir William Chambers, architect of such notable buildings as the Pagoda
in Kew Gardens, Somerset House in London, and a number of outstanding
buildings in England and Ireland, including the classic Casino at Marino, near
Dublin. The king was, therefore, much interested when Chambers approached
him in November, 1768, with a proposal that had been discussed by artists for
years: the foundation of an academy of the arts under royal patronage. The Roy-
al Academy superseded the Society of Artists and the various other groups that
had endeavored to advance the cause of the arts. Aware that, at least for a time,
he would have to support the Academy out of his own pocket, the king wanted
someone he knew and trusted in charge, and so in the founding document he
named Chambers treasurer. Sir Joshua Reynolds was persuaded, with the help
of Benjamin West, to become the first president. Gradually, he asserted a posi-
tion of artistic leadership, while Chambers retained overall control on behalf of
the king.

 By the time Stuart arrived in London in 1775, the Royal Academy was flour-
ishing. Its annual exhibitions were immensely popular. They attracted large and
mixed crowds and were reviewed in the newspapers in lively and frequently con-
tentious fashion by a variety of critics who often resorted to anonymity so that
they could more freely air their personal prejudices and animosities. Its annual
dinners were great events attended not only by the members but also by such
distinguished guests as Dr. Johnson, polymath and lexicographer; David
Garrick, actor and stage director; Richard Brinsley Sheridan, playwright, direc-

tor of the Drury Lane Theatre, and Member of Parliament; Oliver Goldsmith, playwright and essayist; Edmund Burke, statesman and man of letters; and Horace Walpole, diarist and connoisseur. Patrons and collectors such as the dukes of Devonshire and Bedford and the earl of Carlisle were often present, along with visiting artists and dignitaries and members of the royal family. At the suggestion of Reynolds, Dr. Johnson and Oliver Goldsmith were appointed, respectively, to the honorary positions of Professor of Ancient Literature and Professor of Modern Literature; since there were neither duties nor stipend, the latter likened the situation to "giving ruffles to a man who wants a shirt." The one advantage their appointments did provide was the right to attend the Academy's annual dinners. The food and wine were excellent and plentiful and were consumed to the accompaniment of music, speeches, citations, innumerable toasts, and the light of constellations of candles.

The Academy School was ably presided over by Reynolds, whose famous lectures to the students, published as his *Discourses*, can still be read with pleasure and profit. The students included a good number of those who were to be the leaders in the arts of the next generation. One of them remembered with pleasure its handsome quarters in that part of Old Somerset House added by Inigo Jones. They included "one large room for the plaster academy; one for the Life, where two men sat two hours each night by turns every week; a large room in which lectures are given every Monday night by Dr. Hunter on Anatomy, Sir Joshua Reynolds on Painting, and Thomas Sandby on Architecture; and among other apartments there is a choice Library." Richard Wilson, "the father of English landscape painting," served as librarian. Sandby was not only an architect but also a fine architectural draftsman and watercolorist, and he served as deputy ranger of Windsor Forest for the Crown. He enlivened his lectures on perspective and rendering with swiftly executed drawings.

Dr. William Hunter's lectures on anatomy included occasional demonstrations—dissections performed at Surgeons' Hall on the bodies of criminals just executed at Tyburn. Another student recalled having witnessed a double hanging and the subsequent dissection of one of the corpses. The musculature of the other was so extraordinary that Dr. Hunter had it carried to the Academy School where Agostino Carlini, a sculptor member of the Academy, made a cast of it with the body arranged in the posture of the *Dying Gladiator*, the famous classical sculpture. Thereafter the cast, taking its place among those of masterpieces from Greece and Rome, was known as *Smugglerius*, after the crime for which its nameless original had been hanged.

Sir Joshua Reynolds was an acknowledged leader of the artistic establishment. Not as naturally gifted as Thomas Gainsborough, he was nevertheless a highly organized man who planned an artistic career with care and followed his plan with diligence. "Fame was always his desire," his sister told one of his pupils. Like Gainsborough, he came from a middle-class family, and, because his father was a university man who became headmaster of the grammar school at Plympton St. Maurice, Devon, he was better educated than most artists of the period. Full of ambition, he managed to make his way to Italy to study the classical past

and the great Italians. He confessed his initial puzzlement when faced with the Raphaels, Michelangelos, and other old masters, but he gradually gained a vocabulary of compositions, poses, and accessories from the works he studied so assiduously. He returned to England to use what he had learned to create portraits that sometimes included historical or mythological aspects. He used such elements derived from the past much as his friend Dr. Johnson used quotations from classical writers in his Latinate prose.

Sir Joshua's dinners at his handsome house in Leicester Fields—later Leicester Square, long a favorite dueling place—were as well known for the mediocrity of the food and wine as for the genuine distinction of the company and the conversation. Though it seems that he carefully avoided any closeness with fellow artists—probably fearing rivalry—his friends included the leading personalities of the theatrical, musical, and literary worlds. Through his professional practice he did more than any other of his period to raise the social position of the artist from that of a superior servant to that of one accepted in polite circles. He was ideally qualified to be the first president of the Royal Academy, even though his Whiggish political sympathies made him less than a royal favorite.

Gainsborough was as different a type as one could imagine. Naturally intuitive, and showing unusual artistic gifts early in life, he loved the landscape of his native Suffolk and, influenced by the Dutch masters of the previous century, especially Jacob van Ruysdael, painted it appreciatively and eloquently. Though he had formal training from Francis Hayman, a competent professional painter, he seems to have been largely self-taught. Being acutely observant, he learned more from studying nature and the works of older painters, especially the portraits of Van Dyck, than from direct instruction. He started to paint portraits in his native Sudbury and, gaining skill and confidence, moved to Bath, a fashionable watering place, where he soon gained sufficient renown to be chosen a founding member of the Royal Academy. In 1774, the year before young Gilbert Stuart arrived in England, Gainsborough moved to London. There, his reputation having preceded him, he made a notable success and became, as Reynolds was not, a favorite painter of the royal family. Sir Joshua, however, admired him as "one of the greatest ornaments of our Academy." His painting rooms in Schomberg House on Pall Mall, close to Carleton House, "the palace of the Prince of Wales," saw the most fashionable clientele of any painter of the period. He entertained leading musicians because, like Stuart, he not only loved music but also played several instruments with professional skill. One of his closest friends was the composer Johann Christian Bach, who often joined the painter and others in playing chamber music.

A third leader in the artistic world was the Pennsylvania Quaker Benjamin West, greeted in London as the "American Raphael." The son of an innkeeper in Springfield, near Philadelphia—the inn still exists on the campus of Swarthmore College—he was an exact contemporary of his fellow colonial, John Singleton Copley. But where Copley was introspective and apprehensive, West had an ingenuous openness and equanimity that won him instant respect. Like Sir William Chambers, he enjoyed the king's trust and friendship and was a founding mem-

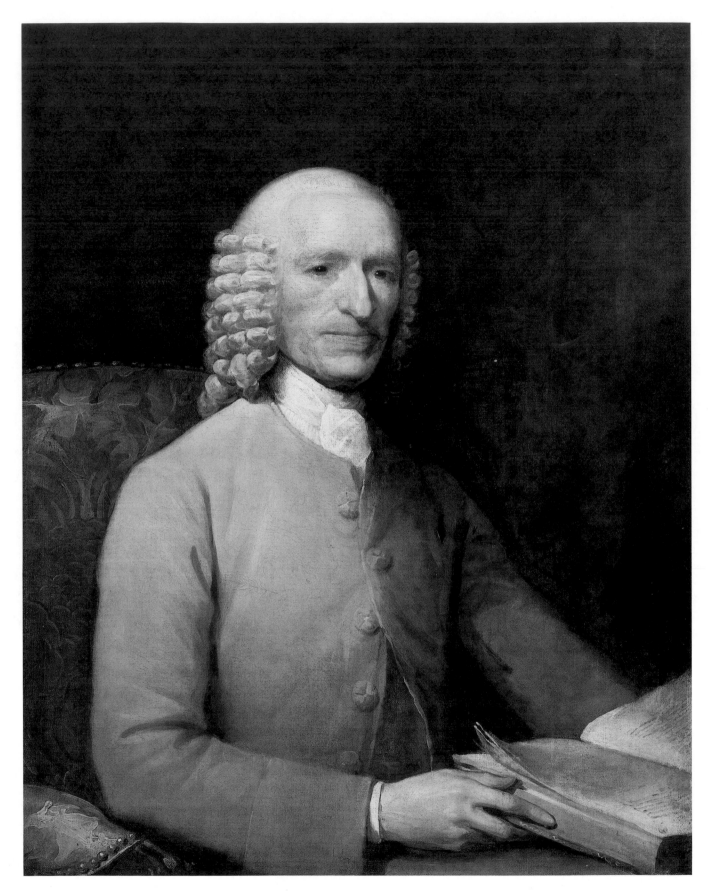

Dr. John Fothergill

ber of the Royal Academy, but his Quaker principles did not allow him to accept a proffered knighthood. Despite his closeness to the king, West was unwavering in his loyalty to the American cause during the Revolution, though his Quaker beliefs prevented him from taking an active part.

Benjamin Waterhouse, who knew West through mutual Quaker connections, had spoken to him on Stuart's behalf, and West had politely suggested that Stuart call on him. Depressed by his lonely situation, Stuart procrastinated. Typically, when he finally decided to visit West, he arrived at the spacious house on Newman Street without having written ahead to ask for an appointment. But luck was with him. West was entertaining a group of Americans, including Joseph Wharton of Philadelphia, a partner of Stuart's uncle, Joseph Anthony. A servant told West that he had an unexpected visitor who said he was an American. Not wanting to leave his guests, West asked Wharton if he would "see what you can make of him." A moment's questioning revealed that Stuart had connections in Philadelphia.

"Whom do you know there?" Wharton asked.

"Joseph Anthony is my uncle," Stuart replied.

"That's enough, come in," Wharton remembered saying, and Stuart received a hearty welcome. He apparently followed West's advice and returned with examples of his work, but his initial contact seems to have stopped there, as he doggedly continued to try to make his own way.

In later years he remembered bitterly that he had been "destitute of the means whereby to support himself, or pay his landlord for board and lodging, already due, . . . walking the streets without any definite object in view." One day, while wandering down Foster's Lane in Cheapside, he heard the sound of an organ coming through the open door of a church, probably St. Vedast's. He stopped to listen. The familiar sound reminded him of Newport, Trinity Church, and Herr Knotchell. When with some trepidation he entered, he learned that auditions were being held for a new organist. After he had listened to a number of the candidates, his spirits rose. He got up his courage to ask one of the vestrymen if he could play. Probably with some doubts because of the applicant's youth and shabby appearance, the vestryman consented. Stuart climbed to the organ loft and performed several selections, his confidence and authority increasing as he played. There was no question of his command of the instrument, and he was awarded the position at thirty pounds a year. For some unknown reason, though one suspects some irresponsibility on Stuart's part, the job lasted only three months.

In the meantime, after Waterhouse's return to London, the two "agreed to devote one day a week to viewing pictures, wherever we could get admittance." Along with many old masters and contemporary works, they saw the famous Raphael cartoons in the Queen's Palace, the collections at the British Museum, and numerous exhibitions at the several auction galleries. On other days, using the two volumes of William Maitland's ponderous *History of London from Its Foundation to the Present Time*—which describes and gives the history of every ancient

Dr. John Fothergill

1781. Oil on canvas, 36 × 27¾"
Pennsylvania Academy of the Fine Arts,
Philadelphia. Annual Membership
Fund Purchase

A posthumous portrait of the eminent Quaker physician and scientist, who lived in London. He was the uncle and benefactor of Stuart's friend Benjamin Waterhouse.

building and monument, parish by parish—they explored, as Waterhouse remembered, "all the narrow lanes of London, and having a pocket map, we marked such streets and lanes as we passed through with a red lead pencil, and our map was a full two thirds streaked over with red when we received some solemn cautions and advice to desist from our too curious rambles. We were told . . . that we ran a risk of bodily injury, or the loss of our hats and watches, if not our lives, when we gave up the project. We had however . . . never experienced other than verbal abuse, chiefly from women, and saw a great deal of that dirty, monstrous, overgrown city, containing, to appearance, no other people than the natives of Britain and Ireland, and a few Jews, not laughing and humming a song like the populace of Paris, but, wearing a stern, anxious, discontented phys." The London of Hogarth's engraving of a desperately squalid Gin Lane of a quarter century earlier was still there.

"With Stuart," Waterhouse wrote, "it was either high tide or low tide. He would sometimes lie abed for weeks, waiting for the tide to lead him on to fortune." He was unable to complete the few commissions he received, frequently ran out of money, and counted on Waterhouse to pay his way out of the "sponging houses" to which he had been dragged by bailiffs for failure to pay his debts. "Of my allowance of pocket money he had two thirds, and more than once the other third," his friend wryly remarked. Yet Waterhouse persevered. He persuaded his uncle, Dr. John Fothergill, a leading scientist and physician, to order a portrait from Stuart, so Fothergill commissioned one of his nephew, not for the sake of the portrait, because as a Quaker he thought such things frivolous, but to assist his nephew's friend. Though the portrait was never seen in Fothergill's house, he must have thought it acceptable, since he arranged to have his colleague William Curtis, a well-known botanist, sit to Stuart. Then Dr. John Coakley Lettsom, a former pupil of the elderly Quaker and a successful London practitioner, posed for a full-length. Terrified of trying something so completely beyond his training and experience, Stuart dawdled and delayed and finally did not deliver. A double portrait of two young Quakeresses as the comic and tragic muses also failed to materialize. Then Stuart did not produce a portrait of Dr. George Fordyce, "a very learned Scotch physician . . . much admired by his pupils," of which Waterhouse was one. It had been paid for by a subscription from his fellow students. Faced with having to repay the students' contributions himself, Waterhouse was literally worried sick and fell ill of a fever brought on by "inexpressible unhappiness and mortification." It was only through the generosity of his uncle that Waterhouse could repay the subscriptions. But Dr. Fothergill had had enough. He forbade Stuart his house and never spoke to him again. On top of this, it was made clear to Stuart that he was no longer welcome in the home of Mr. Chorley, a linen draper and a Quaker relative of Dr. Fothergill, with whom he had been living on Gracechurch Street, close to Waterhouse's lodgings and the doctor's house on Harpur Street. At Easter, 1777, in a state of desperation, Stuart wrote to Benjamin West. The letter is so revealing of the conflicting emotions by which he was possessed that it is worth quoting in full.

Monday Evening No. 30
Gracechurch Street

Mr West
Sir,
The Benevolence of your Disposition encourageth me, while my necesity urgeth
me to write you on so disagreeable a subject. I hope I have not offended by tak-
ing this Liberty; my poverty & ignorance are my only excuse. Lett me beg that I
may not forfeit your good will which to me is so desireable. Pitty me Good Sir
I've just arriv'd att the age of 21 an age when most young men have done some-
thing worthy of notice & find myself Ignorant without Business or Freinds,
without the necessarys of life so far that for some time I have been reduc'd to
one miserable meal a day & frequently not even that, destitute of the means of
acquiring knowledge, my hopes from home blasted & incapable of returning
thither, pitching headlong into misery I have this only hope I pray that it may
not be too great, to live & learn without being a Burthen. Should Mr West in his
abundant kindness think of ought for me I shall esteem it an obligation which
shall bind me forever with gratitude. With the greatest Humility
Sir
Yours at Com^d
G C Stuart

Perhaps made wary by the effusiveness of his anguished outpouring, West
did not immediately take Stuart on as a pupil. He did, however, hire him as a
copyist. Regular work in one of West's painting rooms reassured Stuart. Several
years earlier he had rejected the chance, arranged for him by his uncle Joseph
Anthony, to study with the capable Charles Willson Peale in Philadelphia. Also,
unlike many other young Americans, he had never visited Copley in Boston, de-
spite numerous opportunities. But now he listened to West's advice and observed
him at work with a new respect. He found quarters on Villiers Street, just off the
Strand, to be nearer West's studio on Newman Street, and in due time was ac-
cepted as a pupil. As Jane Stuart described it, "he finally became domesticated in
his [West's] family in the summer of 1777." A crisis seemed to have passed.

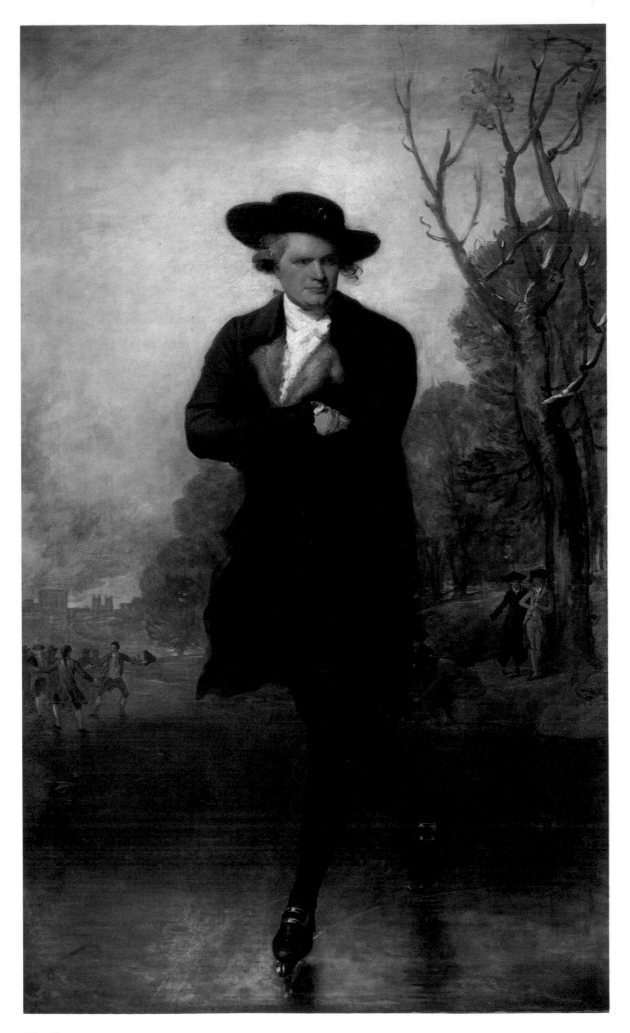

The Skater

III. *"Suddenly Lifted into Fame"*

BENJAMIN WEST WAS AN UNLIKELY intellectual, with his backcountry Pennsylvania provincialisms of accent and his highly original spelling. Yet intellectual he was in a way, in that he was preoccupied with idea and theory, interpreted with high-minded notions of morality and virtue, and expressed not in literary, but in pictorial, terms. In Italy he had mixed with the greatest of the dilettanti and connoisseurs, with princes and prelates, painters, antiquarians, and scholars. He was well read in the classic works on artistic theory, which he had discussed with such internationally respected figures as Cardinal Albani, who, though blind, was a knowledgeable collector of classical art, and the painter Anton Raphael Mengs, court painter in Dresden and Madrid, who was a founder of Neoclassicism, along with Johann Joachim Winckelmann, the first of the great art historians.

In Rome West frequented the famous old Caffé Greco on the Via Condotti, the favorite meeting place for the cognoscenti and the writers, artists, and composers of all nations. With various of them he explored the overgrown ruins of the Forum, the imperial baths, and the Colosseum, where several sculptors had taken over the tall arches of the colonnade as studios; the ancient structure itself often supplied the materials for their art. Like all the visitors from the North and from America, West was overwhelmed by the sights and sounds of Rome. He is said to have fainted at the pitiful appearance and importunities of the numerous beggars who surrounded his carriage on his first visit to see the Vatican collections. The city was so old yet so vividly alive. The pagan past, supposedly long dead, seemed still present in the picturesqueness and rowdy vigor of the spectacle of life in the streets, squares, and alleys. From it all West selected what he needed for the future he sought, and he stored up in his memory a rich stock of images, history, and myth on which he drew for the rest of his life.

With a wealthy English collector named Thomas Robinson, later Lord Grantham, West visited the various art collections, including those in the Roman palaces of the princely families. At Mengs's suggestion he traveled to Florence, Bologna, Parma, Genoa, Turin, Venice, Lucca, and other centers to study not only ancient art but also Italian masters of the Renaissance and the Baroque. His companion on this tour was a Dr. Matthews who, according to John Galt, West's early-nineteenth-century biographer, was "out of all comparison, the best practical antiquary, perhaps, then in that country." While in Italy West met a number of British aristocrats who were taking the requisite Grand Tour, without which

The Skater

1782. Oil on canvas, 96⅝ × 58⅛"
National Gallery of Art, Washington, D.C.
Andrew W. Mellon Collection

When shown in the Royal Academy exhibition in 1782, this portrait of a young Scot, William Grant of Congalton, made an instant and resounding success.

37

one could not be considered properly educated in matters of taste, then of primary importance among the upper classes. So when he returned to England in 1763, he bore with him the reputation of having painted pictures that had won the acclaim of the cognoscenti of Rome, and letters of introduction to leading artists and collectors in England.

That autumn he set up a studio in London and offered to paint portraits. Quite unexpectedly, he attracted wide public attention for the first time that winter with a skill he had learned as a boy on the Schuylkill River in Philadelphia. After the first hard freeze, he put on a dazzling display of fancy skating on the Serpentine in Hyde Park—to the admiration of the large crowds that gathered to see him. (After Gilbert Stuart, unaware of the precedent, did the same thing two decades later, Londoners must have thought that all American artists were expert skaters.) West's success as a painter came rapidly, and in 1766, when Robert Hay Drummond, archbishop of York, commissioned the painting *Agrippina Landing at Brindisium with the Ashes of Germanicus*, West was in his element because he believed that all great art should be educational and morally uplifting. The creator of such pictures seemed to him to be in a category superior to that of the portraitist, who was all too often merely "a fashionable painter of vacant faces." The Roman historian Tacitus tells the story of Agrippina in his *Annals*. The popularity of Germanicus, so named because of his conquest of northern barbarian tribes, aroused the jealousy of his kinsman the emperor Tiberius, who ordered him to the Syrian frontier, where he had him poisoned. Agrippina, the murdered hero's wife, in a spirit of Roman piety and in defiance of an imperial decree, took his ashes back to Italy for burial in sacred soil. When her landing place became known, many of the soldiers who had been under Germanicus's command gathered to pay their last respects, and as the widow and her two children disembarked carrying the urn, a cry of grief rose from the assembled mourners.

In the treatment of such a subject, West could illustrate classic themes: reverence and moral courage in the face of adversity and stoic fulfillment of duty despite tragedy. With the eclecticism that Neoclassicism valued so highly and that he had learned in Rome, West borrowed figures from such ancient sculptures as the Ara Pacis in Rome and from painters of the Bolognese school and Michelangelo; architectural elements came from Poussin, light from Claude Lorrain, and coloring from Raphael, all organized within a composition also borrowed from Raphael. West sought to combine the qualities that he, Mengs, and others had discussed in Rome: harmony, expression, and decorum, all united in a spirit of elegiac dignity.

The archbishop was enchanted. For him the picture had the attributes of a sermon couched in the idiom of the classical past—then so fashionable—but with a message befitting the ideals of his own time. When the archbishop showed West's work to George III, the king was admiring also. It was the beginning of a lifelong friendship between the Pennsylvania Quaker and the Farmer King. West's appointment as History Painter to the King followed. He was given painting rooms in both Buckingham House and Windsor Castle, where he and the monarch often spent hours together planning the colossal paintings of historical,

mythological, and biblical subjects that, over the years, West supplied to his royal patron.

In this way West established a special place for himself in the art of his time. He achieved it by selective methods similar to those used by Reynolds in his historicizing and mythologizing portraits in which, for example, he represented aristocratic young women swathed in decorous draperies, vaguely classical in their voluminous and concealing folds, decking a herm of Hymen, god of marriage, with garlands of flowers. But Sir Joshua more often borrowed the poses and rich color harmonies of Titian, as inherited through Rubens and Van Dyck. Such details as hands were learned from Raphael or, for those with attenuated elegance, from Van Dyck. Though postures were usually similarly derived, the subjects were almost always represented in contemporary costume, the men sometimes in uniform or hunting gear, the women handsomely gowned, the children neatly turned out, frequently with one or more favorite dogs. The figures were usually posed in a landscape setting, perhaps with classicizing architectural elements, and with trees and foliage recycled from engravings after Claude Lorrain or some other old master.

Official portraits presented the subject in requisite robes of position or office and included such borrowed elegancies as Baroque columns, flowing velvet draperies, sculptured architectural details, and decorative accessories. These elements were often mined from the previous century's leading masters, such as the French court painters to Louis XIV, Hyacinthe Rigaud and Nicolas de Largillière, by way of ever-useful engravings. The resulting Grand Manner portraits, when from the hand of an accomplished artist such as Reynolds or Gainsborough, attained the status of original, decorative, and impressive works of art. The "quotations," as Sir Joshua called the borrowings from the art of the past, lent an additional dimension of authority and legitimacy to pictures that became instant ancestors when placed in the grand interiors designed by Chambers, Gibbs, or the brothers Adam, alongside the Van Dycks and Lelys of previous generations.

West painted some fine portraits, such as his *Self-Portrait* of about 1770 and the delightful tondo of his charming wife, Elizabeth, with their first son, Raphael, of similar date. His full-lengths of the king and queen showed him to be as adept as Sir Joshua in borrowing elements from the art of the past to create the sumptuous grandeur required of such commissions. As Charles Merrill Mount pointed out in his exhaustive monograph on Stuart, West turned to an engraving by Pierre Imbert Drevet after Rigaud's full-length portrait of a prominent churchman, Bishop Bossuet, for the combination of agitated drapery, richly patterned folds of costume, and proliferation of details of architecture and furniture to create an appropriately splendid whole. No one knows for sure whether Stuart assisted with any part of these portraits. He is known to have done so on many of West's other commissions, and he certainly showed the effective use of such sources in his own masterful Grand Manner portraits later in his career.

West lacked the knack of Reynolds or Copley in achieving a ready likeness and the sharper instinctive insights into character that were emerging in the

work of his pupil. He much preferred to employ similar eclectic principles to the historical, biblical, and mythological subjects that were to be of such influence on the course of the Romantic movement, especially in France, where his paintings were frequently exhibited to considerable acclaim. Copley's dramatic historical pieces, such as *The Death of the Earl of Chatham in the House of Lords* (1780) and *The Death of Major Pierson* (1781) carried on the tradition of West's *The Death of General Wolfe at Quebec* (1770), which revolutionized the treatment of such heroic subjects by portraying the participants in the uniforms they actually wore instead of in the Roman togas of previously accepted convention. West conceived *Penn's Treaty with the Indians* of the following year in similar fashion, while for his *Battle of La Hogue* (1778) the king arranged for the artist to go to sea on a ship-of-the-line with an admiral to interpret the action as a number of vessels of the royal fleet maneuvered in a brisk breeze and fired blank charges in a re-creation of the famous victory of the British over a French flotilla under the command of the Catholic Stuart pretender, James II, in 1692.

In contrast to his carefully realized historical scenes, West also developed, in the spirit of Edmund Burke's influential essay, *A Philosophical Inquiry into the Origins of Our Ideas on the Sublime and the Beautiful* (1756), what Groce Evans, West's scholarly interpreter, called his Dread Manner. Burke's essay became a kind of manifesto for Romanticism in its reaction against the cool rationalism of Neoclassicism, with its emphasis on order and clarity. For Burke, the sublime had the power of mystery, awe, and grandeur. It called forth the emotions and inspired the free exercise of the unfettered imagination. Despite West's mildness of manner and Quaker reserve, he responded to this idea with such works as the series illustrating *Revealed Religion*, which he painted for the chapel at Windsor (most of which are in the collection of Bob Jones University, Greenville, SC), with their emphasis on often violent motion and the miraculous, expressed in terms of cataclysm and terror. In such paintings West anticipated the spirit of Géricault's *The Raft of the Medusa* (1819) and Delacroix's *Massacre at Chios* (1824) and *The Destruction of Sardanapolis* (1829), landmarks in European Romanticism, and, in America, Washington Allston's ill-fated and famed *Belshazzar's Feast*, the strange and evocative works of William Rimmer, and the epic paintings of Thomas Cole. Such were the developments taking place during the time when Stuart was a major assistant in West's studio. He must have been familiar with all aspects of his mentor's Romantic projects, and he was very probably involved in some phases of their execution.

West was a natural teacher and his house on Newman Street became a kind of American Academy in London, with troops of young colonials coming and going, learning their craft. When they became proficient enough, they assisted with the draperies and other details of the master's large canvases, often with Stuart's participation and supervision. Stuart throve in the orderly environment of West's studio, where tasks were requested rather than assigned, the results thoughtfully discussed and assessed. He soon regained his old confidence, and by July, 1780, when John Trumbull, son of the "Rebel governor of Connecticut" and lately aide-de-camp to General Washington, presented Franklin's letter of

introduction to West, he found Stuart in his own painting room, working as West's principal assistant. Shortly after this, Trumbull, through the animosity of Loyalists in London, was imprisoned in retaliation for the execution in America of Major André as a British spy. Since there were many in England who sympathized with the American cause, including members of Parliament and of the cabinet—such men as Edmund Burke, Charles James Fox, and Lord Shelburne, the great admirer of George Washington—Trumbull's incarceration was not too painful. He was lodged in Bridewell jail in Tothill Fields, the present site of Westminster Cathedral. (The appearance of the prison is recorded in Plate IV of Hogarth's famous series of engravings, The Harlot's Progress.) He was allowed books and painting materials, and he received his friends, including Stuart, who liked to greet him—since Trumbull's formality bordered on the pompous—as "Bridewell Jack, the famous Highwayman," or "notorious murderer," or some similar epithet. Stuart painted his portrait in jail, finishing only the head, while Trumbull himself completed the picture, including the barred window of his cell.

Trumbull's experience with West undoubtedly confirmed his resolve to paint the historical record of the American Revolution, on which his reputation rests. He, Copley, Stuart, and several other students of West's worked on a number of the large canvases that depicted such subjects. Stuart also seems to have been the principal executant on several major projects, among them the ceiling in the lecture room of the Royal Academy's new headquarters in Sir William Chambers's Somerset House. Yet he never attempted subjects of this order on his own initiative, or sought commissions of this kind, though he proved himself eminently capable of carrying them out. He made good-natured fun of his master, busy at work on his "ten-acre canvasses...in company with prophets and apostles," and he told a friend, "No man ever painted history if he could obtain employment in portraits."

Stuart undoubtedly learned much from West and progressed dramatically through association with him, but he seems to have paid little mind to the idea of the moral superiority of the subjects that were West's special interest. Nor did he share the opinion of Reynolds and many others of the period, both in Europe and in America, that such an art was of a loftier order than portraiture because it involved the expression of an ideal beauty that is "general and intellectual," as Sir Joshua described it in his ninth "Discourse," "that subsists only in the mind; the sight never beheld it," a notion not unrelated to that of Bishop Berkeley's *New Theory of Vision*. Stuart was fascinated by the visual and what it revealed of the underlying truth of human personality and character. In his own idiosyncratic way he, as had West in Rome, selected what best served his own purpose, a purpose instinctively rather than intellectually arrived at.

Stuart stubbornly resisted all formal instruction in drawing. In fact, he did not draw at all, incredible though it may seem. There are no known drawings by him, and he refused to participate in the informal drawing classes that West arranged for him and a few other pupils. Nor did he enroll for classes at the Royal Academy, though from time to time he accompanied West's son Raphael, who attended regularly. Stuart did, however, go to Dr. Cruikshank's lectures on

The Graces Unveiling Nature: Earth, Air, Fire, and Water

c. 1779. Oil on canvas; central panel diameter, 60"; each section, 43 × 73" Somerset House, London

While he was Benjamin West's assistant, Stuart painted these panels, which were conceived and designed by West, for a ceiling in the Royal Academy's rooms in Somerset House.

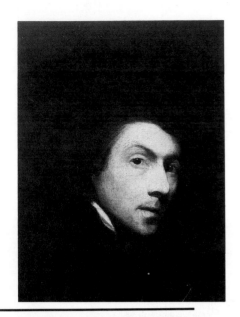

Self-Portrait in a Rubens Hat

1778. Oil on canvas, 16¾ × 12¾"
Redwood Library and Athenaeum,
Newport, Rhode Island

Following the example of Benjamin West's Self-Portrait *of about eight years earlier, Stuart, as a compliment to his master, portrayed himself in a similar pose, wearing a similar Rubensesque hat; but he deliberately borrowed the dramatic light and shade of the Baroque rather than the Renaissance clarity of West's portrait.*

Benjamin West
Self-Portrait

c. 1770. Oil on canvas, 30¼ × 25⅜"
National Gallery of Art, Washington, D.C.
Andrew W. Mellon Collection, 1942

The large hat and the general pose were borrowed from Rubens's Self-Portrait *in Windsor Castle. The picture was painted when West was in his early thirties and had achieved a great success in London.*

anatomy for medical students. There he first met William Coates, who was completing his medical studies after having passed the examination for Surgeon's Mate in the Royal Navy. Since Waterhouse had left London for Leyden to continue his studies at the famous medical school there, Coates, a lively young man who shared Stuart's tastes and humor, became his favorite companion.

In later years Stuart told his pupil Matthew Jouett that "drawing the features distinctly and carefully is a waste of time; . . . all studies should be made with brush in hand." He believed that the process of making a drawing interfered with the immediacy of the relation between the creative mind and the realization of its visual concept in the completed painting. He neither saw nor thought in linear terms, but instead in terms of three-dimensional form, interpreting the nuances and gradations of modeling by means of color and tone. In all his mature work there are no lines, no hard contours. Instead of beginning in the usual fashion with a drawing on the prepared canvas, he began by painting directly, starting with the head, and without the traditional underpainting in lighter and darker neutral tones to establish the underlying form. He faced directly the problem of all portrait painters: "How to be true to nature and their own vision, and yet sell their work," as James Thomas Flexner aptly summarized it in his brief but lively biographical sketch of Stuart; how to compromise "between the downright and the socially smart, the sincere and the salable." Stuart used what he could of the idealizing formulas of the fashionable portraitists of the day without letting go the basic naturalism that underlies all his work.

The *Self-Portrait in a Rubens Hat* of 1778, painted for his friend Benjamin Waterhouse, shows the strides he had made during the short period of time he had been working with West. It shows an intense young man looking directly at us as he studies his own image in the mirror. The pose of the head and the Rubens-style hat are taken directly from West's *Self-Portrait* of about 1770. Where West's picture has a clarity of definition of form and contour that owes much to the Italian Renaissance, particularly to Raphael, Stuart's owes more to Rubens and the Baroque use of chiaroscuro, both as a compositional and an atmospheric device. When Stuart visited Waterhouse in Boston some thirty years later, he looked critically at the picture and Waterhouse heard him say to himself, "Gibby, you needn't be ashamed of that." When Waterhouse remarked that most of his visitors thought the picture very old, Stuart explained, "I olified it on purpose that they should think so," referring to the dark, transparent glazes with which he subtly suggested the shoulder, hair, hat, and shadowy background, which contrast dramatically with the highlighted face. This picture and his portrait of the young James Ward of the following year show him consciously emulating the mode of earlier masters in a deliberate learning process: Ward, wearing a Van Dyck costume, is portrayed with his dog in a broadly painted landscape setting.

In the winter of 1780–81 West himself consented to sit to his pupil for a likeness to be presented to his wife. When it was shown at the Academy's annual exhibition of 1781, it was judged "an excellent portrait of Mr. West" by the critic of the *St. James Chronicle*; "indeed I do not know a better one in the room." High praise when works of Gainsborough and Reynolds were also present. Stuart rep-

SUDDENLY LIFTED INTO FAME

Benjamin West, *Self-Portrait*

James Ward

resented his mentor in a grave mood, silhouetted against a drapery that is drawn aside to reveal a section of West's own painting, *Moses Receiving the Laws on Mount Sinai*, one of the group of pictures commissioned by the king for the royal chapel at Windsor and completed just before the portrait was painted.

Stuart's *Dr. John Fothergill* was also shown. The distinguished old scientist had steadfastly refused, because of his Quaker principles, to have his likeness taken. After his death late in 1780, his family and friends approached Stuart to inquire if he remembered Fothergill well enough to paint a posthumous portrait. Waterhouse, returned from two years in Leyden, sat for the general form of the body, the hand holding the book, and the contours of the head. Waterhouse's and West's features contributed to the resulting face, with its remembered long nose and wide mouth. The heavy, old-fashioned wig was painted from the original, which Waterhouse provided. The portrait is a bit stiff but was convincing enough that a critic, seeing it at the Academy exhibition, enthusiastically wrote, "Mankind are much obliged to this artist, who has paid the debt of gratitude to the memory of Dr. Fothergill. He who has rescued so many from the grave is now restored to life by an admirable pencil. Death, which generally terminated all friendly recollections, has not prevented Mr. Stuart from doing what Dr. Fothergill would not permit when he was alive."

These portraits, too, were valuable learning experiences. No longer would the awkwardness of Dr. Fothergill's portrait appear. There would be summary treatment of details that did not interest the painter, but an increasingly swift and sure handling of the brush would ensure unification into a pictorial whole. Though still an assistant to West, Stuart was gaining recognition for the fresh, clear color and distinctive tone of his work. He began to receive commissions on his own, not merely referrals from West.

Late in 1781 a well-placed young Scotsman named William Grant from Congalton in East Lothian, not far from Edinburgh, ordered a full-length portrait. Suddenly Stuart was again brought face-to-face with a problem he had been studiously avoiding. Though he was still unsure of himself, the recognition he had received for recent works shown at the Royal Academy made him bold, and he agreed. Nevertheless, he was doubtless much relieved when the Scotsman remarked on his arrival for the first sitting on a frosty winter morning that it was a better day for going skating than for posing for one's portrait. That was all that Stuart needed, and soon the two of them, like a pair of happy truants from school, were off to Hyde Park. There on the Serpentine, where twenty years earlier West had similarly won his first public acclaim, they put on a demonstration of fancy figures that soon attracted an admiring crowd.

Exhilarated by the situation, Stuart led off with a series of leaps, turns, and other maneuvers that he had learned as a boy skating on Petaquanset Pond. The Scot, though somewhat overmatched, took up the challenge. When the ice started to crack beneath them, Stuart told Grant to hold on to his coattails, and together, to the applause of the spectators, they outraced the breaking ice to reach the shore.

Back on Newman Street, Stuart began to lay in the sitter's head. His imagi-

Caleb Whitefoord

1782. Oil on canvas, 30 × 25"
Montclair Art Museum, New Jersey
Purchase, Clayton E. Freeman Fund

A writer for the London press and a friend of Dr. Johnson and Benjamin Franklin, Whitefoord was secretary of the peace commission that drafted the Treaty of Paris, which ended the American Revolution.

James Ward

1779. Oil on canvas, 29½ × 25"
The Minneapolis Institute of Arts
The William Hood Dunwoody Fund

Painted while Stuart was still in West's studio, this picture is one of the artist's few signed and dated works. The subject has been identified as James Ward, later a prominent engraver. As did Gainsborough in his famous Blue Boy *of nine years earlier, Stuart dressed his sitter in a Van Dyck costume and painted the portrait in a manner somewhat reminiscent of the Flemish master.*

nation stimulated by their morning's experience, he had a sudden inspiration. Why not represent his subject in the act of skating? Grant agreed to the novel notion, and Stuart proceeded to develop the head with the keen and lively expression that carries the conviction of a telling likeness. Later, alone and working from memory, he painted the tall, athletic figure, arms folded in debonair fashion, gliding across the newly frozen ice of the Serpentine. Grant is wearing Stuart's own broad-brimmed hat at a rakish angle, and he is soberly but stylishly clad in a full-skirted coat with fur lapels, well-fitting smallclothes, and silver-buckled shoes. In the background Stuart showed his mastery of landscape. Above the frozen lake, with its tiny skaters and onlookers, tall trees rise against a wintry sky to form a vista extending eastward toward a far-distant suggestion of city skyline that is defined by the pale silhouette of the towers of Westminster Abbey. All is rendered with an atmospheric softness and a feathery touch that set off the figure of the skater in the immediate foreground, and that also recall the style of Stuart's distinguished contemporary, Gainsborough, to whose brush the picture was later generally attributed.

In its informal interpretation of the subject, the painting reflects an aspect of the British portrait tradition that may be seen in the work of such artists as Francis Hayman and John Zoffany, as well as in the earlier paintings of Gainsborough. In such pictures the figures are represented in a landscape that has a specific importance beyond that of a merely conventional and decorative setting. In most such earlier pictures, however, the figures appear at a comparatively small scale, as in conversation pieces, and were essentially cabinet pictures of a size suitable for domestic interiors, but the skater fills the canvas with his full six feet of height. Furthermore, Stuart borrowed the device, used by many of the Baroque portraitists of the Grand Manner, of using a low point of view to give the figure a looming power that seems to enhance the feeling of movement and the momentary and transitional quality of the unusual pose. The result is a striking and original work that caused a sensation when it was shown with the title *The Skater* at the Royal Academy exhibition of 1782 at Somerset House. "One would have thought," Sir John Collum, the learned clergyman and connoisseur, commented in a letter to a friend, "that almost every attitude of a single figure had long been exhausted in this land of portrait painting, but one is now exhibited which I recollect not before—it is that of skating. There is a noble portrait, large as life, thus exhibited, which produces the most powerful effect." It successfully refuted a notion that appeared in an anonymous review of the period that Stuart "made a tolerable likeness of a face but as to the figure he could not get below the fifth button."

From the opening day, admiring visitors crowded around the four paintings that Stuart had submitted. He had chosen them to make an impression. Beside *The Skater* there were portraits of Dominic Serres, a Gascon ex-sailor who was "a fine boisterous fellow," according to his friends, and a painter respected for his sea pieces and naval battles; Caleb Whitefoord, a wit and popular literary figure who was then acting as the British intermediary between the royal government and the colonial representative, his friend Benjamin Franklin, to bring the Revo-

SUDDENLY LIFTED INTO FAME

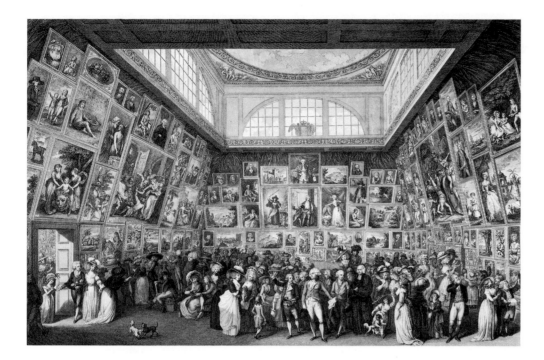

*The Exhibition of
the Royal Academy, 1787*

Engraving by Martini after Ramberg
British Museum

*The incredibly crowded hanging of the
paintings was typical of the period. In the
center foreground Sir Joshua Reynolds,
with his familiar ear trumpet, is pointing
out to the Prince of Wales one of his own
paintings, a portrait of a lady with three
children, above and to the right of the
doorway.*

lution to a close; and a well-known "Swedish gentleman," who has been convinc-
ingly identified by the scholarly detective work of William Sawitzky as the
resourceful merchant Christopher Springer, who fled Sweden for political
reasons, settling first in Archangel, where he made a fortune, and then in Lon-
don, where he made another. The subject of this portrait was once thought to be
Sir William Chambers, the architect and royal academician, who was born in
Sweden and grew up there. All of Stuart's pictures were admired, but *The Skater*
caught everyone's fancy. According to tradition, the duke of Rutland went
straight from the exhibition to Leicester Fields to urge Reynolds to return with
him to Somerset House. "There is a portrait there you must see, painted by a
young man named Stuart. Everyone is enchanted by it." Sir Joshua went and was
impressed. "It does honor to his pencil" was the general opinion of critics, while
Horace Walpole, an arbiter of taste not overly given to enthusiasm, noted "*very
good*" in his exhibition catalogue. Almost overnight Stuart received the recogni-
tion that he had dreamed about as a youth and had come so far to seek. By popu-
lar acclaim his name was bracketed with those of Reynolds and Gainsborough as
a leading portraitist of the day, and he began to receive numerous commissions.
As he told Josiah Quincy many years later in Boston, he was "suddenly lifted into
fame by a single picture."

Henrietta Elizabeth Frederica Vane

IV. "The Vandyck of the Time"

ENCOURAGED BY BENJAMIN WEST, Stuart followed the advice of Sir Nathaniel Dance, a founding member of the Royal Academy and a friend of West's, who had taken a kindly interest in his progress. As Stuart liked to recall, after the exhibition of 1782, Dance came to call on him in his painting room in West's house. "Now you are strong enough to stand alone," Dance told him. "Take rooms. Those who would be unwilling to sit to Mr. West's pupil, will be glad to sit to Mr. Stuart." He took the advice and rented space in a house nearby on Newman Street. The move was probably an indication of his underlying ambivalence. He wanted to be on his own, yet he was reluctant to give up the security of West's studio, with its regular schedule and reassuring streams of distinguished visitors. Earlier, he had been noticeable for the torn coat that had surprised Trumbull and for the generally worn appearance of his clothes, but now he purchased from a fashionable tailor a new wardrobe that transformed him into a macaroni, a stylish buck with powdered hair and colorful waistcoats, lace, and gold buttons. As William Dunlap, another American pupil of West's, whose fame rests far more solidly on his admirable *History of the Rise and Progress of the Arts of Design in the United States* (published in 1834) than on his painting, noted when he saw Stuart at this time: "He emulated in style and costliness the leader of English fashion, the then Prince of Wales, 'the observed of all observers.' "

Stuart acquired a dog for company—breed uncertain—named Dash, who seems to have been as undisciplined as his master. He took exception to certain sitters and barked not only at their persons but also at their likenesses on canvas, and he often had to be banished from the painting room. Since Stuart had spent his money for clothes and rent, he lacked proper furnishings for his new quarters. Dance came to his rescue; having married one of the richest widows in the kingdom, he was retiring to take up the life of a country gentleman. He offered Stuart the contents of his studio, including the palette he had inherited from his and Sir Joshua's master, Thomas Hudson, of which Stuart was always proud. West referred sitters to him, and Dr. William Coates, the companion he had met at Dr. Cruikshank's lectures on anatomy, brought fellow naval officers around for their portraits. One of these officers was Lord Grantham, who had been West's comrade in Rome twenty years before. A commission for a full-length of the engaging dramatist, theater director, actor, and politician, Richard Brinsley Sheridan, followed. He was portrayed with a nonchalant air in a Grand Manner setting, in a pose reminiscent of the Apollo Belvedere, with the same sartorial stylishness that Stuart himself now assumed.

Henrietta Elizabeth Frederica Vane

1783. Oil on canvas, 65⅞ × 38⅝"
Smith College Museum of Art, Northampton, Massachusetts. Given in honor of Jessie Rand Goldthwait ('90) by her husband, Dr. Joel E. Goldthwait, and daughter, Mrs. Roger W. Bennett (Margaret Rand Goldthwait '21), 1957

One of the few likenesses of children that Stuart painted, this is a brilliant example of aristocratic portraiture in its emphasis on costume and setting. The feathery handling of the landscape, like the background in The Skater, *was influenced by Gainsborough.*

49

Sir John Dick

The full-length of Henrietta Elizabeth Frederica Vane, however, is more engaging. A charming ten-year-old, she was the niece of the earl of Darlington, and Stuart painted her life-size, in a simple white dress with an immense, colorful sash; tiny shoes peep out from beneath a long skirt. An absurdly large hat rests on her curly head, and a voluminous cloak is draped over one shoulder and falls into decorative folds at her side. She stands in an idyllic landscape, with feathery foliage, misty sky, and a basket of flowers at her feet. It seems an ideal vision of childhood innocence until one looks again at the little face, with its pointed chin and dark eyes, and one knows that she was a little holy terror—despite the dignified elegance of costume and setting. Stuart's innate realism comes refreshingly through the panache.

The year of the exhibition of *The Skater*, 1782, marked an important change in British politics, and men with whom Stuart had contacts were brought into power. Lord North's Tory government fell, to be replaced by the Whigs, men who were sympathetic to the cause of the American colonies and desired peace. Among them were the earl of Shelburne, Charles James Fox, and Edmund Burke. Stuart saw the danger to his professional position if he appeared partisan. Like West and Copley, he remained somewhat aloof, while the number of his sitters increased.

Stuart's *The Skater* also impressed Alderman Boydell, an ingenious Londoner who made a fortune through publishing engravings made after popular paintings and selling them in quantity. To ensure quality, he commissioned works by leading artists for the purpose. Since a considerable part of West's generous income was derived from the sale of prints after his own works, one could see that this could be a profitable business for all concerned. Boydell ordered a number of portraits by Stuart, including, in 1784, one of Sir Joshua Reynolds himself. Reynolds had by this time recovered from what seems to have been a stroke, though his deafness had increased. He was over sixty, and his natural wariness of competition had intensified. To maintain his control over the Royal Academy and his precedence in it, he resorted to stratagems unworthy of one of his abilities and position. Gainsborough, for instance, had withdrawn all his pictures from the Academy's exhibition of that year, and he never showed at the Academy again because of what appeared to be a deliberately unfavorable hanging—despite his specific request—of *The Three Eldest Daughters of George III*, a royal commission. Stuart's obvious success, as well as his youth, aroused a certain amount of resentment in the aging president, which shows in the dour expression in Stuart's excellent portrait, painted in July and August when potential sitters were out of town and a portraitist's time was comparatively free. Reynolds was too deaf to allow Stuart's usual jocular talk and his anecdotes to work their spell, so the sittings must have been conducted in an unusual and tense silence while Sir Joshua fiddled with his snuffbox and clearly hoped the ordeal would soon be over. The result, however, is a notable portrait.

In a further commission for Alderman Boydell, who was later toasted by the Prince of Wales at an Academy dinner as "an English tradesman who patronizes the arts better than the Grand Monarque of France," Stuart painted another por-

Sir John Dick

1783. Oil on canvas, 36⅛ × 28⅛"
National Gallery of Art,
Washington, D.C.
Andrew W. Mellon Collection

A Scot, the sitter was one of a series of distinguished naval officers painted by Stuart. The large decoration he wears was awarded him by Catherine the Great, Empress of Russia.

Self-Portrait

c. 1786. Oil on canvas, 10⅝ × 8⅞"
The Metropolitan Museum of Art, New York City
Fletcher Fund, 1926

Stuart is thought to have started this self-portrait shortly after his marriage. It was probably left unfinished because of the disturbed state of mind it reveals.

William Woollet the Engraver

1784. Oil on canvas, 35½ × 27¾"
The Tate Gallery, London

In one of several commissions for Alderman Boydell, Stuart painted Woollet while he worked on the plate of his engraving after Benjamin West's The Death of General Wolfe at Quebec, *part of which appears in the background of the portrait.*

trait of Benjamin West. West is posed seated, as in the earlier version, and, again, with a glimpse of one of his own works in the background, appropriately one that Stuart had assisted him with, thus a symbol of the relationship of the artist and his subject. As a gesture to his employer, Stuart had his sitter hold a copy of Boydell's famous *Shakespeare*, bound in handsome leather. West's powdered gray hair is similar in tone to his gray jacket. His level, alert gaze—with which his pupils had become so familiar—and the fact that he holds a pencil in his hand suggest that he was sketching Stuart on a sheet held against the book at the same time that Stuart was painting him, a theory proved correct by a dated drawing of West's inscribed in his hand: "Mr. Stewart, painting Mr. West's portrait." Though West did not wear orthodox Quaker garb, he was always conservatively dressed, "neat as a lad of wax," as Stuart described him, with "white silk stockings, and yellow morocco slippers,...looking as if he had stepped out of a band-box."

Stuart's *John Singleton Copley* was also done at this time. It is a superbly painted bust portrait in oval, without hands so that there is concentration on the head. The coat is broadly brushed in a soft, reddish tone, setting off the immaculate white ruffle rendered in creamy richness with a loaded brush. The dull, green-blue-gray sky, with its adroit scribbles of whitish cloud, is a perfect foil for the firmly modeled head and the expression at once resolute and reserved, the deep-set eyes dark and thoughtful. Stuart sometimes joked about Copley's slow pace and methodical approach to his art, but this portrait is a remarkable statement of his admiration and respect for his distinguished countryman.

Stuart was now established. He was known, his work was admired, and he had many commissions. As William Dunlap wrote, "In 1784, and the years immediately succeeding, I saw the half-lengths, and full-lengths of Stuart occupying the best lights, the most conspicuous places.... From the commencement of his independent establishment as a portrait painter in London, success attended him; but he was a stranger to prudence. He lived in splendor, and was the gayest of the gay."

He was aware of Reynolds's jealousy but recognized the importance of the Royal Academy as a showplace. He saw—as did Reynolds, Romney, Gainsborough, and West—the advantage of having his own gallery, where he could display a changing and continuous exhibition of his work. His meager rooms at 7 Newman Street could not accommodate any such function, so he looked for more suitable quarters, spacious enough to show pictures to groups of viewers. It had to be in a fashionable part of town or there would be no viewers. At 3 New Burlington Street he found the ideal house. Just off Piccadilly and near Burlington House, to which the Royal Academy was to move many years later, it was three stories high with a broad frontage. The annual rent of a hundred guineas was a large commitment for him to make, but commissions continued to flow in, so he took the leap.

As Temple Franklin wrote from London to his famous grandfather Benjamin in the fall of 1784, Stuart was "esteemed by West and everybody the first portrait painter now living.... I have seen several of his performances which appear

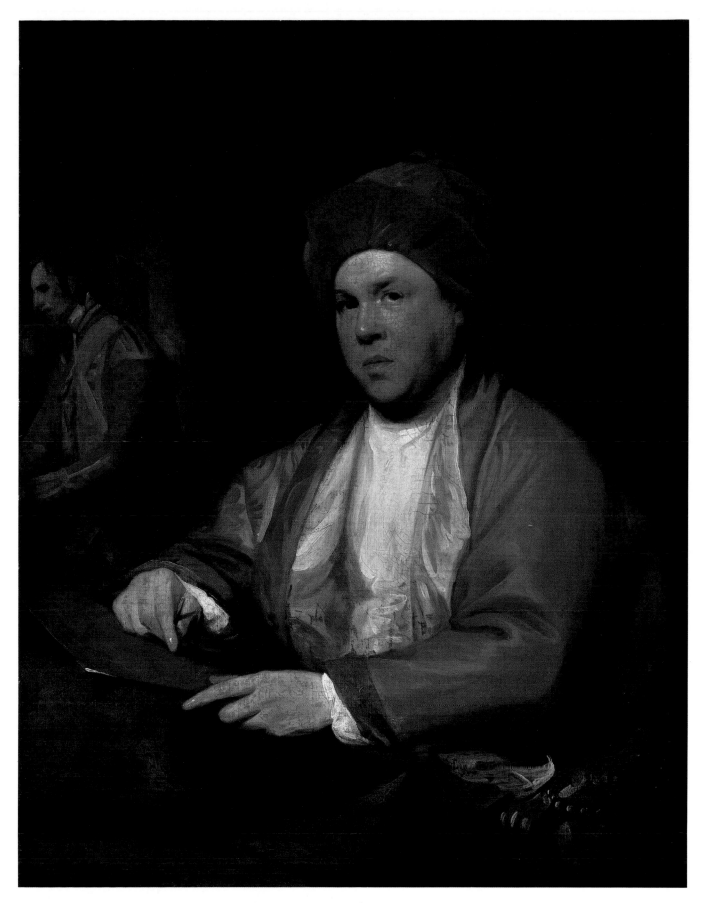

William Woollet the Engraver

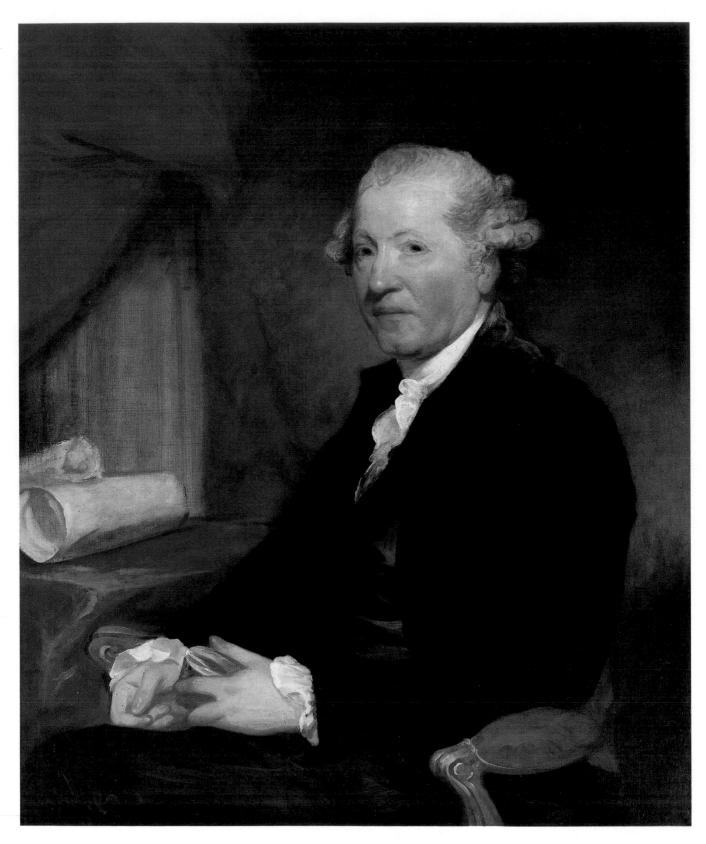

Sir Joshua Reynolds

to me very great indeed! I heard West say that 'he *nails* the face to the canvas' by which he meant I believe to express not only that the resemblance of the person was perfect, but that his coloring did not change; a fault common to some of the first painters in the country, and particularly to Sir Joshua." Reynolds's paintings were notorious for their fugitive color, and it is hard to tell now, handsome though they are, what they originally looked like. He was extremely secretive about his materials, and he always locked his paints, brushes, and palette in a cabinet when he was not using them, so that none of his students could learn his methods. This was just the opposite of West's practice; he shared everything he knew with his students, as did Stuart. Since his illness Reynolds had raised his prices to what, as Fanny Burney confided to her diary, were too high even for him. As a result, Stuart and other leading artists received yet more custom.

At this time Stuart was known primarily for his male portraits, many of them military men whose bluff and forthright personalities he captured in a vigorous style. As his reputation grew, he experimented with half-, three-quarter-, and full-lengths, and when the Younger Pitt, a curiously cool and remote young man in his mid-twenties, was called upon by the Crown to head a government to succeed that of Lord Shelburne, in whose cabinet he had unobtrusively served, Stuart's fortunes rose further. The earl of Shelburne, elevated to become the marquis of Lansdowne as compensation for stepping aside, turned up in Stuart's house one day to look at his paintings. "From his shabby black dress, and respectful politeness," Stuart remembered, "I concluded him to be some poet or author from Grubb Street, and made up my mind that the chief purpose of his visit was to prepare some article as a puff for the next periodical. A few days after this I received a polite invitation from the Earl of Shelburne. And you may judge of my surprise when I found in my host the supposed Grubb Street scribbler." Shelburne gave Stuart a list of those whose portraits he wanted him to paint for a special gallery on the grounds of his house at Bowood.

Through Shelburne's influence, a procession of prominent Whigs progressed through Stuart's painting room. He rose to the occasion. Never was his work more incisive, more directly observed and expressed. There were few women sitters because his drive toward realism did not allow for the expected flattery. John Hoppner, no mean portraitist himself and a defeated rival of Stuart as successor to Sir Joshua, described in *The Morning Post* Stuart's portrait of a naval officer as "without any trickery to dazzle the eye or mislead the judgment. The likeness is very strong, which we understand to be almost invariably the case with the portraits of this artist." Stuart's magical technique was used with such control that his brother artist could call his work "plain and admirably well painted." Gainsborough had but four more years to live, Reynolds scarcely more. Hoppner was out of the picture. George Romney was too infatuated with the beautiful mistress of the Honorable Charles Francis Greville, Emma Hart, who later became Lady Hamilton and the lover of the great naval hero Horatio, Lord Nelson. Henry Raeburn was increasingly involved with his native Scotland. William Beechey and Thomas Lawrence had not yet arrived. Stuart was cock of the walk.

John Philip Kemble

c. 1785. Oil on canvas, 29½ × 24½"
National Portrait Gallery, London

The leading British actor of his day, noted for his dramatic interpretations of Shakespeare, Kemble was a close friend of the artist's.

Sir Joshua Reynolds

1784. Oil on canvas, 36×30"
National Gallery of Art, Washington, D.C.
Andrew W. Mellon Collection

In this portrait, painted for Alderman Boydell, Stuart achieved such a telling likeness that Reynolds, already jealous of the younger artist's brilliant technique and growing success, was considerably annoyed.

Colonel Isaac Barré

1785. Oil on canvas, 36 × 28¼"
The Brooklyn Museum, Carll H. De Silver Fund

A veteran British officer and prominent Whig, Barré was nevertheless sympathetic to the cause of American independence.

Joseph Brant

1786. Oil on canvas, 30 × 25"
New York State Historical Association, Cooperstown

Brant, a chief of the Mohawk Indians, was the friend and secretary of Colonel Sir Guy Johnson, who was royal commissioner of Indian affairs in America. On Brant's visit to England, Stuart painted his portrait and more than one replica, making the most of his interesting personality and picturesque appearance.

In the spring of 1786 he married Charlotte Coates, the eighteen-year-old sister of his friend Dr. William Coates, the surgeon in the Royal Navy whom he had met eight years earlier at Dr. Cruikshank's lectures. Her father was a physician in Reading, west of London in the Thames valley, where Stuart was a welcome visitor from time to time. The Coates family liked and admired him, and they recognized that at thirty he had achieved an extraordinary position in the art world. But they knew him well enough to be aware of his restlessness, moodiness, and extravagance. Both father and son expressed their esteem and warm friendship but absolutely forbade the marriage. Consent was finally and reluctantly given only after it was clear that nature had taken its accustomed course, and Charlotte moved into the splendid house on New Burlington Street. She was attractive, shared her husband's love of music, and had a lovely singing voice, but she had few if any qualifications to be the wife of a man who was self-centered, capricious, and driven, no matter how gifted.

Even Stuart recognized that with marriage—and a child on the way—he had to reassess his situation. He was charging the same prices as Gainsborough: thirty guineas for a bust portrait, sixty for a half-length, and one hundred for a full-length. He discovered, however, that, busy as he was, he was not painting enough half- and full-lengths to supply the income his style of living required. Impatient of record-keeping, he allowed his unpaid bills to mount while his income did not. He was obviously busy and successful, but he was losing ground dangerously. He thought about Reynolds and West and recognized that, though neither maintained the production schedule he did when he was at his busiest, both made more because they painted a greater percentage of historical and other larger works that fetched commensurately much higher prices. They also sold quantities of engravings.

Stuart was fascinated by the glamorous world of the stage, to which he turned for a way out of his difficulties. He had painted a major portrait of Sheridan, the theater's brightest luminary since the death of David Garrick in 1779, and was a friend of John Philip Kemble, a leading actor whose drawling diction Stuart is said to have emulated. They opened stage doors to him. Through his circle of acquaintances in the theater and his business connection with Boydell, he learned that the Alderman was contemplating a new series of paintings of important subjects from Shakespeare, which were to be engraved. Stuart and Kemble, therefore, planned a painting of the latter in his most famous role, as Macbeth. They chose the moment of Macbeth's meeting the witches on the heath. Pictures of episodes from the theater were far from unknown, but they were painted as cabinet pictures, with the figures at small scale. Stuart's was to be life-size.

Rumors of this unique project spread about London, and in February, 1786, *The Morning Chronicle* broke the news that the artist, famous for his "accuracy of similitude, has made a head of Kemble for Macbeth, marvelously exact." Encouraged by the public interest, Stuart went on to paint Kemble as Richard III. But Boydell turned both down. So Stuart turned to larger and more spectacular portraits with the help of such Whig patrons as the duke of Northumber-

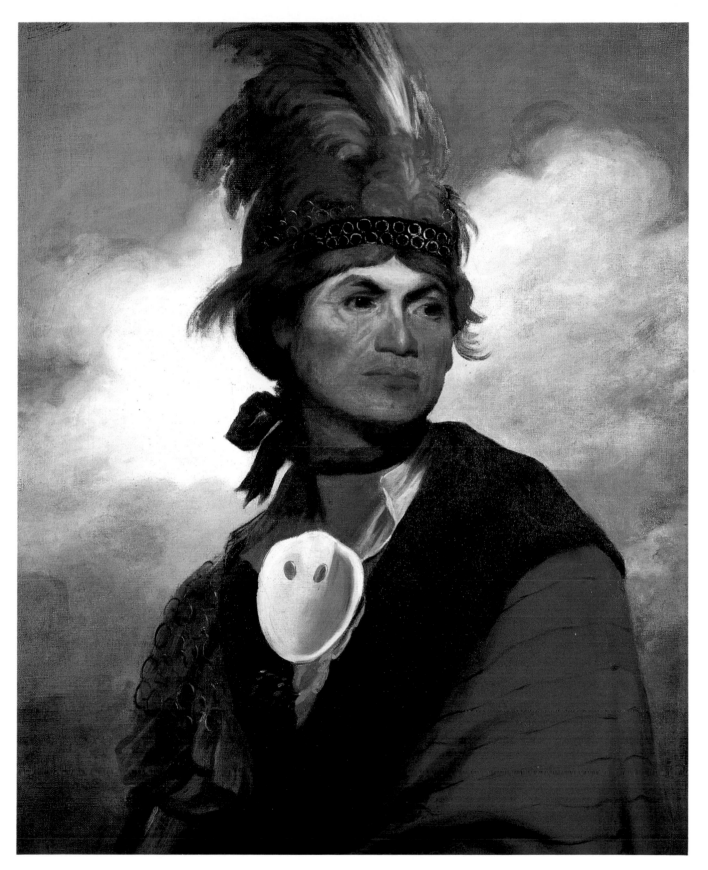

Joseph Brant

Sarah Siddons

c. 1785. Oil on canvas, 29½ × 24½″
National Portrait Gallery, London
Gift of John Thadeus Delano, 1858

Mrs. Siddons, John Philip Kemble's sister, was the leading actress of the period. Far more famous than Stuart's direct and informal likeness is Reynolds's grandiloquent Mrs. Siddons as the Tragic Muse, *painted five years later.*

Hugh, 2nd Duke of Northumberland

1785. Oil on canvas, 28 × 22¾″
Collection Syon House, Isleworth, Middlesex

As Earl Percy, the duke of Northumberland was a British officer during the American Revolution. A leader of the Whigs, he was a patron of Stuart's and an advocate of freedom for the American colonies.

land and Colonel Isaac Barré. Both had served in the American war and had experienced enough to be disgusted with what they considered a wasteful and ill-conducted conflict and to have sympathy with the colonials. But rumors of Stuart's financial straits began to be heard. Concerned for his future, Northumberland, Barré, and Lord St. Vincent, the famous admiral, called on him. Each had sat for a portrait. Now each ordered a replica and insisted on paying half the price at that moment, urging Stuart to demand the same from all his sitters thereafter. Stuart was grateful for what he described as "this delicate mode of showing their friendship."

It was probably through the influence of Stuart's Whig friends that there appeared in *The World* of London, on April 18, 1787, an article headed "Stuart. The Vandyck of the Time." It was an extraordinary paean to Stuart's art: "In the most arduous and valuable achievements of portrait painting, *identity* and *duration*, Stuart takes the lead of every competitor." The anonymous writer goes on to say that "Stuart dives deep—less deep only than Sir Joshua, more deep than every other pencil—Stuart dives deep into *mind*, and brings up with him a conspicuous draught of character and characteristic thought—all as sensible to feeling and to sight as the most palpable projection of any feature of a face." There follows a list of what the writer considered the most outstanding of Stuart's works, naming portraits of a number of leading Whigs, and including that of Kemble as Macbeth, along with "the two best portraits the world before could boast, . . . the Duke of Buckingham by Vandyck, in the king's collection, and the Archbishop of Armagh by Sir Joshua Reynolds." Though there is no question of the quality of Stuart's work, the citation of his Kemble as Macbeth as the equal of "the two best portraits in the world" is a pretty obvious puff. And even though one cannot judge the Kemble because it has been lost since the 1780s, one has to boggle at the choice of the two portraits mentioned as the best in the world. Where are Titian, Raphael, Tintoretto, Rubens, Rembrandt, Hals, and dozens of others, all artists much admired in the period, who—one would think—would have come immediately to mind?

There is no way of measuring the effectiveness of such a notice, but Stuart continued business as usual, except that he worked constantly to keep up with the stream of sitters. He also kept up his usual pace of hospitality, entertaining friends at luncheon and dinner, arranging musical evenings in which leading performers participated, including, among others, the oboists John and William Parke and the composer William Shields. Charlotte sang at a number of these gatherings, and the artist Henry Fuseli expressed the greatest admiration for her voice. While Stuart painted more busily than ever, he followed the advice of his benefactors and demanded half the price of the finished portrait at the first sitting, a practice generally followed at the time. He saw that he was too deep in debt to extricate himself before the summer season, marked by the end of the parliamentary session, sent everyone to the country. He knew very well, however, that his creditors stayed in town.

Recognizing this unfortunate state of affairs, the duke of Northumberland invited Stuart to Syon House, his superb country house with interiors by the

Hugh, 2nd Duke of Northumberland

The Percy Children

brothers Adam, west of London near Kew Gardens. There, isolated behind the walls of the duke's enormous park, Stuart was safe for the time being. That June *The World* of London reported his presence there and the progress of the family portraits on which he was engaged. Charlotte and the two small children may have found refuge at her family home in Reading. Despite the pressures of the situation, Stuart painted full-length, life-size portraits of the duke and duchess, and in July *The World* stated that he had "nearly finished the Duke of Northumberland's family picture," the four Percy children with a large, handsome, and genial dog, posed in the park of Syon House. It was an extraordinarily successful and attractive performance for a man in Stuart's straits. The children are charming and seem to be enjoying themselves. To create such an idyllic and, to quote *The World*'s critic, "agreeable work" under the circumstances was a remarkable achievement. When the large canvas was completed at the end of July, the duke paid him £120.9.0, and he went back to town.

Stuart was in London during August. There were rumors that he had received generous offers to go to France and that his American homeland eagerly awaited his return. Meanwhile, he avoided his creditors and made his plans. Late in August it suddenly became apparent that the handsome house on New Burlington Street was no longer tenanted. His creditors descended upon it and its contents were seized. No one knows what happened to the famous portrait of Kemble as Macbeth, or to the many other paintings that had adorned the walls, or to the many portraits started but not finished. Furniture and furnishings were entirely gone. *The Public Advertiser* reported that "Stuart the painter, when he has done the work that is to employ him in France, has offers of a very liberal kind to settle in America," while *The World* had it that he had gone to America to attend to his father's extensive properties there. Meanwhile, the house stood empty, and of its tenant there was no sign, nothing more than the rumors he had so carefully planted. The leading portrait painter in London had, "at the summit of his powers," in the words of the critic of *The Public Advertiser*, disappeared without a trace.

The Percy Children

1787. Oil on canvas, 71½ × 94"
Syon House, Isleworth, Middlesex

This delightful group was painted in the park of Syon House, the duke of Northumberland's palatial estate near Kew Gardens, just before Stuart fled to Dublin to escape his creditors.

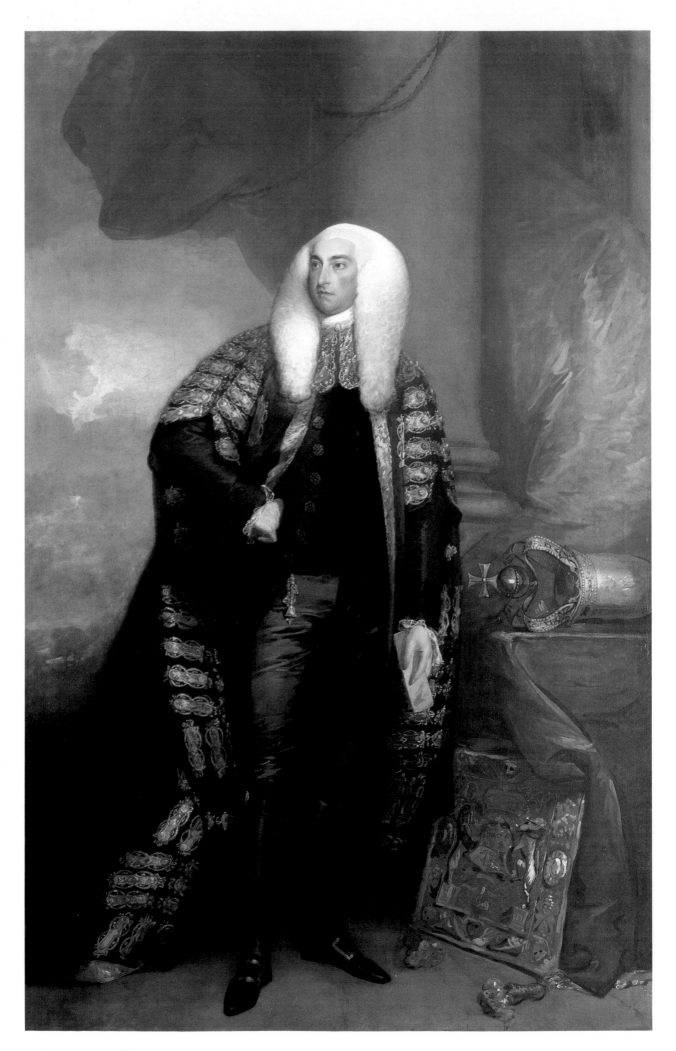

John, Lord Fitzgibbon

V. "A Pre-Eminent Fame for Identity"

BOTH ANN AND JANE Stuart gave the same account of their father's arrival in Dublin in 1787: that he had gone there at the invitation of the duke of Rutland, recently appointed Lord-Lieutenant, and that, as he entered the city, he met the duke's funeral cortege leaving it. As neither of the daughters was born until long after the event, they undoubtedly heard the story from their father, and, like most of Stuart's stories, it is compounded of both fact and fiction. Rutland may well have invited Stuart to the Irish capital—as he is known to have done in the case of Sir Joshua Reynolds and several other artists—since he was "a munificent patron of the arts, dispenser of a princely hospitality," and was genuinely interested in improving the general state of cultural affairs in Ireland. Especially because of his connections with the Whig leadership, Stuart would surely have enjoyed the duke's patronage had Rutland lived. But the fact seems to be that Stuart surfaced in Dublin early in October, because, by the time of the duke's demise on the twenty-fourth, he had received a number of commissions for portraits and had already completed three: of Jonathan Fisher, a topographical artist of some local fame; Luke White, a print-seller; and Henry Grattan, a leading member of the Irish Parliament. He had already been invited to,—and attended—the annual artists' dinner on St. Luke's Day, October 18.

When Stuart arrived in Dublin, he had not only left his debts behind him but also had the considerable fee that the duke of Northumberland had paid him and probably some further sums that he had collected before leaving London. It was strongly in his favor that the young and spirited Rutland, who had so admired *The Skater* when it was exhibited five years earlier, was now the viceroy. Stuart's London patrons, the duke of Northumberland and the earl of Shelburne, had extensive Irish estates—Copley's half brother, Henry Pelham, was Shelburne's agent—and both had powerful friends and relatives, so the painter was warmly welcomed in the handsome houses on Ely Place, Merrion Square, Grafton Street, Great Denmark Street, and the other fashionable parts of the city. Yet within but a short time after his arrival, at six in the morning of October 24, the booming of cannon in Phoenix Park announced the sudden and unexpected death of the lord-lieutenant, not yet forty, from what had been diagnosed as the "putrid fever," contracted a few days before on an official visit to Belfast.

Despite the factionalism that seems to have been endemic to Ireland through the centuries, Rutland was genuinely popular and was almost universally mourned. His was the largest public funeral up to that time, with a procession

John, Lord Fitzgibbon

1789. Oil on canvas, 96½ × 60⅝"
The Cleveland Museum of Art,
General Income Fund

This impressive portrait of the notorious "Black Jack" Fitzgibbon, complete with robe and insignia of office and with a Grand Manner setting, assured Stuart's success in the Dublin of the Ascendancy.

Luke White

c. 1790. Oil on canvas, 30 × 25"
National Gallery of Art, Washington, D.C.
Andrew W. Mellon Collection, 1942

White was a print-seller whose portrait was among the first that Stuart painted after his arrival in Dublin.

that stretched on and on, as much of the city's population accompanied the duke's body to the vessel that took it back to England for burial. The brightness of the viceregal court was dimmed. No longer was his beautiful and popular young duchess seen taking the air in "the magnificent viceregal equipage," a coach-and-six, with liveried footmen and postilion, the yellow-wheeled carriage emblazoned with the ducal arms. For a time the public entertainments ceased, but gradually the city resumed life much as before, with a round of social activity, gala assemblies at the Rotunda, balls at the Castle, and the latest theatrical performances at Crow Street and Smock Alley. On North Circular Drive, Lord Cloncurry recollected, "it was the custom, on Sundays, for all the great folk to rendezvous in the afternoon, just as, in later times, the fashionables of London did in Hyde Park; and upon that magnificent drive I have frequently seen three or four coaches-and-six, and eight or ten coaches-and-four passing slowly to and fro in a long procession of other carriages, and between a double column of well-mounted horsemen." Also on Sundays there were promenades in St. Stephen's Green and the New Gardens, next to the Rotunda, with an "artificial waterfall lit with 'artificial moonlight,'" and "a coffee room and pavillions."

And there was always music, because Dublin had a musical tradition—in 1742 Handel first presented his *Messiah* at a benefit performance in the Music Hall on Fishamble Street. There were programs of choral societies, church choirs, professional opera, burlettas, oratorios, and serenatas; the audiences were "a motley throng including the elite of the nobility and gentry attired in the gorgeous and picturesque costumes of the period," the men in powdered wigs, dressed in regimentals or suits of scarlet, sea-green, or sky-blue, with claret-colored coats and green-and-gold waistcoats, often heavy with gold braid. Many of the ladies wore such fantastic hairdresses that some had cupolas on their sedan chairs to accommodate these extraordinary constructions of feathers, ribbons, and other decorative materials. All sorts of others—except the very poor—attended, including merchants and shopkeepers, clerics and craftsmen, physicians and professors. The colorful pageantry of such affairs provided a form of public entertainment. Far more than in the London Stuart had just left, in Dublin social life was a public matter, involving all classes despite the disparity between the extravagant wealth of the Anglo-Irish upper class and the poverty of the Gaelic majority. "There never," wrote the Parliamentary Reporter to a friend in 1785, "was so splendid a metropolis in so poor a country."

Dublin was a city of contrasts, of great power among the few and of penury among the many, of palatial houses and squalid slums, of assured privilege and hopeless mendicancy. In Stuart's day there was "a standing army of 2000 city beggars," who attached themselves in large groups to any prosperous-appearing visitor. They "accompanied him in his walks abroad, blocked the exits from the shops in which he made his purchases, and against whose persistence the closed doors of a private dwelling alone availed to protect him." "Till I saw the beggars of Dublin," Samuel Foote, the eighteenth-century playwright wrote, "I could never imagine what the beggars of London did with their cast-off cloathes."

Ladies went about in sedan chairs because of the unspeakable condition of

A PRE-EMINENT FAME FOR IDENTITY

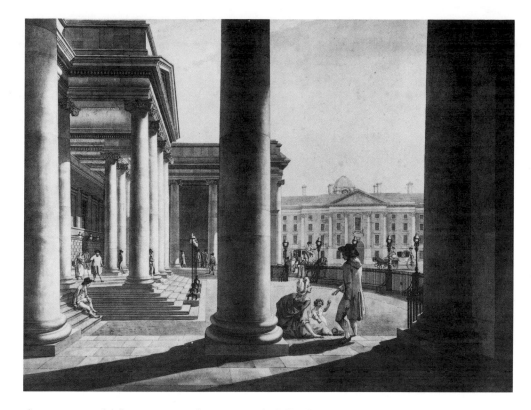

James Malton
*Forecourt of the Houses of
Parliament, Dublin*

1792–93. From a watercolor
National Gallery of Ireland, Dublin

*Trinity College is in the background.
James Gandon was one of the architects of
the superb Parliament House, later the
headquarters of the Bank of Ireland.*

the streets, which were mostly unpaved, full of potholes, and, after a rain, a morass of mud and filth. They were accompanied by footmen with staves to make a way through the swarms of indigents, and, at night, by armed linkmen for protection against footpads. Additional violence was supplied by the "Bloods, young men of fashion," who amused themselves by attacking the citizenry, breaking windows, or "pinking" with their swords "those unoffending passers-by on whom they saw fit to bestow their attentions," having cut off the tips of their scabbards the better to practice this form of sport, for which they were known as "pinkindindies." By the time Stuart had settled in the city, the Independent Dublin Volunteers, groups of gentlemen who patrolled the streets at night, were beginning to discourage such activities. However, blazing—that is, dueling—was considered the only proper way to settle an argument—no matter how insignificant—and was so prevalent that it was said to be dangerous to go strolling in Phoenix Park early in the morning because of stray bullets. One might live through a duel only to lose a fortune by gambling it away at such gaming places as Daly's on College Green or at the Eagle on Cork Hill, where other slights led, in turn, to further blazing. Gratuitous murder was not uncommon and was frequently got away with, if one had money and connections. When a Blood named Buck Whitley shot a waiter for being insufficiently expeditious, he had him charged on his bill at 50 pounds. The fact that the majority of the males of the upper classes went about armed and were rarely sober—and that many prided themselves on staying roaring drunk—contributed both to the gaming and the blazing.

The Protestant Ascendancy of the eighteenth century was the great period of Dublin's flowering—the most cultivated in Ireland's troubled history. Anglo-

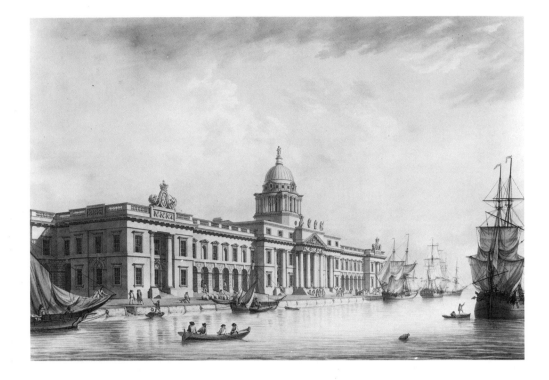

James Malton
The Custom House, Dublin

1792
National Gallery of Ireland, Dublin

The masterpiece of James Gandon, a pupil of Sir William Chambers, the Custom House was completed in 1791. Malton was a noted architectural draftsman.

Irish magnates, British in origin but joined by certain old Irish families, owed their allegiance to the British Crown and controlled the Irish Parliament as a ruling minority. All were Anglican. The great majority of the native Catholic population, poor and uneducated to begin with, were condemned to stay that way by the notorious Penal Laws, which forbade their voting, owning land, marrying Protestants, joining the professions, or standing for Parliament. Secure in their Palladian palaces on their vast estates, the Anglo-Irish, resentful of such evidences of English paternalism as restraints of trade and endless taxes, took note of the lesson of the American Revolution, and in 1782, Henry Grattan, a prominent Dublin lawyer and Member of Parliament—and one of Stuart's first sitters—persuaded the Irish Parliament to pass an act declaring Irish legislative independence. Whereupon the royal government in Westminster, seeking to avoid a repetition of the American Revolution in Ireland, passed the Act of Renunciation, confirming the Parliament in Dublin in its sole right to legislate for Ireland. To regain control, the representatives of the Crown turned to the time-honored methods of Irish government: influence, manipulation, bribery, and the rewards of titles, offices, and monopolies. Within a few seasons, the Act of Renunciation was, in effect, nullified, and the Ascendancy again dominated a Parliament that represented only its own interests. As Stuart settled in Dublin, he recognized that his patrons, the Anglo-Irish, were in firm control, but he was also aware of the rising disaffection of the disenfranchised native population, which was expressing itself through sporadic acts of violence and a rise in crime.

Under the Ascendancy, Dublin became one of the handsomest capitals of Europe. During this period, almost every important building, public or private, was built, including the College Green with the Houses of Parliament and Trinity College, with their monumental classical porticoes, and the Law Courts and

A PRE-EMINENT FAME FOR IDENTITY

James Gandon's magnificent Custom House, both on the quays of the Liffey, and the great hospitals, among the earliest and finest in Europe: the Kilmainham, the Blue Coat, and the Lying-in, with its famous Rotunda where the assemblies took place. Also of this period were the wide streets and spacious squares, lined with beautiful mansions, their dignified doorways surmounted by intricate fanlights and surrounded by wrought-iron fences, gates, and lamps. Their light and airy interiors were resplendent with brilliant chandeliers and decorative plaster ceilings, perhaps the finest in Europe, executed by visiting Italian artisans. All that gives Dublin its unique quality and extraordinary picturesqueness makes the city as we know it a monument to the Ascendancy.

The city's culture matched its architecture. For a person of Stuart's character, with his love of good food, wine, and fellowship, of finery, talk, and show, Dublin obviously provided a fascinating and stimulating atmosphere. As his daughter Ann wrote, "The elegant manners and the wit and hospitality of the upper classes of the Irish suited his genial temperament." But given his proven improvidence and capriciousness, Dublin was scarcely the ideal environment.

He had painted several Irish sitters in London, and his reputation had preceded him. It was as a well-known artistic personality that he attended the artists' dinner on St. Luke's Day. His financial difficulties in England seemed to be common knowledge but carried little stigma. He was busy from the beginning, charging thirty guineas for a head and shoulders, more than any of the local painters, and getting it without protest. Busy as he was in the fall, the demand doubled when Parliament met that winter. He began as many portraits as he could, collecting half the fee for each as he had been advised by his Whig patrons in London. By spring he had quite a bit of money and quite a number of unfinished portraits. He rented a house in Pill Lane, a highly respectable street near the river Liffey and, though most of Stuart's biographers have stated or implied otherwise, in a fashionable part of town. He returned to England to fetch his wife and family, managing to slip in and out of the country without attracting the attention of bailiffs or creditors. He was back in Dublin by early April, 1788.

Among the wielders of power in Ireland during the later years of the Ascendancy, none was more powerful or ruthless than John, Lord Fitzgibbon, later the earl of Clare. He was a prominent lawyer and Member of Parliament, whose bullying manner and arrogance concealed a cunning and conspiratorial mind unhampered by compunction. As lord chancellor, he was virtually dictator of Ireland for much of the rest of the century. Though he was Irish by birth and family, his strength lay in his close alliance with Pitt and the royal government in Westminster. The first major commission that Stuart received in Ireland was for a full-length portrait of Fitzgibbon in his robes of office. Stuart attacked the project, his first official portrait, with a vigor that is expressed in the bravura of his brushwork. In the chancellor's stance—right arm akimbo, left hanging negligently at his side, right foot forward—Stuart transformed the easy grace of a favorite pose of Van Dyck into a statement of haughty power. The full black robe, weighty with gold bullion, enframes the figure within a Grand Manner setting, complete with massive column and scarlet drapery floating against an atmo-

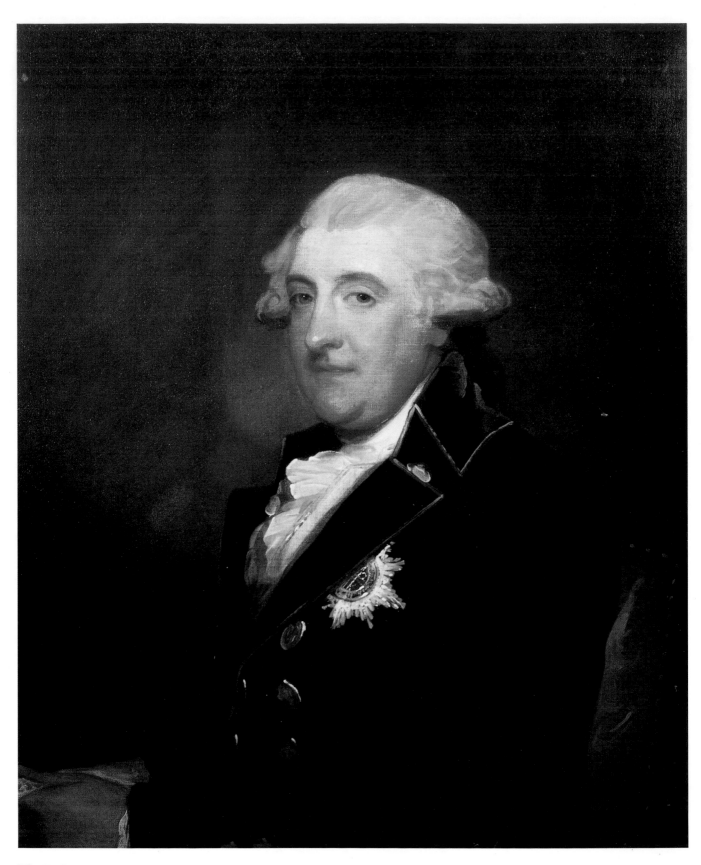

The Duke of Leinster

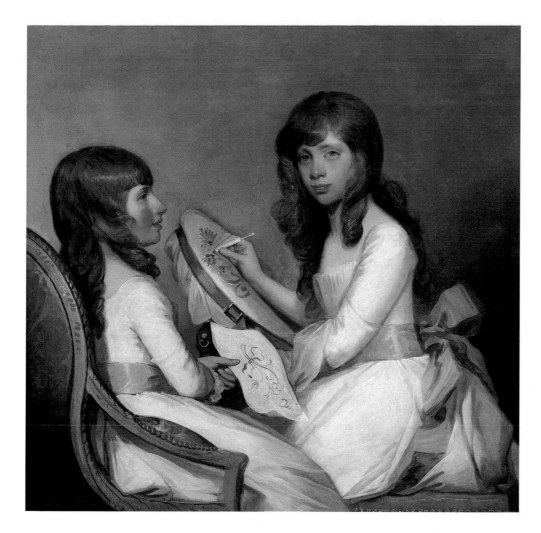

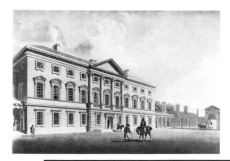

Miss Dick and Her Cousin,
Miss Forster

c. 1792–97. Oil on canvas, 36 × 37″
Collection Mr. and Mrs. R. Philip Hanes, Jr.,
Winston-Salem, North Carolina

An inscription on the back of the painting
identifies the two girls and includes Stu-
art's signature. Painted in Ireland, it is
one of his rare double portraits and also
one of the very few showing a sitter in
profile.

James Malton
Leinster House, Dublin

1792. Engraving
National Gallery of Ireland, Dublin

This town house of the duke of Leinster
was later used by the Irish Parliament.

The Duke of Leinster

c. 1787. Oil on canvas, 32¼ × 26¾″
Collection of the Montclair Art Museum,
New Jersey. Purchased from the Freeman Fund

Leinster was a prominent figure in the
Ireland of the Ascendancy.

spheric sky. On a table at Fitzgibbon's left hand lies the golden mace, topped with crown, orb, and cross, signifying the importance of his office, whose source is revealed by the royal arms of the kingdom of Ireland on the heavily tasseled chancellor's burse below. His face is framed by the unexpected softness of the curly white wig, and he looks out to the viewer's left with an icy gaze, his thin lips drawn up into what is almost a sneer, an expression of aristocratic hauteur and insolent disdain. Again, Stuart's penetrating grasp of truth stabs through the panoply of grandeur to produce a memorable portrait, a revealing document of a personality, a period, and a society—and a magnificent painting.

Stuart was a frequent visitor to Fitzgibbon's handsome house on Ely Place. On one occasion, after dinner had been delayed for half an hour because one of the guests had not arrived, the missing diner appeared after the cloth had been removed and the other diners were enjoying their port. Fitzgibbon directed a servant to set a small table for him and serve him a belated dinner. After the guest was seated, the chancellor turned confidentially to Stuart:

"Now Stuart, you are accustomed to look all men in the face who come before you—you must be a good judge of character. Do you know the gentleman at the side table?"

"No, my lord, I never saw him before."

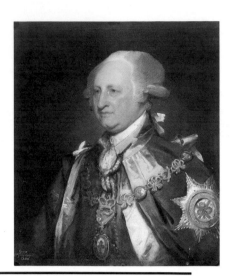

George,
First Marquis of Waterford

c. 1791. Oil on canvas, 29¼ × 24½"
Curraghmore, Ireland

A member of a prominent Anglo-Irish
family, the Beresfords, Waterford was a
powerful figure in the Ascendancy.

"Well, now, tell me what sort of man he is in disposition."

"Is he a friend?" Stuart asked.

"No," Fitzgibbon answered.

"Then I may speak frankly?"

"Yes," the chancellor assured him.

"Why then, my lord," said Stuart, "if the Almighty ever wrote a legible hand, he is the greatest rascal that ever disgraced society."

Fitzgibbon roared with laughter and assured Stuart that his estimate had been entirely correct. Unfortunately, the record is silent as to the identity of the gentleman in question.

Fitzgibbon could be a relentless enemy and a dangerous friend, but his patronage and his portrait ensured Stuart's position as virtually the official painter to the Ascendancy. The newspaper critics were enthusiastic in their praise of the picture, and the competition of other artists, established and busy before his arrival, melted away.

Stuart kept in touch with affairs in the art world back in London. He was aware of the death of Gainsborough in 1788, of the blindness that came upon Reynolds suddenly the following year, and of Copley's diminishing production, which left only Romney with any kind of claim to be his rival. Hoppner and Opie had not achieved first rank; Beechey and Lawrence were promising but as yet untried. Stuart had never given up hope of returning in triumph, paying his debts, and assuming his rightful position as the leading painter in London. Now was the time, if he could somehow manage it through his conquest of Dublin.

Stuart invited a leading English engraver, Charles Hodges, to come from London. Hodges was a master of the mezzotint technique, with which he had successfully reproduced portraits by Reynolds, Gainsborough, and others. Hodges's plate of Stuart's Fitzgibbon was handsomely done, and the engravings sold well both in London and in Dublin. A series of portraits of outstanding personalities in Irish public life, each accompanied by an edition of engraved prints, followed. The mezzotints were popular, and Stuart began to catch up on the debts that had been accumulating. According to the account written many years later by James Dowling, a minor artist who assisted and much admired him, Stuart had returned to the open-handed entertaining and convivial life that had brought about his downfall in London. Dublin's temptations were obviously beyond his power to resist.

One of the problems inherent in Stuart's situation was not within his capacity to solve. Inevitably, he was very busy for the few months that Parliament was in session, but during the rest of the year, when most of the gentry left the city to live on their estates, there simply were not enough potential sitters, no matter what monopoly he had achieved. So he painted furiously during the parliamentary season, claiming half-fees for completed heads, and finished the pictures during the slow months. He found this not only boring but also discouraging, because, by the time the season rolled around again, he was already behind on his bills and had to start painting himself out of debt.

It was probably in 1790 that there came a change for the better. Through

A PRE-EMINENT FAME FOR IDENTITY

the generosity of the earl of Carysfort, a friend and admirer of Sir Joshua Reynolds and a connoisseur, Stuart left town for Stillorgan, a few miles south of Dublin, where he moved into a small but comfortable house with several acres of land, surrounded by the earl's famous deer park. Though Carysfort owned Stillorgan, his home was in England, and he had probably met Stuart in London, where he kept up with the worlds of art and music and had many friends.

The cottage at Stillorgan was ideal for Stuart and his family. He had room for vegetable and flower gardens; there were fruit trees, and he raised pigs and chickens and kept a cow. He laid out borders and walks and filled the house with potted plants and flowers. The satisfactions of living in the countryside, unknown since boyhood, and the pleasures of working on the land came flooding back to him. Stillorgan lay on high ground. From his house he could look northeastward across Dublin Bay to Howth Castle on its rocky promontory in the far distance, and eastward over the pleasant demesne of Newtown House and Dalkey Island, and across the Irish Sea toward Holyhead. He had given up the house in Pill Lane but had hired painting rooms in the same part of town for the convenience of his sitters. He traveled the three or four miles back and forth on horseback or by public coach from the inn in the hamlet of Black Rock, down the hill from his house.

He still found it necessary, however, to paint furiously during the parliamentary season and complete his work at greater leisure during the following months. With a less critical patronage than that which he had enjoyed in London, his painting tended to become routine. But when faced with sitters with the intelligence and charm of Sir William and Lady Barker, he produced portraits of appropriate distinction. Using an unusual oblong format, he painted seated half-lengths. Sir William's background is a vista of the ruins of Kilcooly Abbey in County Tipperary, near which he built a country house whose plans appear in the portrait. Lady Barker works in colored silks on fabric stretched on an embroidery frame, while behind her is another view of Kilcooly. The flesh tones are fresh, the expressions alert, the paint applied with gusto. Stuart was obviously delighted with both personalities.

Prominent among the full-lengths of leading figures in public life that he painted at this time are the portraits of the patriotic MP Henry Grattan and of Speaker John Foster of 1791. The original of the *Grattan* has been lost, but a copy or a much-repainted replica is at Trinity College, and there is an engraving that perhaps suggests more of the quality of the original. Both invite comparison with his *Fitzgibbon* of two years earlier, since both are also official portraits, showing figures in formal settings suggestive of the importance of their public roles. The Right Honorable John Foster appears as the Speaker of the Irish House of Commons, with robe and wig that rival those of the formidable Lord Fitzgibbon. The pose is more animated because Stuart chose to record a moment when, in the course of an address, the Speaker gestures with his left hand to emphasize a point. His right hand rests on a partly rolled document. The heavy gold mace of office is nearby, while the two leather-bound tomes behind it, *The Trade of Ireland* and *The History of Commerce*, allude to his previous position, chancellor of the ex-

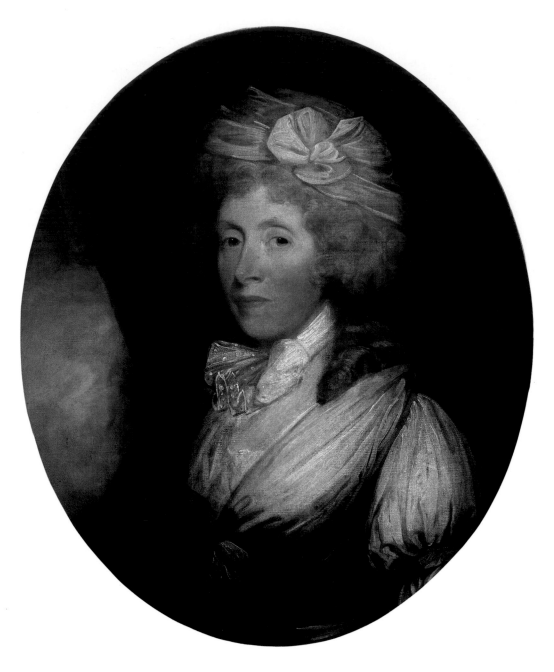

Mrs. George Hamilton

c. 1790. Oil on canvas, 28 × 22¾"
William A. Farnsworth Library and Art Museum,
Rockland, Maine. Gift of
Mr. and Mrs. J. Philip Walker, 1968

The Hamilton portraits were among a group Stuart painted after he had moved his family to the farm at Stillorgan. He commuted by horse or stagecoach to Dublin and worked with considerable speed to meet a growing demand.

George Hamilton

c. 1790. Oil on canvas, 48½ × 37"
William A. Farnsworth Library and Art Museum,
Rockland, Maine. Gift of
Mr. and Mrs. J. Philip Walker, 1968

As Baron of the Exchequer, Hamilton was an important member of the government establishment in Dublin during the Ascendancy.

chequer. He stands silhouetted against the spacious interior of the House of Commons, with its domed ceiling supported by an Ionic colonnade, all of which was removed when Parliament House became the Bank of Ireland at the beginning of the nineteenth century. Both the Grattan and the Foster portraits are impressive, but neither has the power of the Fitzgibbon. Stuart was not to achieve that level of controlled force in a full-length again until he painted Washington five years later.

Shortly after he completed these pictures, an unexpected event marked another turning point in his life. On a night journey from Dublin to Black Rock, the overloaded coach upset, and he discovered on reaching home that the pain in his right arm was the result of a broken bone. A local doctor set it, but the pain increased, inflammation set in, and the best medical advice was to amputate before the infection spread and killed him. Unable to work, in pain, and faced with the

A PRE-EMINENT FAME FOR IDENTITY

George Hamilton

The Right Honorable John Foster

1791. Oil on canvas, 83½ × 59⅞"
The Nelson-Atkins Museum of Art,
Kansas City, Missouri. Nelson Fund

The Speaker of the Irish House of Commons, Foster was a leading figure in the political world of his day.

loss of his painting arm, he fell into a depression deepened yet further by the reluctant recognition that his long-nourished hope of a triumphal return to London was a will-o'-the-wisp. Sir Joshua's death in 1792 marked the end of an era; the benevolent Benjamin West had succeeded him as president of the Royal Academy, and the brilliant and precocious Thomas Lawrence had been appointed Painter to the King. Not yet forty but feeling much older, Stuart doubted his ability to shine again in the changed artistic scene in London, even if he could find the means to go there.

His arm was saved by a young doctor, recently returned from study in Edinburgh, who recommended frequent treatments with cold spring water, which gradually eliminated the infection. He then prescribed exercise to restore strength to the arm. As the illness receded, Stuart's spirits began to rise, but he recognized that he was trapped. There would still be a period of time before he could hope to recover his old skill and control, yet the months of enforced idleness had plunged him deeper into debt than ever, though the move to Stillorgan and the intensive work schedule had brought his finances momentarily—perhaps for the only time in his life—under control. He saw that a Dublin career, because of its seasonal character, could never provide a consistent living. Deeply troubled, he considered his situation and pondered possible solutions as realistically as he could.

Ever since the Revolution had started there had been much talk in Ireland about events in America: the establishment of a constitution, the convening of the first Congress, and the election of an aristocrat as the first president of the new republic. Washington's background was similar to that of the Irish gentry: a gentleman of culture who lived off the fruits of his own estate. He was as much a hero in Ireland as he was among many of the Whigs in England.

Stuart kept busy. When Parliament was in session, he turned out rafts of half-finished portraits, but his heart was not in it, and the results varied greatly. His natural tolerance was increasingly disturbed by the hostility among Anglicans, Catholics, and Presbyterians. The disparity in privilege between the Anglo-Irish and the native Gaels became more painfully apparent. The desperation just beneath the surface of Irish society became more obvious. His assistant, James Dowling, noted his democratic attitude and that he seemed unimpressed and even sometimes contemptuous of social position, so significant in Irish society. An important decision was forming in his mind.

In the fall of 1792, he invited Dowling to spend a Sunday at Stillorgan. After getting off the coach at the inn at Black Rock, Dowling later recalled, "I walked up a narrow road,...and saw some very pretty pigs; it struck me, at one moment's view, that they belonged to Stuart, and that I could not be distant from his house. To try that I was right in my conjecture, I took up some little pebbles and threw them at them. They ran on, and I followed. They led me to a gate, into which they entered.... Before the house I saw Stuart tending some flower-pots.

"'Ha!' said he, 'you are come.'

"'Yes, please the pigs.' Then I told him how they led me. He was delighted....

74 A PRE-EMINENT FAME FOR IDENTITY

"'You shall taste pork of their kind, and you will acknowledge my plan to be a good one for feeding.'

"He then took me to his garden, which was well cropped, all by his own hands, walked me over his grounds, and pointed out his skill in farming. He valued himself more on these points than on painting. I candidly confessed . . . that I was ignorant of farming, gardening, or feeding of pigs. He pitied me very much, observing what a loss I sustained by not attending to the cultivation of that on which mankind were supported and rendered wealthy and powerful. We then got back to the house, and dinner was served. I ate of the apple-fed pork, and I was greatly pleased with it. I praised it, and he felt vain on the subject."

Stuart then confessed that he was deeply in debt.

"'Well, great patronage, then,' Dowling said, 'is less productive than I thought for; I have had, in my humble practice, but a moderate share of patronage, and I never incurred a debt of one pound.'

"'Well, I have to learn that art. . . . So silly am I, and so careless of keeping out of debt, it has cost me more to Bailiffs for my liberty than would pay the debt for which they were to arrest me. I confess my folly. . . . I am unwilling to be plucked by these vultures—the bailiffs.' "

Stuart then outlined his plans. After the new Parliament convened, "'I'll get some of my first sittings finished, and when I can get a sum sufficient to take me to America, I shall be off to my native soil. There I expect to make a fortune by Washington alone. . . . And if I shall be fortunate, I will repay my English and Irish creditors. To Ireland and England I shall bid adieu.'"

When Dowling expressed doubts about the honesty of leaving a lot of unfinished canvases, Stuart reassured him. "'The artists of Dublin will get employment in finishing them. You may reckon on making something handsome by it; and I shan't regret my default, when a friend is benefited by it in the end. The possessors will be well off. The likeness is there, and the finishing may be better than I should have made it.'" Dowling disapproved but did not give him away.

When Parliament reconvened in the winter of 1793, Stuart worked furiously and, stimulated by the excitement he felt over his plans for the future, worked faster and better than he had in months. But he was overtaken by events of far larger significance than anything going on in Dublin. In January, 1793, Louis XVI was guillotined, France under the Convention declared war on Britain, Spain, and Holland, and the old familiar world of Western Europe was washed away by the tidal wave of revolution. In France the Reign of Terror had begun.

Ireland was stunned. Desperate preparations were made for the invasion of the French, who, they feared, would rouse the Catholic populace to rebellion. Time and circumstance had overtaken Stuart. Swiftly, he prepared for departure. Finding a large ship named the *Draper* getting ready to sail—despite the season and the dangers of war—early in March, he gathered his family and, packing what possessions he could, along with painting materials and a portfolio of engravings, took ship. Dublin knew him no more.

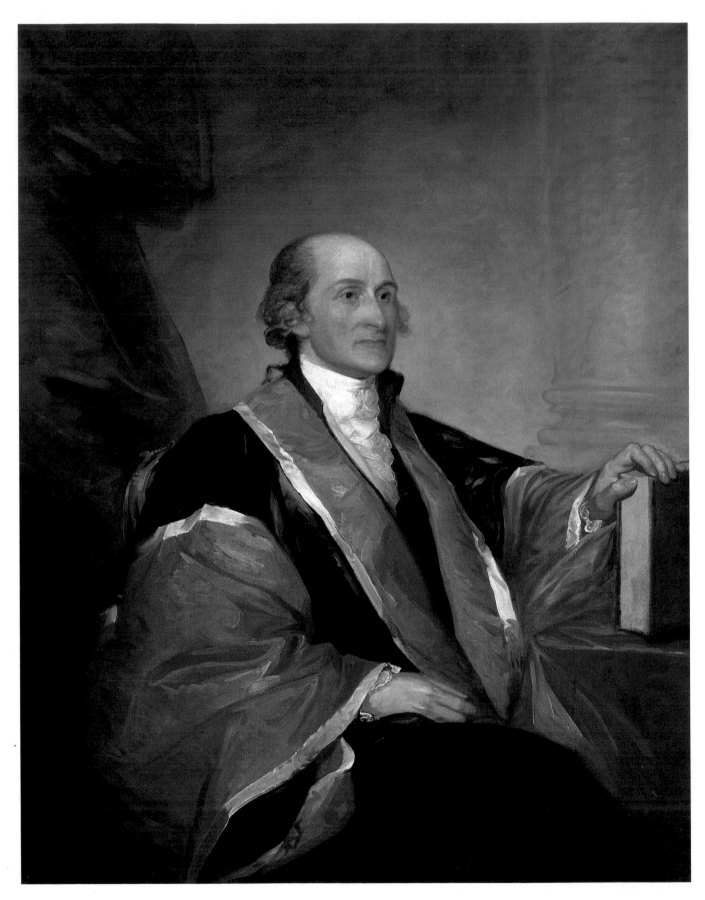

Chief Justice John Jay

VI. "I Expect to Make a Fortune"

THE VOYAGE SEEMED INTERMINABLE. The weather was foul and so was Stuart's temper. Cooped up in a cabin, he endured the nagging recognition that again he had failed. The experience was made yet more trying by the constant fear of attack by a French privateer bearing letters of marque or by a man-of-war. After almost eight weeks of plowing through the stormy seas of the North Atlantic, the ship made landfall, and as the *Draper* sailed up New York harbor amidst the clutter of local and coastal vessels, the Stuarts saw the town lying at the tip of Manhattan, a clustering of houses, none more than three stories high, the low skyline broken by an occasional church steeple. There were docks along the shore, crowded with shipping, and broken rows of warehouses nearby. Ten years earlier, New York had been left a burned-out ruin by the retreating British as they finally withdrew their occupation troops, but its industrious inhabitants had rebuilt, and it was now a prosperous and growing seaport. A great deal of history had been crowded into those ten years; they had seen Washington take the oath of office as the first president under the new constitution, and Old Federal Hall, on whose balcony the ceremony had taken place, briefly serve as the Capitol of the new nation. New York's population had tripled to reach about sixty thousand, and the town had already assumed the bustling and somewhat boisterous commercial character that it has maintained to this day. It was with gratitude and relief that the Stuarts stepped ashore just north of the Battery on the sixth of May, 1793.

Stuart found a world different from that which he had left almost twenty years before. A struggling but vigorous young republic had replaced the congeries of colonies he remembered. The old, leisurely patterns of life familiar to his colonial boyhood were gone, replaced by a sense of urgency and purpose. A new class with new leaders was in the ascendant. Almost all the connections through family or friends that Stuart may formerly have had were long since severed. He must have felt the differences strongly as he made his way through busy streets, thronging with people in a hurry: businessmen and lawyers, sailors and tradesmen, delivery boys and porters, and an occasional black, backwoodsman, or painted Indian—and not a sign of a beggar. His prospects seemed as bleak as the chill and blustery day on which he landed. Perhaps he was stimulated by the sense of change, for he acted with unaccustomed resolution. He found rooms for himself, Charlotte, and the children at 63 Stone Street, near what is now Chatham Square in New York's Chinatown, but was then a neighborhood of small

Chief Justice John Jay

1794. Oil on canvas, 51½ × 40⅛"
Department of State, Washington, D.C.

The first important portrait painted by Stuart after his return to America, this picture led to the famous Washington *portraits and successfully launched his American career.*

77

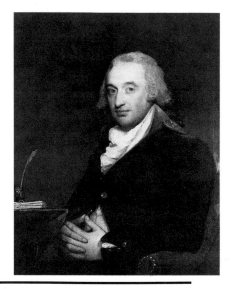

shops and residences. In the nearby color shop of William Barrow he was relieved to find canvas, pigments, oil, and turpentine. He arranged one room as a painting room and announced that he was prepared to paint portraits, a head and shoulders for fifty dollars, scarcely a third of his Dublin price.

In the meantime, he presented his few letters of introduction, mostly addressed to leading New York merchants, and soon sitters began to arrive at the house on Stone Street. Then, through a stroke of luck—or perhaps because of the threat of a yellow fever epidemic in Philadelphia, the seat of the federal government—Stuart found John Jay, the only member of the administration with whom he was acquainted, in New York. An architect of the constitution and Chief Justice of the Supreme Court, Jay had the president's confidence. Through him, Stuart hoped to reach Washington. Somehow Jay found time to sit for him briefly while Stuart painted his head from life. Peter Jay Munro, a nephew, wore his uncle's judicial robe for the necessary additional sittings. Jay's rather ascetic features are delicately but firmly modeled, his dark, deep-set eyes are focused, and his cool intellectuality further emphasized by the contrast of the broadly painted folds of the scarlet and black robe. There is the mere suggestion of a Grand Manner drapery and column in the background. Everything is concentrated on the head, which is placed very slightly left of center but balanced by the fact that it is turned to the viewer's right and by the vertical of the law book lightly held upright in the left hand. In most official portraits the sitter is painted because of the position he holds, and the accoutrements of rank are therefore emphasized. Here, Stuart has made clear that the portrait is primarily of John Jay, not of the Chief Justice.

"A smart attack of the fever and the ague," as Stuart wrote his uncle, Joseph Anthony, in Philadelphia, delayed not only his trip there but also his final work to complete the Jay portrait. But when the artist himself delivered it to Mrs. Jay, she was delighted. "It is your very self,…an inimitable picture," she wrote her hus-

I EXPECT TO MAKE A FORTUNE

band in London. It "hangs in the dining-room, where the little prints used to hang, and you cannot imagine how much I am gratified in having it." With this portrait Stuart demonstrated beyond any possible doubt that he was without peer in America.

The emphasis of the Jay portrait shows Stuart's ready adaptation to the facts of life in the United States. His merchant sitters and their wives wished to be painted with their own hands, not Van Dyck's. His own innate tendencies toward realism caused him to respond with greater factuality in representation. George Pollock, for instance, is shown with his hands clasped across his abdomen in a gesture that is totally convincing in its lack of elegance; he was interrupted at his desk and momentarily turned his attention to the painter. When confronted with old Petrus Stuyvesant, Stuart painted the golden waistcoat with a brilliant brush, contrasting it with a richly dark coat and snowy neckcloth, but the suspicious look in the narrow eyes and the thin-lipped, downturned mouth show all too clearly the character of the wealthy old burgher.

Faced with Mr. and Mrs. Richard Yates, Sir Joshua himself might well have quailed. With a proper wig, uniform, or modish suit of clothes, and with a dignified pose and genteel setting, Richard Yates could have been disguised in an acceptable British manner. But what to do with his wife? Mrs. Yates was thin to the point of being skeletal, and with her long, sharp nose she could never have been pretty, even in youth. Stuart showed her husband dressed for every day, husky body slightly hunched forward over his desk, holding a sheaf of papers and looking at us with a keen and alert gaze. He was not handsome, and Stuart made no effort to make him so; but straightforward, responsible, and vigorous he was, and the portrait shows it. With Mrs. Yates, Stuart performed a miracle. He gave her the same pose as that of Miss Dick in the double portrait he had painted just before leaving Ireland, *Miss Dick and Her Cousin, Miss Forster*, torso sideways with the left side foremost, head turned toward the viewer. Instead of giving her the willowy slimness of the young Miss Dick, Stuart transformed Mrs. Yates's thinness into a mature and spare elegance that is emphasized by the lovely textures of her dress and the slender hands so gracefully but practically occupied with sewing. The tall lace cap stresses the long, thin face, and her cool and appraising look, with the slight droop of the right eyelid, totally captures the viewer's attention. As Stuart observed to a friend, "In England my efforts were compared with those of Van Dyck, Titian, and other great painters—here they are compared with the works of the Almighty!" In such portraits as these he showed that he was equal to being judged by such a rigorous standard.

Stuart's contact with Jay bore fruit. The Chief Justice knew at firsthand of his reputation abroad, and he could understand his interest in painting Washington. In due time he informed the painter that the president had consented to sit for him that fall when he returned to Philadelphia for the convening of Congress. Meanwhile, Stuart was busy painting various members of the Jays' considerable circle of friends. The circle widened to take in such veteran heroes of the Revolution as General Matthew Clarkson, handsome and decisive in his buff-and-blue uniform; General Horatio Gates and Major-General Henry Dearborn;

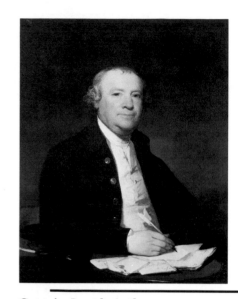

Captain Joseph Anthony

1793–94. Oil on canvas, 36 × 28"
National Gallery of Art, Washington, D.C.
Andrew W. Mellon Collection, 1942

One of several portraits of Stuart's uncle, a Philadelphia merchant and shipowner.

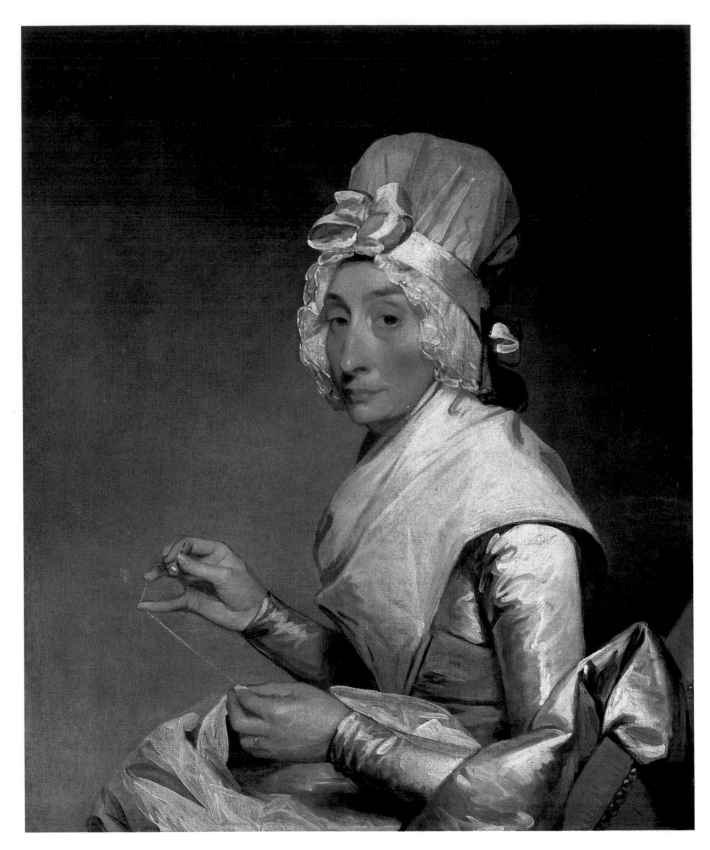

Mrs. Richard Yates

and such members of the old New York aristocracy as Stephen van Rensselaer, General Peter Gansevoort, Chancellor Robert R. Livingston, Judge William Cooper of Cooperstown, father of the novelist, and the Reverend John Henry Livingston, president of Queen's College, now Rutgers University. To this period also belongs the penetrating portrait of Dr. William Samuel Johnson, who had studied divinity at Yale and law at Harvard, and was the distinguished president of Columbia. He sat for Stuart in the colorful gown of an Oxford Doctor of Civil Law, which the artist rendered with a breadth and dash appropriate to a subject known for his keenness of intellect and as one of the most brilliant orators of his age.

Stuart eagerly awaited word from Washington that he should proceed to Philadelphia, but the appointment was delayed by insurrection in western Pennsylvania. And there were problems with Spain, France, and England that sent the much-respected Chief Justice back to London and brought an arrogant, shifty little Spanish envoy, Don Josef de Jaudenes y Nebot, to America, where he wooed and won the sixteen-year-old doe-eyed daughter of "Don Juan" Stoughton, the rich Boston merchant who was Spanish consul there for many years. During their visit to New York, the newlyweds sat for their portraits, remarkable examples of the mature virtuosity that Stuart achieved in America. All Rococo color and shimmering grace, the portraits are the personification of aristocratic elegance, the sitters looking—as Mrs. Gabriel Manigault noted in her diary after meeting them at a reception at Mrs. Jay's—"as fine as little dolls."

It was not until late in the winter of 1795 that Stuart received word from Washington, and in March he left New York for Philadelphia. On his arrival he went to the modest row house where the president was living, left his card and letter of introduction from John Jay, and awaited an appointment. He was amazed to receive a note from Washington's secretary, Bartholomew Dandridge, at his lodgings later in the day, with an invitation for that very evening. It was one of Mrs. Washington's Friday receptions, when she and the president entertained as private citizens, and could, without observing protocol, mix with their guests, who might include foreign visitors as well as visiting Americans, Philadelphians, and members of the government. Taken aback by an informality to which he was totally unused, Stuart was surprised when the president introduced himself. He was also impressed by Washington's friendly but reserved manner and his unself-conscious dignity. Stuart had met King George and Queen Charlotte, prime ministers, peers, admirals, and generals, but he had never met a man like this. At the sittings that soon followed, he translated that awe into a powerful image.

He posed the president looking directly at him, his head turned slightly to his left, with the light falling so that the left side of the head was softened by shadow. As he studied the face before him, Stuart saw "features...totally different from what I had observed in any other human being. The sockets of the eyes, for instance, were larger than what I had ever met with before, and the upper part of the nose broader. All his features were indicative of the strongest passions; yet, like Socrates his judgment and self-command made him appear a man of differ-

Richard Yates

1793–94. Oil on canvas, 32¼ × 27⅜"
National Gallery of Art, Washington, D.C.
Andrew W. Mellon Collection, 1942

Yates was a New York merchant. His portrait, among the first that Stuart painted after his arrival in America, shows the directness and simplicity that characterize the artist's American works.

Mrs. Richard Yates

1793–94. Oil on canvas, 30¼ × 25"
National Gallery of Art, Washington, D.C.
Andrew W. Mellon Collection

Born of a Dutch family in New York, Catherine Bras married Richard Yates, senior partner of the firm of Yates & Pollock, importers of European and East Indian goods.

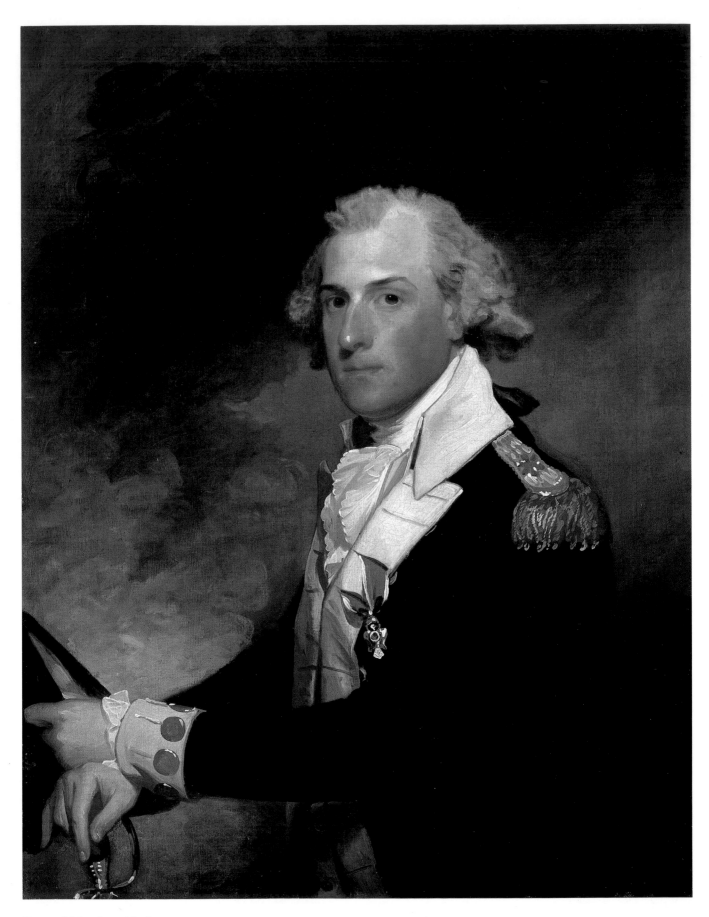

General Matthew Clarkson

ent cast in the eyes of the world." But as he studied his subject, "an apathy seemed to seize him, and a vacuity spread over his countenance most appalling to paint." The trouble was that Washington hated to sit for his portrait. "I am so hackneyed to the touches of the painter's pencil," he complained, "that I am now altogether at their beck, and sit like Patience on a monument, whilst they are delineating the lines of my face."

Many of Stuart's sitters remarked on the amusement afforded by his patter, as he put them at their ease with humorous and, more often than not, tall stories. He endeavored to discover their interests so that their faces were animated by the conversation, and he could record the personality rather than merely an outward appearance. Waterhouse tells us that his usual approach when painting the great was to speak "to military men . . . of battles by sea and land, with statesmen on Hume's and Gibbon's histories; with the lawyer on jurisprudence or remarkable criminal trials. . . . He had wit at will, always ample, sometimes redundant," and, one fears, in the case of Washington, it proved redundant, because the president remained, as he himself described it, "in so grave, so sullen a mood, and now and then under the influence of Morpheus." It was only when Stuart spoke of farming—perhaps he mentioned his experiments with apple-fed pigs—and of horses that the president's features came suddenly alive, and it is highly likely that the sittings for this first—which many consider his greatest— presidential portrait were conducted with long periods of silence while Stuart worked with intense concentration and his subject sat with impregnable dignity. Struck by the lack of ostentation in Washington's attire, Stuart painted him in a black coat, relieved only by the immaculate white of the neckcloth and ruffle, and against a reddish background dark enough to throw the head into relief. How deeply he was impressed by his sitter is expressed in the resulting portrait, with its fresh complexion—"as fair as a girl of seventeen," as Elizabeth Parke Custis, Mrs. Washington's eldest granddaughter, described it—its soberness to the point of severity, and a reserve that suggests the exercise of a heroic will.

Stuart was not entirely satisfied with the picture. He seems to have felt somewhat defeated by his inability to penetrate Washington's monumental reticence and his failure "to elicit the expression he knew must accord with such features and such a man." History, however, has decided otherwise. The evidence of the painting itself proves that he produced it with the swiftness, sureness of touch and tint, and immediacy of his finest works. His instinctive rightness of approach, in showing just the head, without hands, setting, or accessory, is a major reason for its effectiveness. Nothing intrudes to vitiate the extraordinarily controlled power and intensity of the image. Without his knowing it, he had created an icon.

Word got around in Philadelphia that Stuart was painting the president, and there was a growing curiosity to see the result of his efforts. Most unusually, therefore, he arranged for its public exhibition, and, according to the account of George Washington Parke Custis, Mrs. Washington's grandson, who lived with the presidential family, it created a sensation. Though a few found minor fault with the accuracy of details, the many, including the president's old friends,

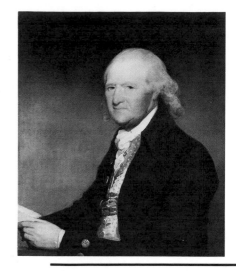

Petrus Stuyvesant

1793–95. Oil on canvas, 30 × 25"
New-York Historical Society, New York City

Stuyvesant was a prominent New Yorker and a descendant of Peter Stuyvesant, the Dutch governor of New Amsterdam.

General Matthew Clarkson

c. 1794. Oil on canvas, 36⅛ × 28¼"
The Metropolitan Museum of Art, New York City
Bequest of Helen Shelton Clarkson, 1938

General Clarkson served brilliantly in the Revolution. Stuart shows him in uniform with the Order of the Cincinnati. A regent of the University of the State of New York and governor of the New York Hospital, he devoted his life to public service.

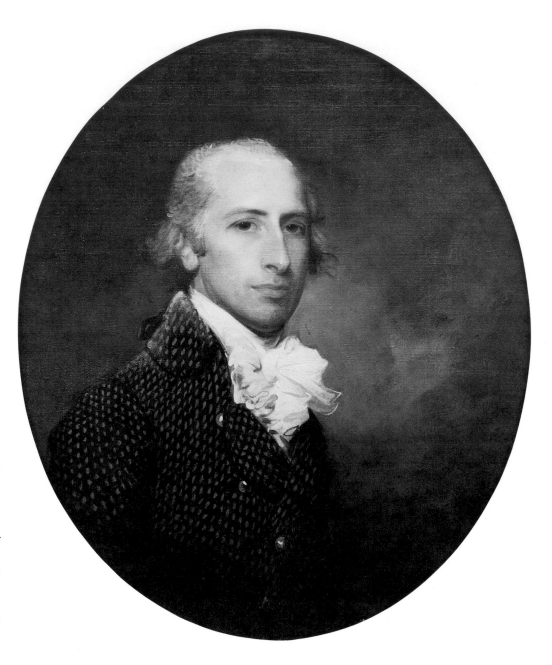

Gabriel Manigault

1794. Oil on canvas, 30 × 25"
Albright-Knox Art Gallery, Buffalo
James G. Forsyth Fund, 1923

A leading citizen of Charleston, South Carolina, Manigault ran the New York office of his family's shipping business. Of this portrait, one of several Stuart painted of him, he wrote, "I am not altogether pleased about the coat.... (I think a spotted coat too youthful.) But it is Stuart's choice, and I promised him that I would leave everything to him."

found it a compelling likeness. It was Stuart's greatest triumph, and he received dozens of orders for replicas from admirers on both sides of the Atlantic, including his old master, Benjamin West; the marquis of Lansdowne, formerly the earl of Shelburne; Don Josef de Jaudenes y Nebot, who wanted five, a request no doubt disregarded by Stuart because the Spaniard was notorious for not paying his bills; Viscount Cremorne, who, as Lord Dartrey, had been painted by Stuart in London; John Jay; Colonel Aaron Burr of New York; and a number of others, among whom were several of Washington's old friends and fellow veterans of the Revolution.

Though Stuart in his last years claimed to have "rubbed out" the original portrait from life, there is every reason to believe that this is untrue, and that the likeness taken in Philadelphia in 1795, and not a replica of it, was sold to the

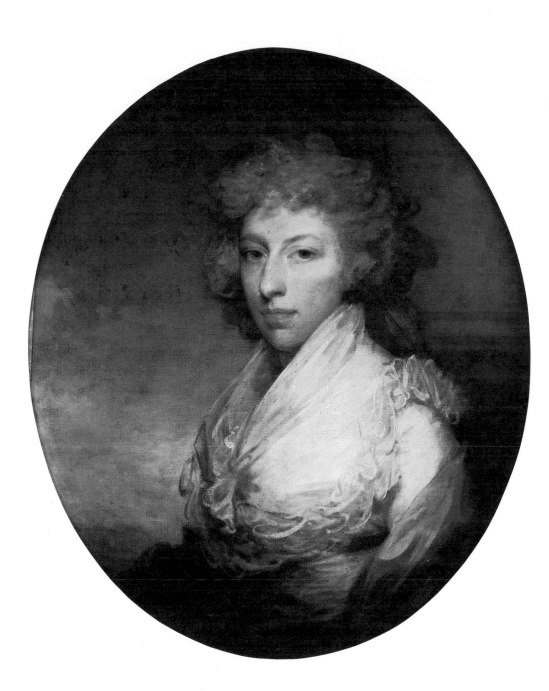

Mrs. Gabriel Manigault

1794. Oil on canvas, 30¼×25¼″
Albright-Knox Art Gallery, Buffalo
James G. Forsyth Fund, 1923

Margaret de Long Izard Manigault kept a delightfully gossipy diary.

American merchant Samuel Vaughan, who lived in London. Of the several versions extant of the Vaughan type, as it has come to be called, this picture seems the most likely original and is generally so considered. Vaughan was an interesting personality, a friend of Lansdowne, Dr. Joseph Priestley, Benjamin Franklin, and other leading personages, and a man of varied and intellectual concerns. He was a friend and admirer of Washington, whom he visited at Mount Vernon, and he presented to the president the carved marble mantelpiece that can still be seen in the drawing room there. Family tradition has it that Vaughan acquired the portrait directly from Stuart, and that it was inherited by his second son, William, who lived on in the London house until he died at the age of ninety-eight. The house and its contents were inherited in turn by William's nephew, Petty Vaughan, who had been given a family name of Lord Shelburne's for friend-

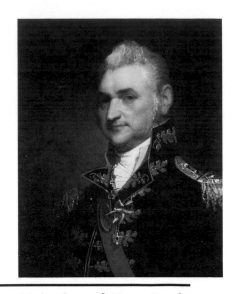

Major-General Henry Dearborn

1811–12. Oil on canvas, 28³⁄₁₆ × 22¾″
The Art Institute of Chicago
Friends of American Art Gift

General Dearborn served in the Revolution and the War of 1812. As secretary of war, several frontier posts were named after him.

George Washington

1795. Oil on canvas, 29 × 23¾″
National Gallery of Art, Washington, D.C.
Andrew W. Mellon Collection

The first of the two portraits of Washington that Stuart painted from life, this is called the "Vaughan Washington" because it was owned by an American resident of London, Samuel Vaughan, a friend and admirer of the first president. The artist made many replicas of this portrait, and his daughter Jane made numerous copies.

ship's sake. Petty Vaughan died only two years later, whereupon, in the words of a descendant and biographer of Samuel Vaughan, "a rascally manservant then sold this portrait along with many other furnishings and after going through several hands it is now at the National Gallery in Washington, labelled 'The Vaughan Washington.' "

Because of the resounding success of the first Washington, Stuart decided to stay in Philadelphia. It was not only the capital—and he had learned from experience that that was where sitters were to be found—but it was also the nation's cultural center. The demand for replicas of the *Washington* was overwhelming, and there were floods of other commissions also. He rented a house at Chestnut and Fifth streets, went to New York to fetch his family, and returned as fast as possible to keep up with the many sitters awaiting his attention. Stuart had first met John Vanderlyn in Barrow's color shop in New York, and he had encouraged the young man to pursue a career as a painter. Vanderlyn was now a protégé of Aaron Burr's, but he moved to Philadelphia to assist in the production of the replicas of the *Washington* by grinding colors, preparing canvases, and carrying out other such tasks, while a procession of sitters continued to pass through his painting rooms.

Stuart enjoyed the lively social life of Philadelphia, especially the lavish hospitality of William Bingham, an ambitious land speculator, politician, international banker, and assiduous opportunist, whose primary asset was an exceedingly beautiful and charming wife. Years earlier in London Stuart, angry at something he considered a slight, had abandoned a portrait of the Bingham family. But in view of Stuart's position as an undisputed leader in the arts in America, Bingham found it easy to forget the matter, as he had conceived a plan for which he wanted Stuart's assistance. Through Mrs. Bingham, he commissioned a half-length of the president, seated in the manner so successful in Stuart's *John Jay*, engravings after which were then selling in numbers in Philadelphia as well as in London. And only the delightful Mrs. Bingham could have persuaded the aging president to undergo the hated ordeal of sitting again for his portrait.

When Washington arrived, at nine o'clock on the morning of April 12, 1796, at the Chestnut Street house for his first sitting, Charlotte Stuart caught a glimpse of him that indelibly impressed itself on her memory. As her daughter Jane recorded it many years later, "She saw him as he entered the hall door, when she was passing from the entry into the parlour, and she thought him the most superb looking person she had ever seen. He was then dressed in black velvet with white lace ruffles, exactly as Stuart's picture represents him." She treasured that momentary vision for the rest of her life.

Courteously, the president sat as Stuart directed, showing this time the left side of his face, and the artist began laying in the major forms of the head on the canvas, noting with sympathy that his subject had aged since the last sitting, that he had a new set of false teeth that obviously bothered him and changed the shape of his mouth, and that he had grown longer sideburns. Probably at Stuart's suggestion, and surely with his subject's approval, a series of visitors enlivened

I EXPECT TO MAKE A FORTUNE

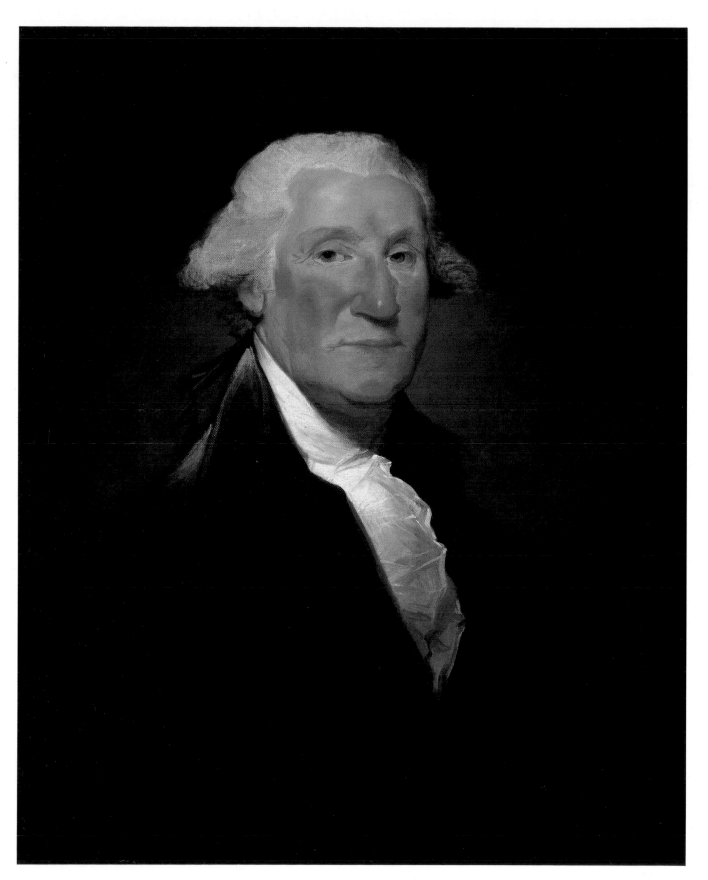

George Washington

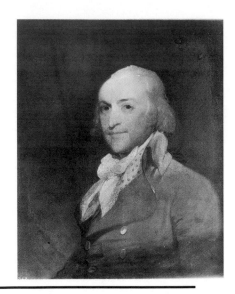

John Jacob Astor

1794. Oil on canvas, 30 × 25"
Private collection

A German immigrant who made a vast fortune in the fur trade, Astor was a leading citizen of New York.

the sittings: General Henry Knox and General Henry Lee, old companions in arms; Betsy Custis, lively and charming, with various of her friends; and, occasionally, Mrs. Washington herself.

During three sittings, Stuart realized the head in strong relief against a section of darker-toned background, but with a considerable expanse of canvas left bare. A companion portrait of Mrs. Washington was brought to a similar degree of incompletion. The two most renowned portraits in America were to remain unfinished. They are known as the Athenaeum Portraits because, after the artist's death, they were purchased by the Boston Athenaeum from Stuart's estate, as much as a means of making a contribution to his widow and surviving children—who had been left with little at his death—as for the importance of the paintings.

Stuart's success proved something of a burden as well as an encouragement. All Philadelphia seemed to be trooping through the house to see the Washington portraits. Unfinished though they were, the likenesses were striking, and many who came to look stayed to sit for their own. Stuart's wit and gift of gab kept them amused, somewhat to his own detriment, because it encouraged fashionable idlers and hangers-on. When William Bingham saw the portraits, he was sufficiently impressed to decide that he wanted a full-length of Washington instead of the half-length originally ordered. With this major commission, the painter felt that he could afford to move to less expensive quarters, less centrally located. The move should eliminate the curious and yet, he hoped, not discourage those who wanted likenesses taken. He rented a comfortable, old-fashioned house in the suburb of Germantown, a village of solid stone houses, ancient trees, and green lawns. In the rear were outbuildings, including a barn, which he adapted as a studio. There he had room enough to tackle the still-daunting project of a life-size, full-length portrait.

From the beginning the concept was that of an official portrait: Washington as president rather than as a military leader or as a private citizen. Stuart's *Washington* as military hero came later, after he had moved to Boston. Referring to his portfolio of engravings, he posed the president with his whole figure facing slightly to the viewer's left, feet planted somewhat apart, weight evenly distributed, right hand outstretched in a variation on a mirror image of the Foster portrait, and with the left hand at his side, holding a sword. Massive columns and heavy drapery against a limpid sky appear in the background. Several critics have found the sources of these elements in specific paintings by Renaissance and Baroque masters. Though this may well be true, and the method is entirely consistent with artistic practice of the day, Stuart has sufficiently transformed them so that they suit the mood of quiet dignity he sought as appropriate to the subject. The draperies in the Baroque portraits billow and undulate, but Stuart's are at rest. There is no uneasy wind blowing through his colonnade. Where the Baroque poses seem momentary, as if in nervous transition, Stuart's figure is as still as a statue. Because of the low viewpoint of the perspective he used, and the scale of the furniture and objects, the president looms majestically at what seems larger-than-life-size. The sobriety of his costume is emphasized by the rich tones

I EXPECT TO MAKE A FORTUNE

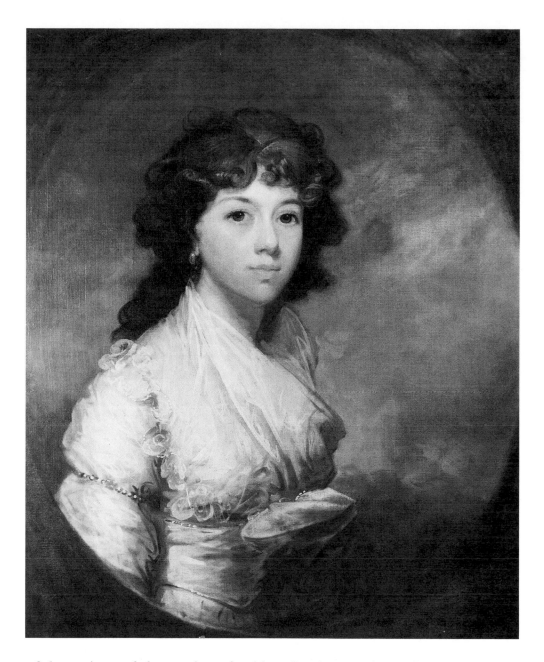

FOLLOWING PAGE

Anne Izard

1794. Oil on canvas, 30 × 25⅛"

The younger sister of Mrs. Gabriel Manigault, Anne was painted when she was fourteen. Unfortunately, this portrait, the gift of Governor and Mrs. Averell Harriman to the Albany Institute of History and Art, was destroyed in 1961 by a fire in the executive mansion, where it was on loan.

Matilda Stoughton de Jaudenes y Nebot

1794. Oil on canvas, 50⅝ × 39½"
The Metropolitan Museum of Art, New York City
Rogers Fund, 1907

The daughter of the Spanish consul in Boston—an American merchant called "Don Juan" Stoughton because of the consulship—Matilda Stoughton was married at sixteen. In their Grand Manner panache, Stuart's portraits of her and her husband are unique among his American works. The coats of arms and inscriptions were added later in Spain.

of the setting and the touches of gold on furniture and sword. Stuart worked slowly on the enormous canvas, seeking gradually to integrate its various parts in an organized whole.

In the meantime, the procession of sitters continued, and he worked steadily, producing such outstanding pictures as that of the beautiful Ann Penn Allen, the granddaughter of Benjamin West's early patron, with its fascinating blue accents; the painter's cousin, Joseph Anthony, Jr., an outstanding Philadelphia silversmith, and his attractive wife; Elizabeth Parke Custis, caught in the informal, folded-arms pose with which, it is said, she watched Stuart paint the president; and William Kerin Constable, an Irish-born New York merchant and shipowner who was active in the China trade. The nineteenth-century artist Henry Inman judged the Constable portrait "the finest portrait ever painted by the hand of man." Constable himself was not only pleased with his own portrait, but was also

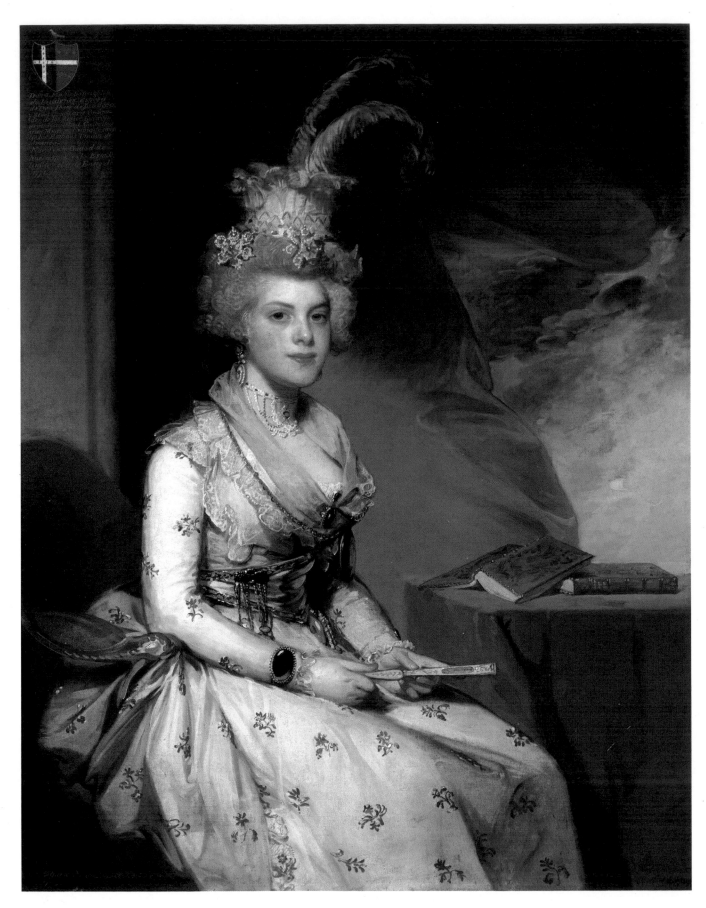

Matilda Stoughton de Jaudenes y Nebot

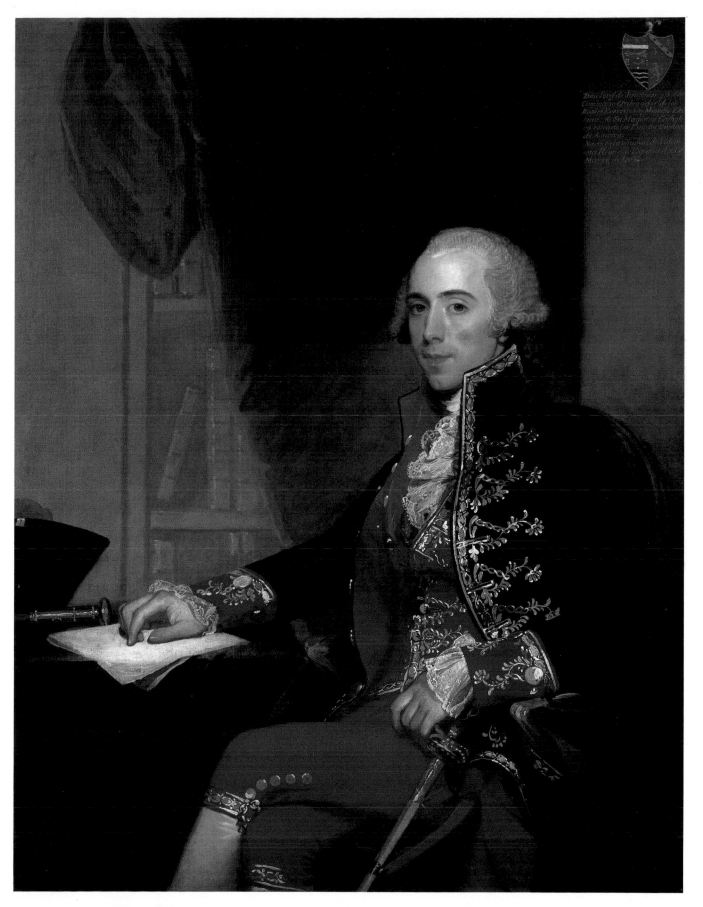

Don Josef de Jaudenes y Nebot

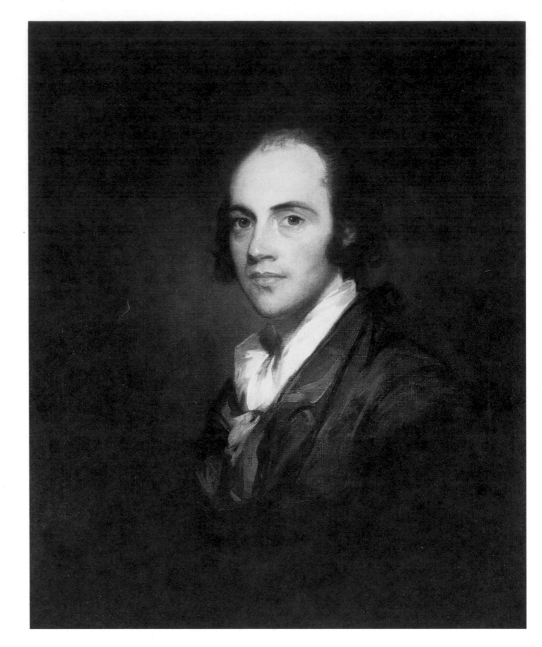

Aaron Burr

c. 1794. Oil on canvas, 30¼ × 25″
New Jersey Historical Society, Newark
Gift of David A. Hays for John Chetwood

The portrait was made when Burr was a brilliant young lawyer and rising New York politician—before he gained notoriety by killing Alexander Hamilton in a duel in 1804.

PRECEDING PAGE

Don Josef
de Jaudenes y Nebot

1794. Oil on canvas, 50¼ × 39½″
The Metropolitan Museum of Art, New York City
Rogers Fund, 1907

A native of Valencia, Don Josef came to America as Spanish chargé d'affaires in 1791; three years later he married Louisa Carolina Matilda Stoughton. In 1796, after living luxuriously in a fine house in Philadelphia, the couple retired to his estates on Majorca.

sufficiently impressed with the half-finished full-length of Washington to commission one like it, asking that Stuart work on both simultaneously so that both might equally be originals.

With great concentration, Stuart carried on the now dual project, aware that he had reached such a degree of fame that he could command the same kind of fees that Sir Joshua Reynolds had received at the height of his career. The gleaming metal of the Vicomte de Noailles's sword—he had been on Lafayette's staff at Yorktown—given to Stuart for the occasion, and the silver inkwell and other objects on the table are brilliant still-life details. The Ushak Anatolian carpet on the floor adds further richness. Though there is a touch of stiffness about the figure, the effect of the whole is impressive, and the president has great presence. America had never seen anything like it, and it was greeted with enthusiasm and profound respect.

I EXPECT TO MAKE A FORTUNE

Thomas Birch
*Delaware River Front,
Philadelphia*

Early 19th century
Watercolor, 10⅛ × 13⅞"
Museum of Fine Arts, Boston
M. and M. Karolik Collection

*When Stuart lived there, Philadelphia
was not only the nation's capital but also
its business and cultural center and a
thriving seaport. Despite its Quaker heri-
tage, the city impressed John Adams with
the spaciousness and elegance of many of
its houses and the formality and sophisti-
cation of its social life. Birch (1779–
1851) was a painter of landscapes and
city scenes.*

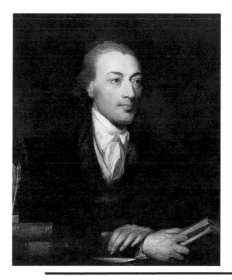

Constantine François Volney

c. 1795. Oil on canvas, 29 × 23"
Pennsylvania Academy of the Fine Arts,
Philadelphia. Gift of Mrs. Thomas Bayard

*Volney was an early explorer of the Near
East, and his poem* Ruins, A Medita-
tion on Revolutions and Empires *was
an important work of the Romantic move-
ment. He found refuge from the French
Revolution near Philadelphia.*

Again Senator Bingham came into the picture. As delighted with his paint-
ing as Constable was with his, Bingham decided that he wanted to order another
as a present to Lord Lansdowne. It was a somewhat unexpected notion, since
Lansdowne was not a friend of Bingham's, though they had briefly met and cor-
responded. When Stuart, who knew Lord Lansdowne, pointed out that the mar-
quis might take umbrage at becoming obligated to an acquaintance, Bingham
suggested that the gift should come from his wife instead. So Stuart painted a
third version, "executed . . . with a great deal of enthusiasm and in his best man-
ner," as Bingham wrote Rufus King, the American minister to England, to whom
it was consigned for forwarding to Lord Lansdowne in the fall of 1796. Since it
was painted in a steady progression instead of being, like the first two, left from
time to time and then taken up again, it has a slightly greater degree of coherence
and unity of tone and atmosphere. Stuart was pleased, and recognizing the po-
tentially great income to be derived from the sale of a good engraving made from
it, he instructed Mrs. Bingham, who made all the arrangements regarding the
picture for herself and her husband, that he reserved the engraving rights, and
that Lansdowne should be so informed. He then wrote to Benjamin West to ask
him to have the engraving properly made.

Early in the new year came news about the Lansdowne *Washington.* The
marquis was delighted and so were the London critics. *The Oracle and Public Ad-
vertiser* for May 15, 1797, called it "one of the finest pictures we have ever seen
since the death of Reynolds. Stuart painted it, who, if he had done nothing more,
established a first-rate fame by his picture of Kemble." The critic described the
president's appearance and the picture's various details. "The Marquis of Lans-
downe is exceedingly flattered by the present," the writer went on, "and Lord

Martha Washington

1796. Oil on canvas, 48 × 37″
Museum of Fine Arts, Boston,
and The National Portrait Gallery,
Smithsonian Institution, Washington, D.C.

This portrait and the one opposite, painted
at the same time, were left unfinished so
that Stuart could keep them as the basis for
further replicas, which provided a major
part of his income for many years.

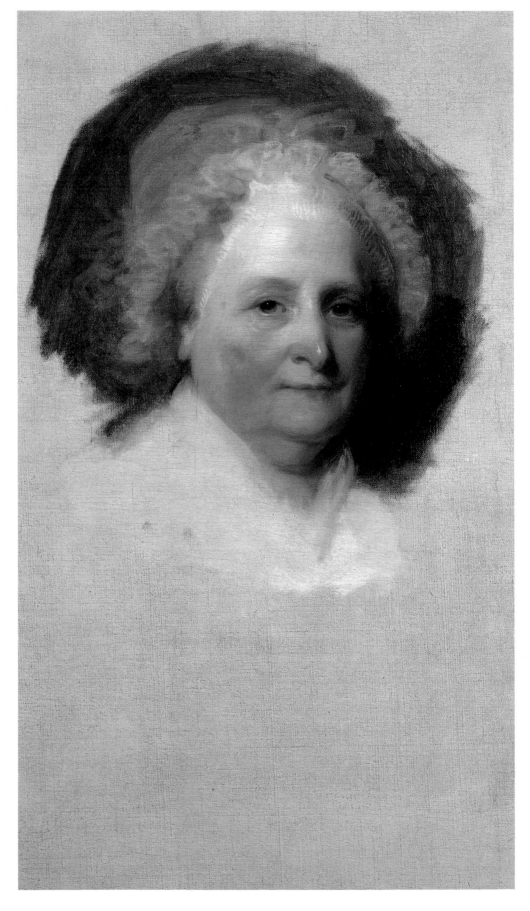

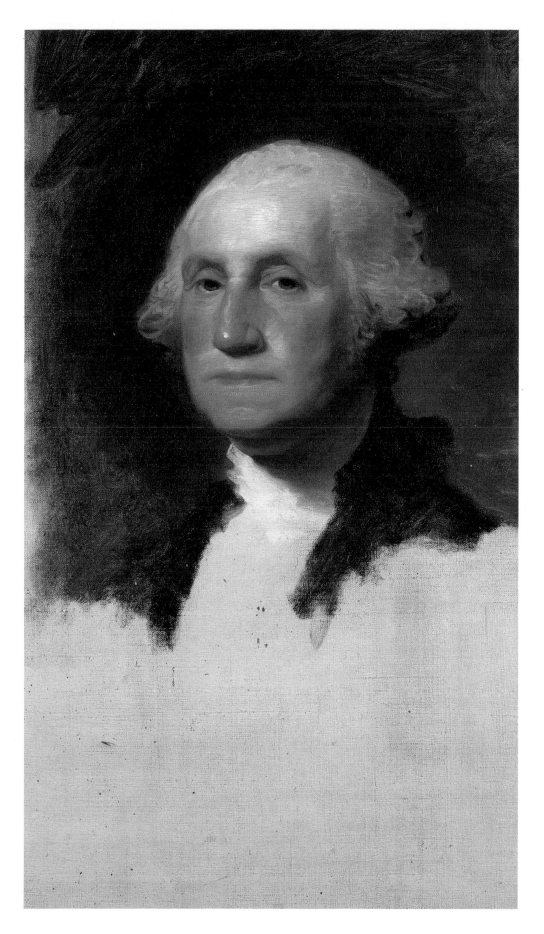

George Washington

1796. Oil on canvas, 39⅝ × 34½″
Museum of Fine Arts, Boston, and
The National Portrait Gallery, Smithsonian
Institution, Washington, D.C.

The second of Stuart's two life portraits of the first president, this is known as the "Athenaeum Washington" because it was purchased just after the artist's death by the Boston Athenaeum. It was left unfinished so that Stuart could keep it as the basis for further replicas, which provided a major part of his income for many years.

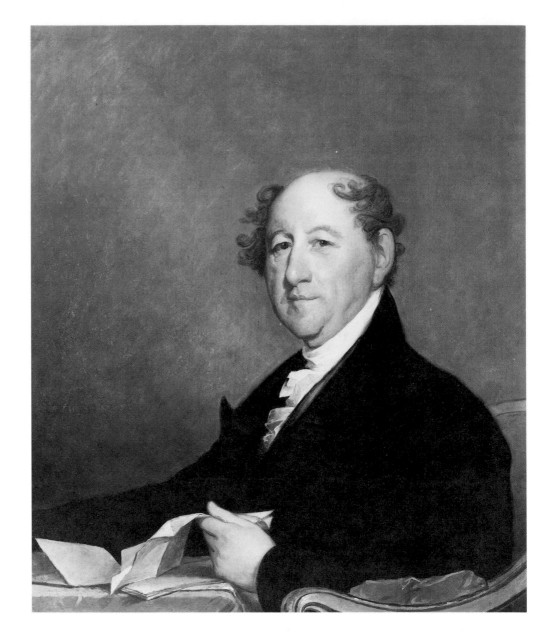

Rufus King

1820. Oil on panel, 36½ × 28¼"
Museum of the City of New York

Rufus King, older half brother of the passionate Jeffersonian William King, was a staunch Federalist. As the United States minister to the Court of St. James's, he delivered Stuart's full-length of Washington, the gift of Senator Bingham, to the marquis of Lansdowne.

Wycombe [Lansdowne's eldest son who had been a guest at Mount Vernon] has assured him of its perfect resemblance.... The liberality of his Lordship has consigned it to the graver, but we cannot resist the pleasure of describing the effect which the picture produced upon us. It is at his Lordship's house in Berkeley Square," where it was hung, amid classical sculptures and paintings by Rubens, Claude Lorrain, and other old masters, in a place of honor in the great library of Lansdowne House.

When Stuart received the news of "the liberality of his Lordship" having "consigned it to the graver," he was deeply distressed. He had not heard from West, so he turned to Bingham, who, instead of writing to Lansdowne, wrote instead to Rufus King, merely telling him of Stuart's fears rather than asking assistance on his behalf. The result is to be expected. When poring over a new shipment of engravings just arrived from London at a bookstore in Philadelphia, Stuart came upon one of the Lansdowne *Washington* made by James Heath, the

I EXPECT TO MAKE A FORTUNE

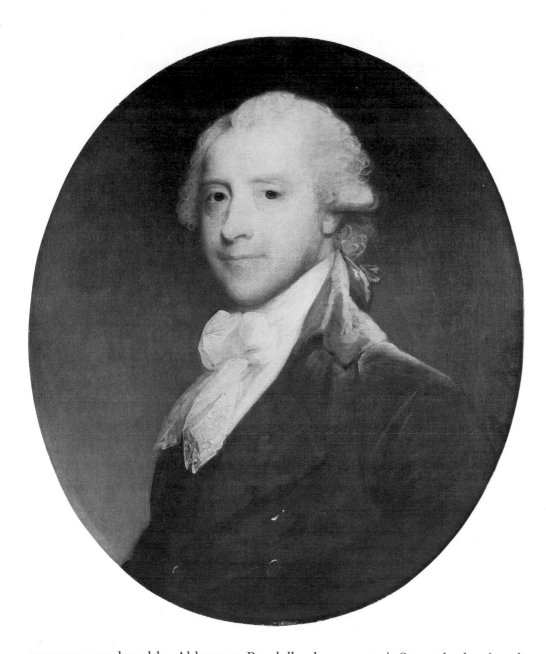

engraver employed by Alderman Boydell, whose portrait Stuart had painted several years earlier. It was not only done after his picture, and without his permission, but was poorly executed as well, being far below Heath's usual standard. He had become notorious in recent years for delegating work to assistants to increase his production and thus his sales. Stuart was furious, hurt, and outraged. He protested to Bingham and received no satisfaction. He wrote to Lansdowne, getting no answer as far as we know, and early in the summer of 1800 he ran a long advertisement in the Philadelphia *Aurora* announcing his own engraving after the *Washington*, "executed upon a large scale by an eminent artist," and that "engravings of his portraits of the president and vice-president [Adams and Jefferson] are likewise preparing under his immediate direction and will be published in the course of a few weeks."

In the meantime, the pirated print sold in enormous numbers. Washington's sudden death in December, 1799, had left a tremendous void. Though dur-

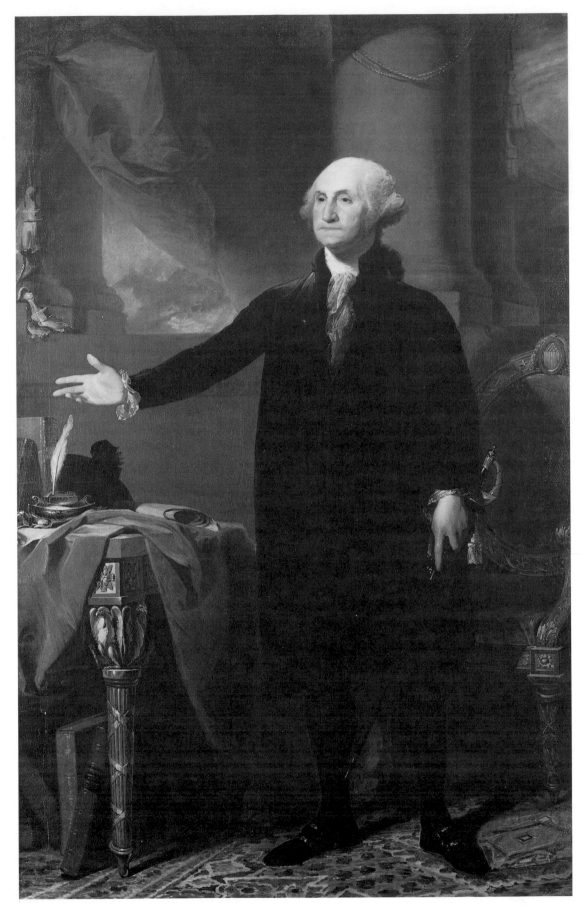

George Washington

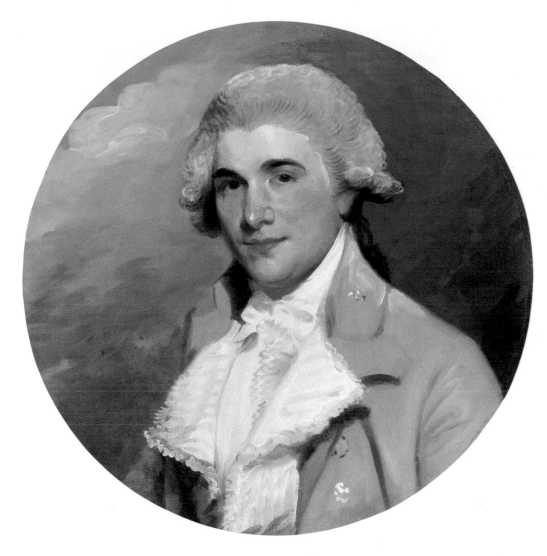

James Heath

1783–84. Oil on canvas, 23 × 27", matted oval
Wadsworth Atheneum, Hartford
Gift of Samuel P. Avery

*Heath was a leading London engraver
who produced many plates for Alderman
Boydell and others, after works of the ma-
jor painters of the period.*

ing his last years, political opponents had reviled him in a disturbing anticipation of the yellow journalism of more recent times, he had nevertheless represented to the overwhelming majority of his countrymen continuity in a swiftly changing world. His presence had seemed to guarantee the maintenance of the union and the future of the republic. One can imagine Stuart's frustration and ire as demand for icons of the departed president became more insistent and widespread.

Despite this disruptive event, Stuart was working on the commission he had received from General Charles Cotesworth Pinckney, newly appointed minister to France, for another full-length to be presented to the French Directory. After Pinckney had been refused recognition by the Directory in an unprecedented diplomatic insult, the finished replica, paid for by the government because of its official destination, appropriately became a part of the collection of the White House. It was rescued by a determined Dolley Madison at the time of the War of 1812 and thus saved from being burned by the British invaders. It was returned to the White House, where it has remained.

At the same time Stuart was busy with other portraits, among them those of Sir Robert and Lady Liston, the popular British minister and his wife. They were

George Washington

1796. Oil on canvas, 96¼ × 60¼"
Pennsylvania Academy of the Fine Arts,
Philadelphia. Bequest of William Bingham

*Painted for William Bingham of Phila-
delphia, this is the first of several versions,
the best known being the "Lansdowne
Washington," so called because it was
sent as Bingham's gift to the marquis of
Lansdowne. It is now on loan to the Na-
tional Portrait Gallery, Washington. An-
other version is in the White House.*

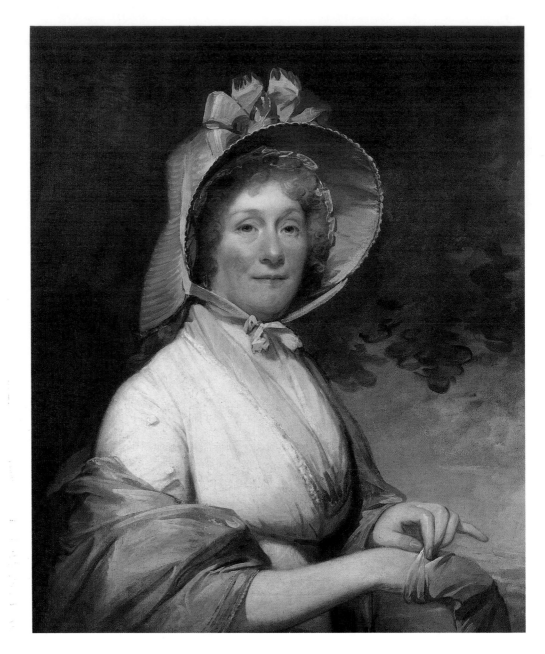

Mrs. Robert Liston

c. 1800. Oil on canvas, 29⅛ × 24⅛″
National Gallery of Art, Washington, D.C.
Gift of Chester Dale, 1960

Lady Liston was delighted with the portraits: "The pictures, for they really are pictures as well as portraits, are nearly finished," she wrote in October of that year.

great admirers of Washington, at whose farewell reception Lady Liston had wept unashamedly, along with many others. Horace Binney's portrait was also painted at about this time, perhaps to repay him for legal advice when Stuart wished to enjoin the sale of portraits of the late president, which were painted on glass and imported from China. Binney was a lively and interesting young man who enjoyed Stuart's company.

Requests for full-length replicas continued to come in, from various state governments as well as from private individuals. Put on his mettle by the unhappy circumstance of the pirated engraving and the subsequent free-for-all as all sorts of people endeavored to cash in on the demand for Washington portraits, Stuart radically rethought his formula. He posed the figure differently: with the feet close together, it seemed more upright and poised. He subtly al-

I EXPECT TO MAKE A FORTUNE

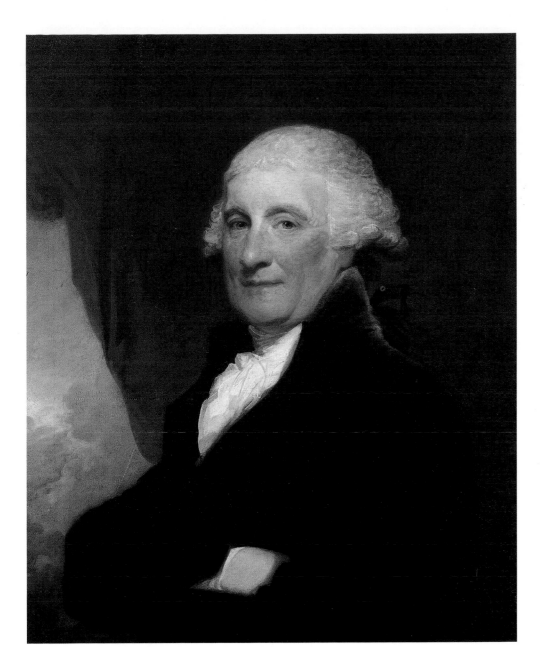

Robert Liston

c. 1800. Oil on canvas, 29¼ × 24⅛"
National Gallery of Art, Washington, D.C.
Gift of Chester Dale, 1957

Liston was the popular British minister to the United States during Washington's administration. After the first president's retirement from public life, the Listons returned to London. This portrait and his wife's were shipped to England and then to his house in Scotland, where their authorship was completely forgotten for many years before they were rediscovered and properly identified.

tered the proportion of the subject to the picture field. The left hand holds the sword less obtrusively, the right rests on a copy of the Constitution, which is partly unrolled on the table. The handsome still-life details on the tabletop and of the books beneath it are still there, but more deftly subordinated to the whole. The background drapery reveals more sky, and the president stands on a marble floor derived from Rigaud's *Bossuet*, by way of the ever-useful engraving by Drevet that Benjamin West had introduced Stuart to so many years before.

The Empire-style table and chair are still there, as in the earlier versions, but the composition is more controlled in terms of light and dark, which are manipulated expertly to provide a compositional coherence and emotional expression less completely realized in the previous renderings. Here the president looks directly out at the viewer, as in the Athenaeum portrait, on which the head is based.

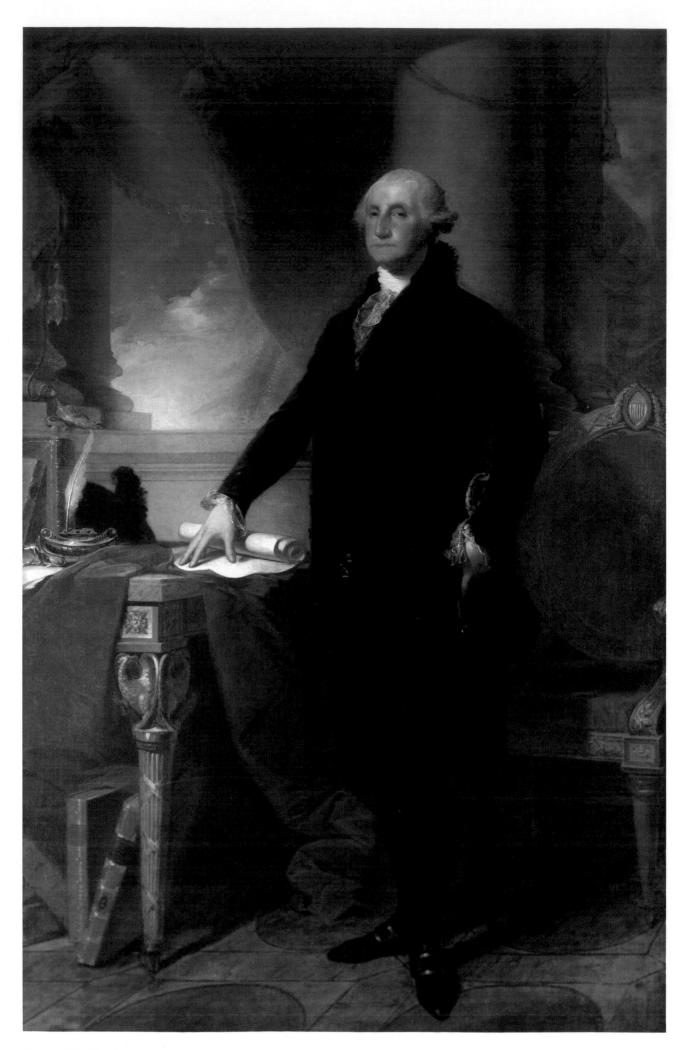

George Washington

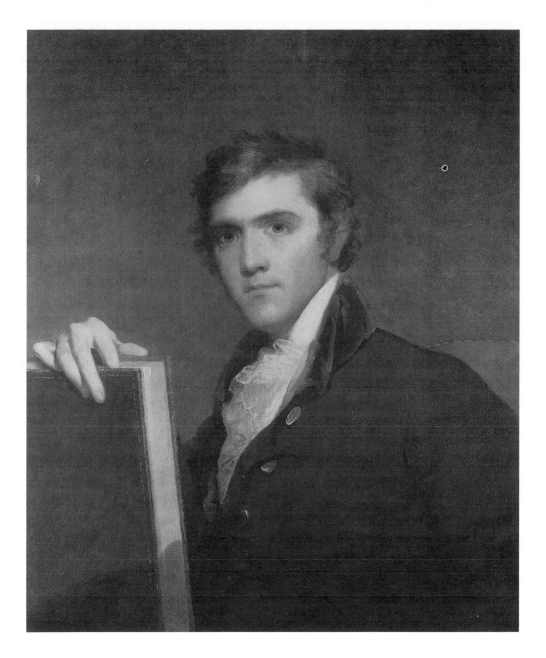

The result is at once more grand and more personal, and incomparably the finest of Stuart's full-length portraits of Washington. But despite the power and conviction of the Vaughan portrait and the achievement of the final full-length, it was only of the Athenaeum head that the American historian, William Hickling Prescott, could have written, as he did a generation later to Washington Irving about that author's biography of his namesake, "The general sentiment of the country has been too decidedly expressed for you to doubt for a moment that this is the portrait of him which is to hold a permanent place in the national gallery."

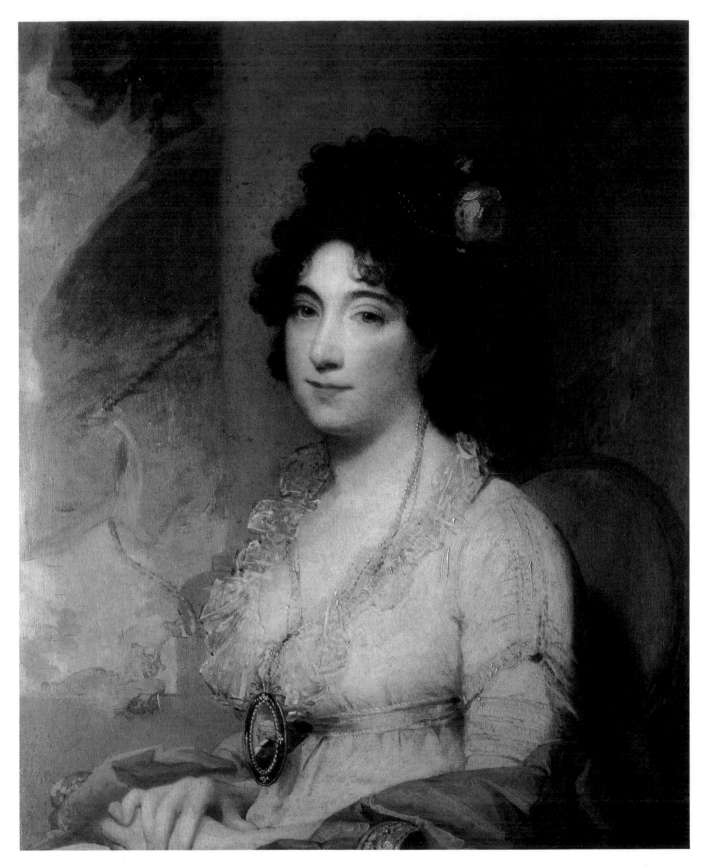

Sally McKean Martínez d'Yrujo

VII. *"The Only Man Who Ever Took a Correct Likeness of Washington"*

URING THE SUMMER OF 1800, the seat of government was transferred to its new and permanent site on the Potomac, and in November, Congress convened for the first time in what the poet Tom Moore scornfully called "This embryo capital, where Fancy sees/Squares in morasses, obelisks in trees." The change meant little to Philadelphia, which remained by far the largest city in the country, and its unquestioned business and cultural center. Stuart had already painted President John Adams and Vice-President Thomas Jefferson before they left for the little village beside the swampy shore of Goose Creek. He was busy with Washingtons and other commissions. Several replicas of his final full-length of the late president had been completed, one for the state of Connecticut, two for Rhode Island, and another for Peter Jay Munro of New York. Meanwhile, in an unusually forward-thinking move, Stuart was investing the considerable sums received for these pictures in farmland to secure the future for himself and his family, for he now had nine living children.

When he looked back across the sea to what had been going on in Britain and on the Continent, he was surely satisfied that he had returned to America when he did. War and revolution raged in Europe. Dublin was no longer the seat of an Irish Parliament; that institution had not lasted past the turn of the century, and the United Kingdom was ruled from London. Even Thomas Lawrence and John Hoppner, busily jockeying for the leadership of the art world, could not count on the patronage enjoyed by Reynolds and Gainsborough a generation earlier. A new spirit in art was abroad, epitomized by the Romantic land- and seascapes of that young genius J. M. W. Turner, while Stuart, isolated in America, was transforming the Georgian portrait into something different in mood and essence, something very much his own, that looked ahead to future developments extending past mid-century.

The slippery little Spanish envoy, Don Josef de Jaudenes y Nebot, who, with his blooming young wife, Stuart had painted so brilliantly six years earlier, had sailed off to Spain, to ancestral estates in Majorca, leaving large debts behind him. He had been succeeded by the more congenial Don Carlos Maria Martínez d'Yrujo, a graduate of the University of Salamanca, who was appointed Envoy Extraordinary and Minister Plenipotentiary to the United States by His Most Catholic Majesty, the King of Spain, in 1796. Following the example of his predecessor, in 1798 he married a delightful American girl, Sally McKean, the daughter of the chief justice, and later governor, of Pennsylvania. A year or two later

Sally McKean Martínez d'Yrujo

c. 1799. Oil on panel, 30¾ × 31⅞″
Collection the duke of Sotomayor, Spain

After her marriage to Don Carlos Maria Martínez d'Yrujo in 1798, she lived at Mount Pleasant, near Philadelphia, then the capital. According to John Adams, Mount Pleasant was "the most elegant seat in Pennsylvania." The youngest child born to the couple in America later became prime minister of Spain and the duke of Sotomayor. The family returned to Spain in 1807.

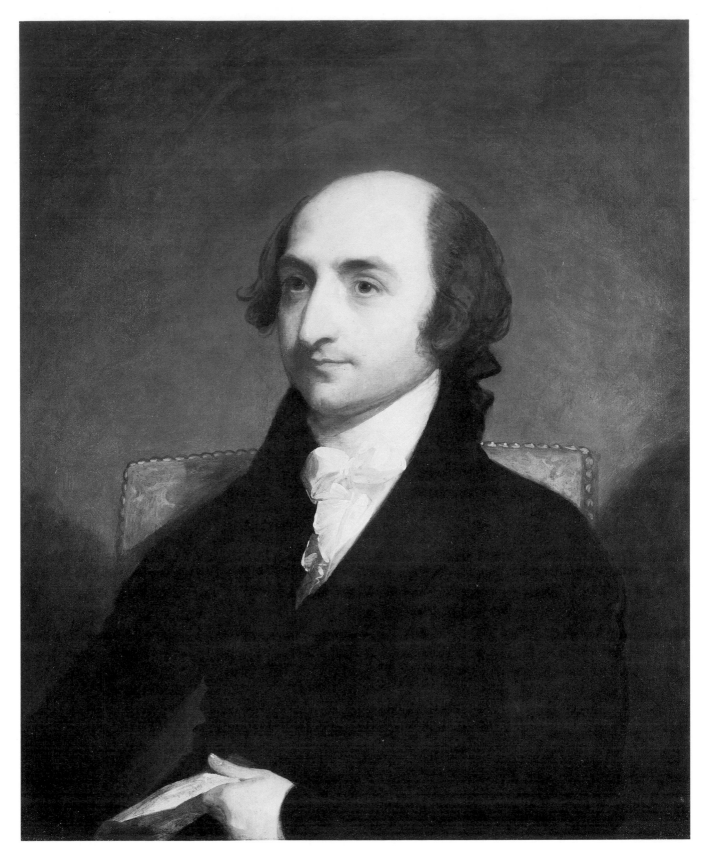

Albert Gallatin

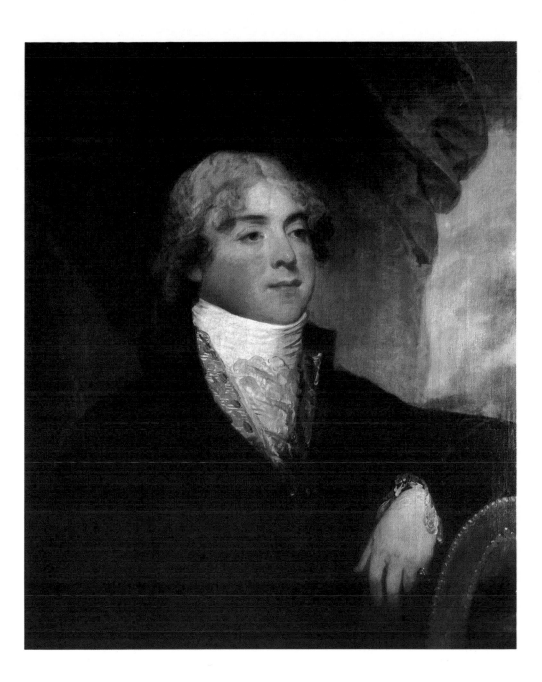

Don Carlos Maria Martínez
d'Yrujo

c. 1799. Oil on canvas, 30¾ × 31⅞″
Collection the duke of Sotomayor, Spain

*Don Carlos, later the marques de Casa
d'Yrujo, replaced Don Josef de Jaudenes y
Nebot as Spanish envoy to the United
States in 1796.*

the couple sat to Stuart for their portraits. He painted them without Grand Manner panache but with far less formality, in stylish head-and-shoulder compositions against a suggestion of windswept sky. The young couple lived in Mount Pleasant, a house overlooking the Schuylkill River in Philadelphia. It is fortunately still preserved in Fairmount Park.

Stuart had been charmed by Elizabeth Parke Custis, whom he portrayed so strikingly in 1796, and by her sister, Eleanor, who married Lawrence Lewis, Washington's nephew. Both had grown up at Mount Vernon and had been favorites of the first president. Around the turn of the century, Stuart painted Eleanor, in one of his rare portraits of mood. In a curiously indeterminate, shadowy interior, suggestive of the inwardness of her thoughts, she sits in a contemplative, relaxed pose, her dark eyes gazing out of the picture to the viewer's

Albert Gallatin

c. 1803. Oil on canvas, 29⅜ × 23⅞″
The Metropolitan Museum of Art, New York City
Gift of Frederic W. Stevens, 1908

*Born in Switzerland, Gallatin was Jefferson's able secretary of the treasury and the
first naturalized American to achieve political prominence.*

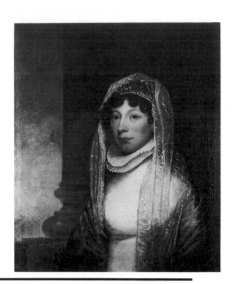

Mrs. James Bowdoin III

c. 1806. Oil on canvas, 30 × 25⅛"
Bowdoin College Museum of Art,
Brunswick, Maine. Bequest of
Mrs. Sarah Bowdoin Dearborn

The Bowdoins were a distinguished family of Huguenot origin. In 1794 James Bowdoin III founded the college that bears his name. He bequeathed his extraordinary art collection of old master paintings and drawings to the school, which made it the first college or university in the country to be so endowed.

Thomas Lowndes

c. 1800. Oil on canvas, 28⅞ × 23⅝"
Gibbes Art Gallery, Carolina Art Association,
Charleston, South Carolina
Bequest of Mrs. Royal Phelps Carroll

Lowndes, a prominent southerner, was probably painted by Stuart either in Germantown or in Washington.

left, a pensive, serious, and attractive young woman, depicted without sentimentality. Also at about this time, he painted Dr. William Smith, a Scotsman who had come over to the colonies in 1751 and had had an active and stormy career as an educator, finally becoming provost of the University of Pennsylvania. Using the horizontal format of the Barker portraits painted in Ireland a decade earlier, he shows Dr. Smith against a curtain drawn back to reveal a bit of landscape, a glimpse of the provost's estate at the falls of the Schuylkill. On a table at his right hand, on pages of manuscript of work in process, lie volumes of his writings on the theory of education and the theodolite he used in tracing the transit of Venus on June 5, 1769.

Though Stuart showed himself capable of such brilliant performances as these, he was increasingly overcome during the first years of the new century by the return of enervating lethargy and depression. He had been devastated when he learned that the man from whom he had bought the farm—which he had "stocked with the Durham breed of cows" and which he hoped would keep him and his family—had died suddenly without transferring the title to his name, as had been agreed. So he lost not only the farm but also several thousand dollars, the only money he had ever been able to save in his entire life.

He did his best to rouse himself, and occasionally he did so, but a growing mood of helplessness descended upon him. His efforts to break through it made him more short-tempered than usual; he was forgetful and disorganized. Those around him could not understand his apparent willfulness. They were put off by the petulance, overindulgence in wine, and other such signs of the tensions growing within him. He kept up with a certain number of sittings, which continued because of the resounding reputation he had so painfully earned, and, finally, there came a client whose beneficent influence enabled him to gather himself again.

Known as the "American Sappho" because of her reputation as a poet, Sarah Wentworth Apthorp Morton was married to Perez Morton, a successful Boston lawyer who served as speaker of the House and attorney-general for the Commonwealth of Massachusetts, and who was in Washington to represent the western land interests of a group of Bostonians. She had survived the trauma of a domestic tragedy that had resulted in the suicide of her sister. In the public interest—because of her husband's prominence––and out of sympathy for her, John Adams and James Bowdoin, a former governor of Massachusetts, took official measures to try to neutralize the consequent scandal. Sarah Morton heroically went on to assist her husband's advancing career in public life. She was an outstanding hostess in Washington, as she had been in Boston, where she was famous for her receptions in the beautiful house designed for her by her cousin, Charles Bulfinch. When she sat for Stuart, he saw a mature and beautiful woman of wit and humor, and he responded in courtly kind. Her social experience lent an ease and urbanity to the sittings that both enjoyed, and beneath the surface she must have sensed that he, like herself, had suffered life's blows. The resulting friendship led to three portraits, and it was also celebrated by an exchange of verses that were published in *The Portfolio* of January, 1803, in a column devoted

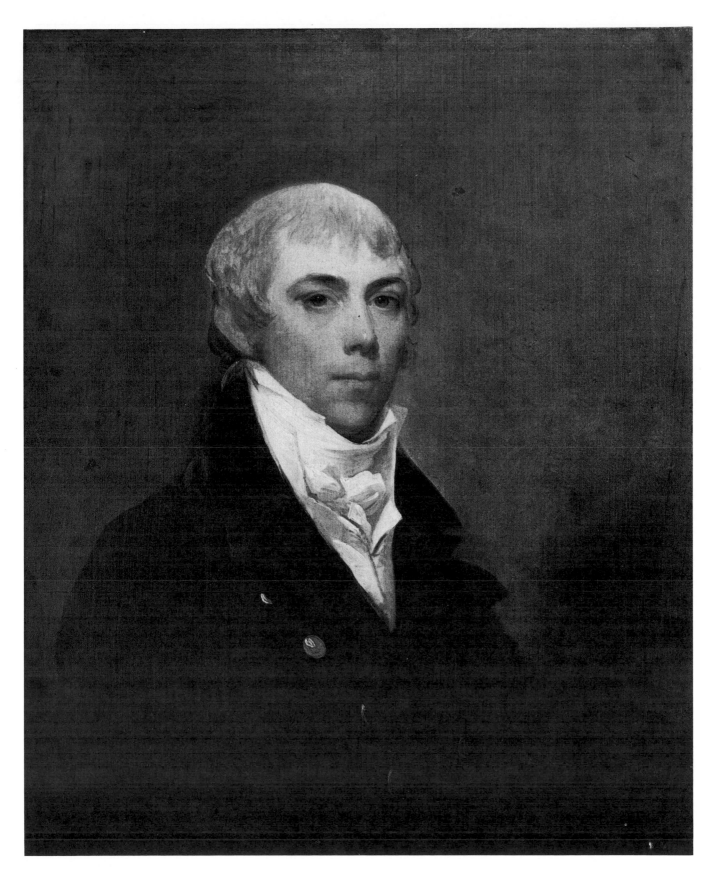

Thomas Lowndes

Mrs. Perez Morton

c. 1802. Oil on canvas, 29⅛ × 24⅛"
Worcester Art Museum, Massachusetts

Sarah Wentworth Apthorp Morton was known as the "American Sappho" for her poetic compositions. She sat three times to Stuart, and this, the last of the three, was found in his studio at his death. Unfinished and informal in pose, it conveys the charm that captivated the artist and her many other friends.

to the arts, fulsomely written under the nom de plume "Samuel Saunter," who was "drawn into a rapt admiration for the eloquent pencil of Stuart, an American artist of transcendent powers, who has the rare and happy talent of delineating on his exquisite canvas all the emotions of the heart and all the operations of the mind. I have been led to the cheerful and volunteer praise of this gentleman from an opportunity I have lately enjoyed of examining one of his most beautiful, captivating and highly finished performances. I allude to his spirited portrait of the impassioned and ingenious features of a Lady whose rank is high in the Monarchy of letters, and whose conversational powers and attractive grace are the delight of the society she gladdens by her presence." Samuel Saunter then quotes from two poems, one written by the lady, and the other, a reply, by the artist.

Stuart, thy portraits speak with skill divine;
Round the bright Graces flows the waving line. . . .
'Tis character that breathes, 'tis soul that twines,
Round the rich canvas, traced in living lines.
Speaks in the face, or in the form display'd,
Warms in the tint, and mellows in the shade.
E'en me, by thy enlivening grace arrayed,
Me, born to linger in affection's shade,
Hast thou, kind artist, with attraction drest,
With all that nature in my soul expressed.
Go on, and may reward thy cares attend,
The friend of Genius must remain thy friend. . . .

Then Stuart replied "To Mrs. M. . . .n":

Who would not glory in the wreath of praise
Which M. . . . n offers in her polished lays?
I feel their cheering influence at my heart,
And more complacent I review my art;
Yet, ah, with Poesy, that gift divine,
Compared, how poor, how impotent is mine!
What though my pencil trace the hero's form,
Trace the soft female cheek with beauty warm;
No farther goes my power; 'tis thine to spread
Glory's proud ensign o'er the hero's head. . . .
Mid varied scenes of life, howe'er depressed,
This blest reflection still shall soothe my breast,
M. . . . n commends—and this alike outweighs
The vulgar's censure or the vulgar's praise.
With such distinction, wrapt in proud content
No more my adverse fortune I lament.
Enough for me that *she* extends her meed,
Whose approbation is applause indeed.

And Samuel Saunter concluded: "I ardently hope that Mr. Stuart will never experience any of those sorrows" of "adverse fortune." "May patronage attend every exercise of his pencil, and American opulence enrich an artist of America. . . . May we hope that for the sake of honour, merit, and justice, that no chill neglect or austere adversity, will ever urge Mr. Stuart to migrate." Stuart could not but have enthusiastically agreed.

Beneath the playful verses, couched in the rather stilted poetic diction of the period, one can sense a rapport, and it is easy to understand why the mutual sympathies that produced them were a balm to the artist's too easily injured ego. The most interesting of the three portraits of Mrs. Morton is the last, which remained unfinished, perhaps because it was not done as a commission but for friendship's

FOLLOWING PAGES

Mrs. John Adams

c. 1800–15. Oil on canvas, 29 × 23¾"
National Gallery of Art, Washington, D.C.
Gift of Mrs. Robert Homans

Abigail Adams was the first First Lady to live in the new White House. She hung the family laundry in the main reception rooms because they were not yet complete.

John Adams

c. 1800–15. Oil on canvas, 29 × 24"
National Gallery of Art, Washington, D.C.
Gift of Mrs. Robert Homans

This portrait of the second president and that of his wife, Abigail, were apparently virtually completed in about 1800. As was too often the case, however, they were not delivered until fifteen years later, after the finishing touches had been applied. Referring to this portrait, Stuart exclaimed to a friend, "Isn't it like? Do you know what he is about to do? He is about to sneeze!"

Mrs. John Adams

John Adams

Benjamin H. Latrobe
Pennsylvania Avenue Near 20th Street, N.W., Washington, D.C.

1813. Sketch
Maryland Historical Society, Baltimore

While Stuart worked in Washington, his family stayed in Bordentown, New Jersey, because there were virtually no lodgings available in the capital, then a mere village strung out along the unpaved length of Pennsylvania Avenue between the uncompleted Capitol and the White House. Latrobe made this sketch after he was appointed Surveyor of the Public Buildings by President Jefferson in 1803.

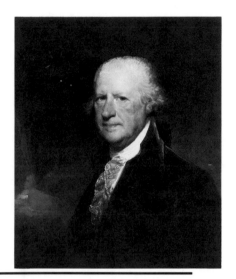

Chief Justice Edward Shippen of Pennsylvania

1803. Oil on canvas, 29 × 24″
The Corcoran Gallery of Art, Washington, D.C.

The head of one of Philadelphia's leading families, Shippen wrote to his daughter, Mrs. Benedict Arnold, in London, "I have lately got my picture taken by one Mr. Stewart [sic] who is said to have been eminent in London."

General Henry Knox

c. 1805. Oil on panel, 47 × 38½″
Deposited by the city of Boston, 1876,
Museum of Fine Arts, Boston

Knox, an overweight bookseller, became a most determined and successful soldier in the Revolution. Here, in one of his most effective portraits, Stuart records Knox's powerful presence. Though some scholars have dated this portrait before 1800, a slightly later date seems more likely.

sake. There is evidence in the picture that he changed his mind about the pose after the painting had been started. It was begun with the sitter's arms at her sides, hands in her lap, then altered so that her arms are raised to adjust the veil over her head in a charming and momentary movement that probably records a spontaneous gesture that appealed to the artist. The first two portraits went to members of her family, but the last, with its greater informality and immediacy, remained unfinished in Stuart's studio throughout his life.

Heartened by Mrs. Morton's encouragement, in December, 1803, he moved to Washington and found a painting room. Charlotte and the children went to Bordentown, New Jersey, as there were no houses and few rooms available in the brand-new, incomplete capital. Most of the legislators stayed in rooming houses, as did Stuart. Immediately, the Athenaeum *Washington* brought forth a flood of commissions. A friend of Dolley Madison's reported that "Stuart is all the rage. He is almost worked to death, and everyone afraid they will be the last to be finished. He says—'The ladies come and say, *dear* Mr. Stuart, I am afraid you must be very much tired, you really must rest when *my* picture is done.'" More irritable than ever, Stuart tried to keep up with the demand. As usual, his finances were in a hopeless tangle. Some pictures he had been paid for were not yet painted, others partly done, still others promised but not begun. There were bills in Philadelphia, bills in Washington, and now bills in Bordentown. Good friends like Edward Stow, a Philadelphia broker and businessman, and Isaac Franks, who had served as a colonel under Washington in the Revolution, tried to help him out. Franks paid some of the bills himself and occasionally lent money, while Stow forwarded funds to Bordentown.

Robert Gilmor, that admirable patron of American art and friend of American artists, invited Stuart to visit Baltimore, where he had arranged a number of commissions for him. His Gilmor portrait suggests something of that gentleman's quiet charm and ease of manner. The triple portrait of Princess Jérôme Bonaparte, the former Elizabeth Patterson, whom Napoleon's brother met, fell in love with, and married, much to the emperor's anger, is a fanciful and unusual picture, in the form of an upright oval. A contemporary remembered the sitter as "a model of fashion, and many of our belles strive to imitate her, but without

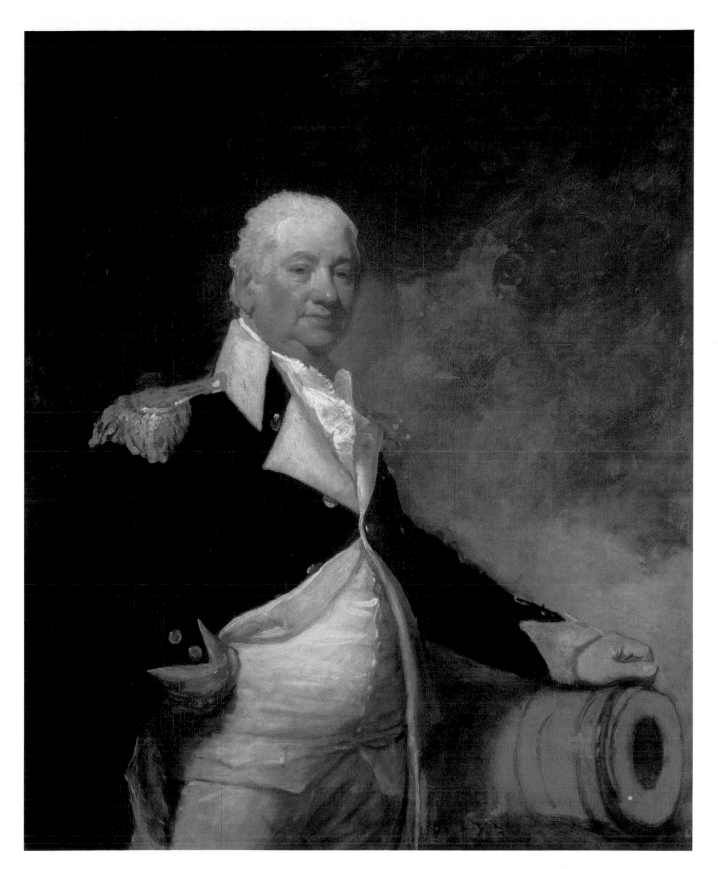

General Henry Knox

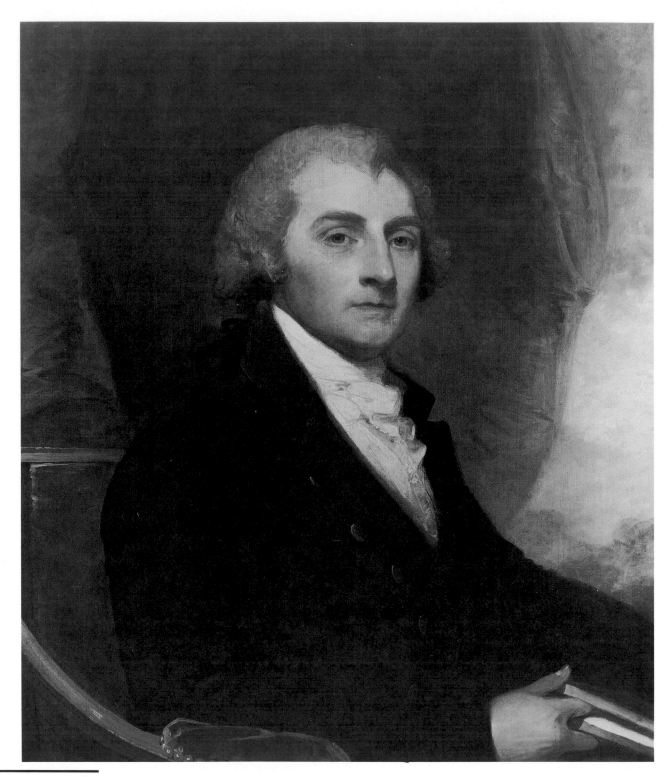

William Thornton

1804. Oil on canvas, 29 × 24⅛″
National Gallery of Art, Washington, D.C.
Andrew W. Mellon Collection, 1942

A "witty and crotchety West Indian Quaker," Dr. Thornton was an enthusiastic amateur architect whose Classical Revival design for the national Capitol was chosen over those of Jefferson, McIntire, and others.

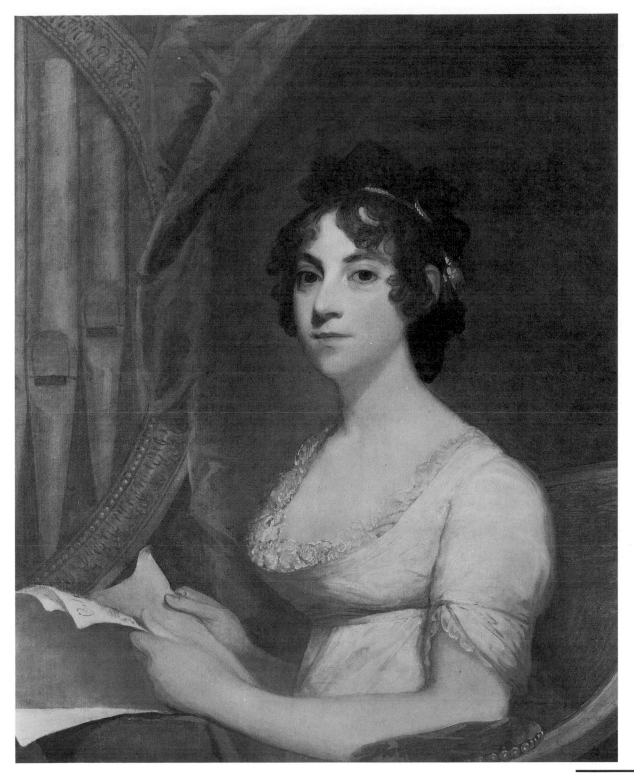

Mrs. William Thornton

1804. Oil on canvas, 28¾ × 24″
National Gallery of Art, Washington, D.C.
Andrew W. Mellon Collection, 1942

Mrs. Thornton was known for her beautiful singing voice; her musical interests are suggested by the details that the artist, himself an accomplished musician, included in the portrait.

Charles Willson Peale, *Gilbert Stuart*

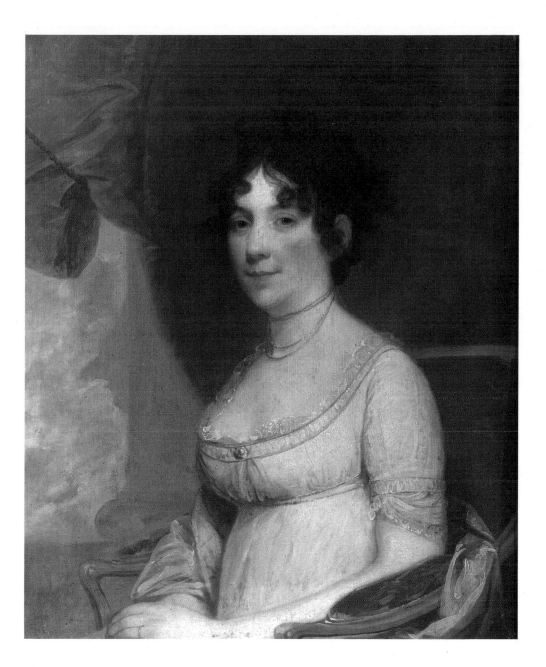

equal *éclat*, as Madame Bonaparte has certainly the most transcendently beautiful back and shoulders that ever were seen." The subject was delighted with the painting—"It is the only likeness that has ever been taken of me. My other pictures are quite as like anyone else as me"—but her young and somewhat arrogant husband took exception to it. Apparently, he thought the artist should have painted properly costumed shoulders below the three views of the head—full-face, profile, and three-quarters. According to one account, the painter exploded, "But you can buy that in any shop in the city!" Stuart instantly stopped working on the prince's portrait and refused to deliver either of them. Years later he relented as far as hers was concerned, long after the pusillanimous prince had repudiated his beautiful American wife, and only after Robert Gilmor had interceded on her behalf. Jérôme's portrait remained, unfinished and stretcher-

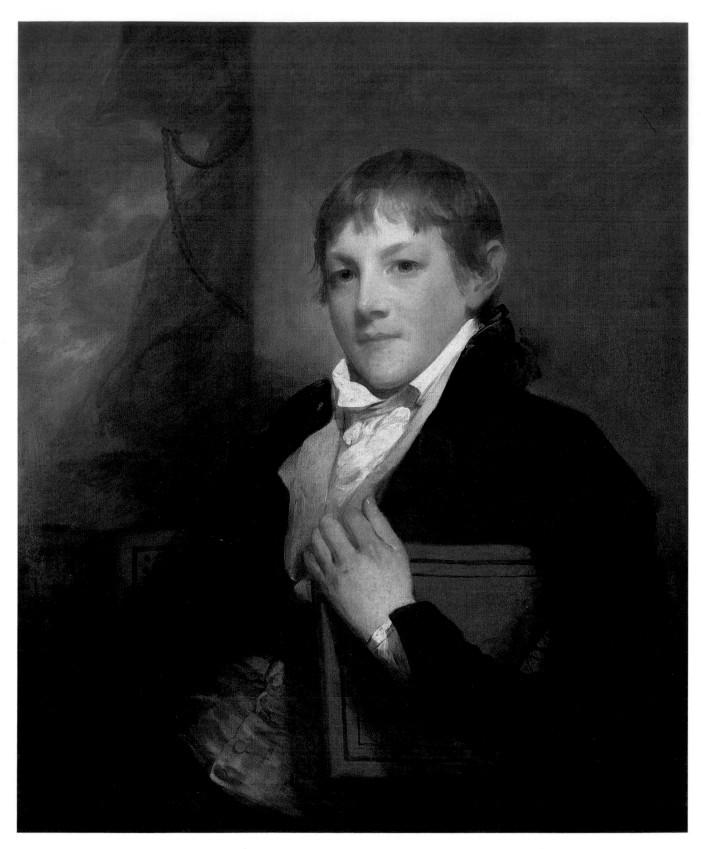

John Randolph

less, in the artist's studio. When Thomas Sully, studying with Stuart in Boston, inadvertently stepped on a corner of a canvas that was lying neglected on the floor, Stuart remarked mildly, "You needn't mind, it's only a damn French barber."

The portraits of the Madisons date from this period. Both are excellent, but that of Dolley caught the sparkle of her personality, while the secretary of state's has a diplomatic reserve, though his wife called it "an admirable likeness," as she wrote to her sister. "Dr. and Mrs. T[hornton] sat for the last time yesterday. He has now nearly finished all his portraits and says he means to go directly to Boston, but that is what he has said these two years; being a man of genius, he, of course, does things differently from other people. I hope he will be here next winter, as he has already bought a square to build a 'Temple' upon."

Stuart's appearance at this time was recorded by the Peales, Charles Willson and Rembrandt, father and son—Peale named all his numerous children, boys and girls alike, after famous painters—for Peale's popular museum, which may have given Stuart his notion of the "Temple" mentioned in Dolley Madison's letter. Peale's extraordinary institution contained not only likenesses of the great but also the first habitat groups known to history—and a fascinating miscellany, including a mastodon skeleton dug up by Peale himself; geological, botanical, ornithological, and other specimens; Indian artifacts; stuffed animals; and various scientific maps, diagrams, and publications. It seems that Stuart's idea of the Temple and the notion that he had purchased land to build it on were equally ephemeral. Yet he had seen and painted leading personalities on both sides of the Atlantic, and a gallery of their likenesses as interpreted by his sophisticated and stylish brush would have made an impressive display.

Both Peales were good painters who produced their share of memorable portraits, but they approached their work in a spirit different from Stuart's. They painted honest, painstaking pictures, emphasizing literal similitude, without either stylistic brio or psychological revelation. But their straightforward, unadorned factuality produced admirably convincing results. We can be grateful that they so recorded Stuart, with his keen, dark eyes, prominent nose, firm mouth with slightly compressed lips, and wearing his own hair, a lock of which carelessly falls over his forehead. The subject, who, though fifty years old, still thought of himself as a youthful cavalier, judged it a poor resemblance, but his son considered it "the best likeness he ever had."

Among the many public figures whom Stuart painted in Washington was Senator Jonathan Mason of Massachusetts. Mason admired the artist and understood the impermanence of his situation there: staying in a boardinghouse while his family lived in Bordentown, his business fluctuating wildly between the time when Congress was in session and the place was a hive of activity and the months when everyone seemed to abandon the still raw and incomplete little capital. So Mason urged him to go to Boston, promising the patronage of his own family and friends, and pledging his assistance in gaining further commissions. Despite his undoubted successes, Stuart's discontent had grown. He could produce his *Washington* replicas as well in Boston as anywhere. Furthermore, his mother and

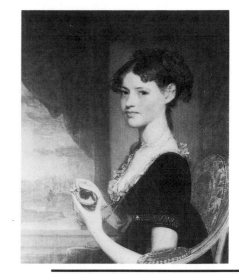

Anne Pennington

c. 1805. Oil on canvas, 29 × 23½″
The Philadelphia Society for the
Preservation of Landmarks, Powell House
Bequest of Miss Frances Wister

Uniquely among Stuart's works, this portrait is signed and dated "G. Stuart, Bordentown, 1805," so it was painted while he was on his way from Washington to Boston, where he spent the rest of his life.

John Randolph

1805. Oil on canvas, 29⅛ × 24⅛″
National Gallery of Art, Washington, D.C.
Andrew W. Mellon Collection

John Randolph was a unique figure in America's political history. A boyhood disease left him beardless and with an unchanged voice, yet he lived an active life, was a brilliant orator, a wickedly effective debater, and the most forceful member of Congress in his day. Stuart's likeness records his deceptively youthful appearance at the height of his congressional career.

Thomas Jefferson

1805. Oil on paper, 18⅜ × 18½"
Fogg Art Museum, Harvard University,
Cambridge, Massachusetts

*This near-grisaille medallion portrait,
painted in fluid style on blue paper mount-
ed on canvas, is unique in Stuart's work
and expresses the artist's awareness of Jef-
ferson's interest in the classical past.*

Thomas Jefferson

1805–7. Oil on canvas, 48⅜ × 39¾"
Collection Bowdoin College Museum of Art,
Brunswick, Maine

*In 1805 James Bowdoin III, an ardent
Jeffersonian, asked his old friend Major-
General Henry Dearborn, secretary of
war, to commission portraits of Jefferson
and Madison. Two years later, after some
procrastination, Stuart completed them.*

sister, now both widows, whom he had not seen for thirty years, had returned
from Halifax to New England, where Ann Stuart Newton was conducting a girls'
school. His boyhood friend, Benjamin Waterhouse, was now a Harvard profes-
sor, and Mrs. Perez Morton was a leading hostess with a large circle of influential
friends. Weary of Washington and feeling the weight of his years, he finally de-
cided to make the move.

After leaving Washington, Stuart seems to have stayed briefly in Philadel-
phia before moving on to Bordentown, where he lingered long enough to paint a
portrait of Anne Pennington. She is a poised young woman of twenty-one, seat-
ed in a fashionable chair with upholstered back and padded arms, with a glimpse
of landscape traditionally identified as the valley of the Delaware River. She
holds what has been thought to be a miniature silhouette of her half sister, Eliza-
beth Harvey Wister, who commissioned the portrait. Her dark hair, piled on top
of her head, falls in fashionable ringlets. In her pale slenderness and seriousness
of expression are suggestions of the illness that took her life soon after the picture
was painted.

Leaving his family in Bordentown until he could arrange to settle in Boston,
Stuart arrived there late in July to be greeted warmly by an announcement in *The
Columbian Centinel* on the thirty-first: "Mr. Stuart, the celebrated painter, who has
immortalized his fame by his masterly portrait of our deceased Washington, is
now on a visit to this town from Philadelphia." The Mason family portraits that
he had done before his visit had met with the senator's enthusiastic approval, and
other paintings, already ordered, remained to be done. He took with him two in-
complete half-lengths of President Jefferson and James Madison, commissioned
by Major-General Henry Dearborn, the secretary of war, on behalf of James
Bowdoin, newly appointed minister to Spain, probably for use in the embassy in
Madrid, though perhaps for presentation. Jefferson had sat for his portrait just
before Stuart left Washington, and, at the same time, Stuart painted the unique
near-grisaille profile of Jefferson "à la antique," in Jefferson's own description.
These official portraits, along with the *Washington*, were to prove effective in
gaining business in Boston.

At about this time, John Trumbull, having recently returned from abroad
with his English wife, thought to settle in Boston as a portraitist. He was wel-
comed cordially, as his work was admired and he himself was highly regarded.
He soon observed, however, that whenever he broached the subject of his staying
in Boston to pursue a career in portraiture, "a cloud seemed to pass over and chill
the conversation."

*I could not, for a long time, account for this, but at length I learned that my old friend and
fellow student, Stewart [sic], who having pursued the profession of portrait painter for more
than twenty years had established a well merited reputation, and who had for some years re-
sided in Washington, had lately received an invitation from Mr. Jonathan Mason, one of
the members of Congress, to come and settle in Boston. He had been promised the patronage
of Mr. Mason and his friends (who were the rich and fashionable of the place) and Mr.
Stewart having accordingly accepted the invitation, was preparing to quit Washington and*

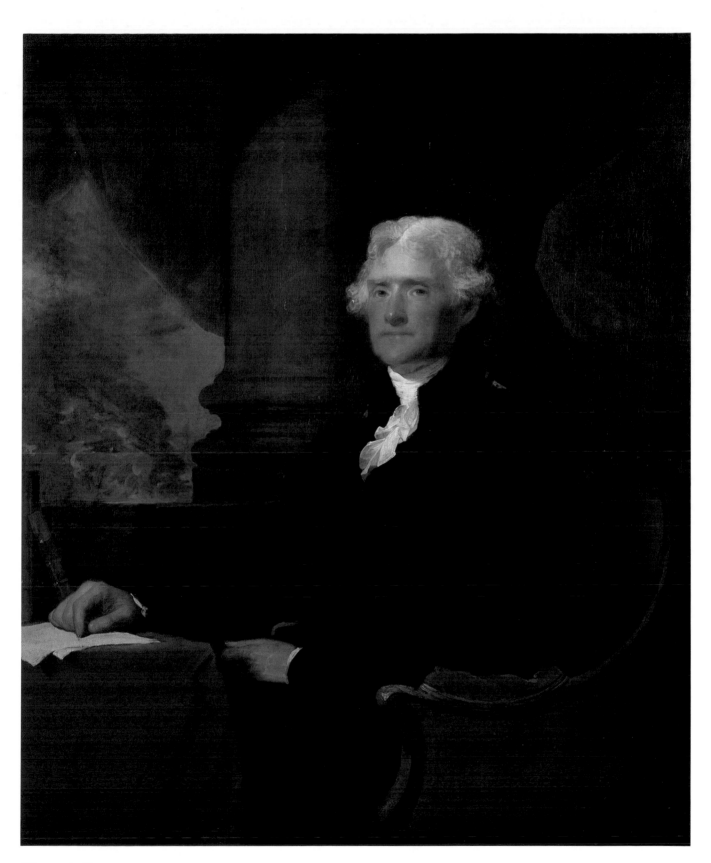

Thomas Jefferson

General John Roger Fenwick

c. 1804. Oil on canvas, 28¾ × 24″
Gibbes Art Gallery, Carolina Art Association,
Charleston, South Carolina
Gift of Mrs. William Phelps

One of a series of portraits of military men, this was probably painted shortly before Stuart left Washington for Boston.

James Madison

1805–7. Oil on canvas, 48¼ × 39¾″
Collection Bowdoin College Museum of Art,
Brunswick, Maine

This portrait, like that of Jefferson in the same collection, was commissioned by James Bowdoin III, a friend and admirer of both presidents. Dolley Madison considered her husband's portrait an excellent likeness.

to establish himself in Boston. This was enough, for Boston was then a small town, compared with its present importance and did by no means offer an adequate field of success for two rival artists. I therefore immediately returned to New York, took a furnished house for the winter and began my course as portrait painter.

When Stuart first arrived, Boston was indeed, as Trumbull observed, a small town, at least when compared with Philadelphia. An active seaport served by a magnificent harbor, it was still isolated on its peninsula, joined to the mainland, except for the Charlestown bridge, only by the Neck, so narrow that at high tide passersby were often showered with the cold salt spray that was driven by the east wind blowing across the water. There were still cultivated fields, pastures with grazing cattle and sheep, and windmills within the tidal boundaries of the town. The spires of Christ Church, the Old South Church, and the Brattle Street Church were landmarks that could be seen by vessels coming up the harbor. One could still find food, drink, and lodging at the Bunch of Grapes, the inn famous as the headquarters of Paul Revere and the Liberty Boys, or at the Green Dragon in Union Street, meeting place of the Tea Party Indians. On top of the cupola of Province House, the former palace of the royal governors, Deacon Shem Drowne's Indian hunter still told the direction of the wind to the nautical-minded Bostonians.

Except for the handsome stone Hancock House and a few others along Beacon Street, Beacon Hill and "Copley's pasture" on its slopes were still green. The Old State House had been superseded by Charles Bulfinch's fine new Capitol on the Hill, and his architectural practice was in the process of miraculously transforming the old town into a gracious Federal city, classical without being archaeological: rational, practical, and livable. The downtown streets were still largely a tangle of narrow medieval lanes and passageways—a few of which still exist— but the logical composition of Bulfinch's Tontine Crescent, the Colonnade, and Park Row presaged the orderly development taking place and about to spread into the Back Bay. Thanks also to Bulfinch, Boston's streets were well lighted, and despite the election of Jefferson in 1801, an event that Federalist Boston greeted with gloom and foreboding, the city prospered during the early years of the new century.

Stuart established himself at Champotin's Hotel on Summer Street, where he opened painting rooms, showed the works he had brought with him, and welcomed potential sitters. Though he lived at the hotel, he also visited his old friend Waterhouse in Cambridge, staying "as long as his snuff lasted, and then nothing would detain him from Boston." On one of these visits, according to the doctor's letter to Dunlap, Stuart got up early one morning and descended to look critically at the self-portrait he had painted so long ago as a gift for his friend. He was, as Waterhouse observed, "a much altered man." The years had taken their toll. The line between fact and fantasy—as in judging the accuracy of the likeness of the Peales' portrait of him—was blurring. He seems not to have been able to remember, in many cases, the difference between what he had promised and what he had accomplished. The wished for and the real had always been closely allied in

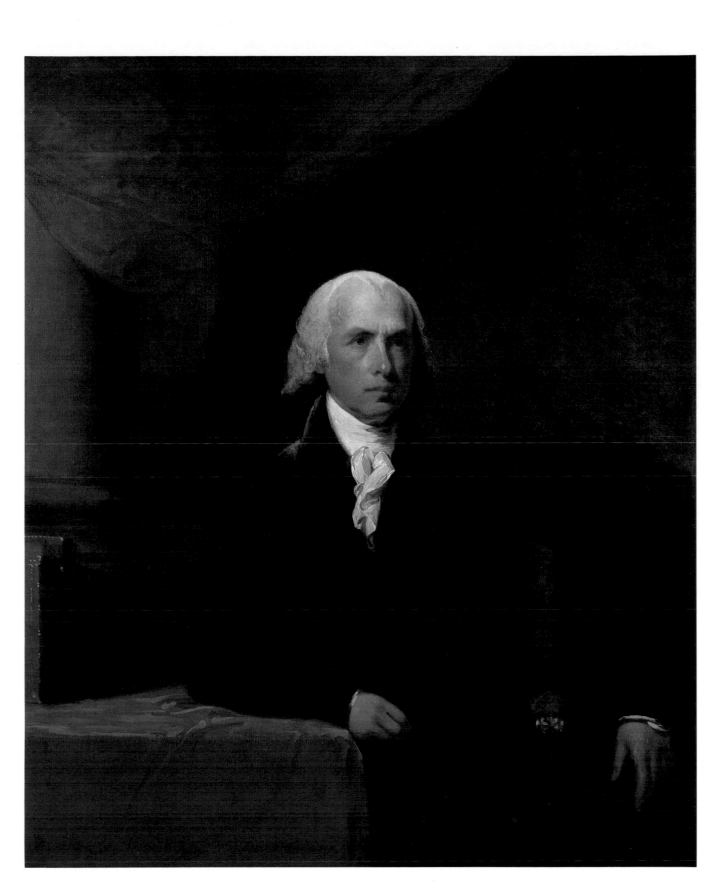

James Madison

William King

1806. Oil on canvas, 29 × 23½″
Maine State House Portrait Collection,
Augusta

*The younger half brother of Rufus and
Cyrus King, William was as passionate a
Jeffersonian as they were Federalists. He
played a leading role in the move to sepa-
rate his native Maine from Massachusetts
and gain its admission to the Union in
1820. As first commissioner of public
buildings, he saw to the construction of the
State House in Augusta, to Charles Bul-
finch's design, and was elected first gover-
nor of the state.*

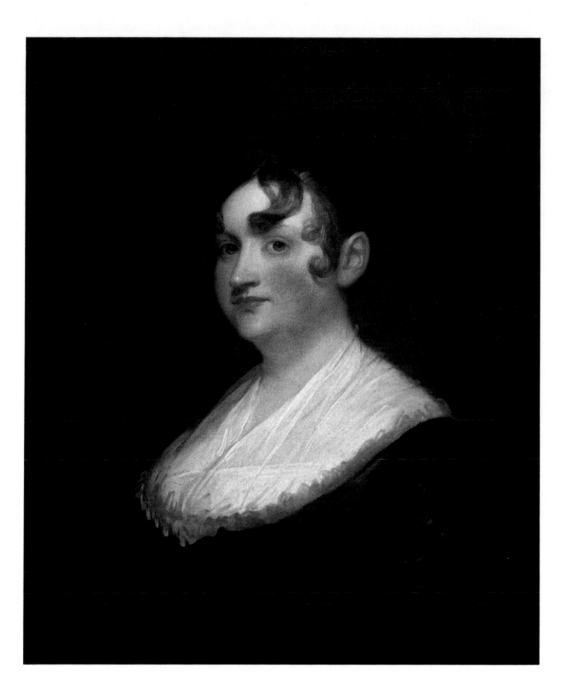

Mrs. William King

1806. Oil on canvas, 29 × 23½″
Maine State House Portrait Collection,
Augusta

*Governor and Mrs. William King were
for years leading citizens of Bath, Maine,
where the governor took a great interest in
the ship-building industry that still flour-
ishes there.*

Washington at Dorchester Heights

Harrison Grey Otis

1809. Oil on canvas, 32 × 26″
Collection Society for the Preservation
of New England Antiquities, Boston

Otis was a leading citizen of Boston, famous for the lavish hospitality he provided in the series of three handsome houses designed for him by his friend Charles Bulfinch. The frequently replenished punch bowl, placed on the landing of the stairs for the refreshment of his many guests, was reported to have held ten gallons.

his mind. Yet he mobilized himself to make the most of the change from Washington to Boston, welcoming sitters with much of his old charm, and he did his best to organize his time and keep track of his commitments.

Early in 1806 there occurred an event that was very much to Stuart's advantage. Bulfinch's respectful enlargement of historic Faneuil Hall had just been completed, and Samuel Parkman, a leading citizen, proposed to present to the city, to hang in the renewed Hall, a copy of Stuart's Lansdowne *Washington*, one of several made by a visiting English artist of more zeal than genius, one William Winstanley. At the town meeting at which the gift was to be acknowledged, Joseph Baston (or Batson, as the name also appears), an expert stuccoworker who was responsible for a share of the fine plasterwork that graced the interiors of so many Boston houses—and obviously a Jeffersonian—rose to protest. When he

Washington at Dorchester Heights

1806. Oil on panel, 107½ × 71¼″
Deposited by the city of Boston, 1876,
Museum of Fine Arts, Boston

Stuart painted this immense canvas, commissioned by Samuel Parkman, in ten days. He borrowed a horse from Rubens, and, using the Athenaeum head, he showed Washington just after he had taken possession of Dorchester Heights.

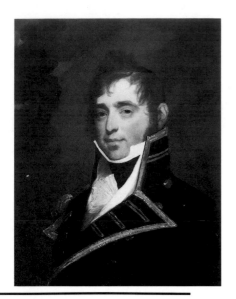

Master Commandant
James Lawrence, U.S.N.

1812. Oil on panel, 28½ × 23½″
United States Naval Academy, Annapolis

A hero of the War of 1812, Lawrence died in battle in June, 1813, while commanding the United States frigate Chesapeake *against the more heavily armed British ship* Shannon.

stated his opinion that the situation demanded an original painting, not an un-worthy copy, the moderator threatened him with unemployment in Boston thereafter and adjourned the meeting. Whereupon Baston wrote a letter to *The Columbian Centinel* stating his case. "I had Determined to express myself more fully on the subject, but this was disagreeable to the moderator, and still more to the paper skull of Mr. Clough, who insisted that foreigners had no business to come there 'bull-ragging,' as he called it." (Ebenezer Clough was a paper manufacturer and a Federalist, and Baston was perhaps French, as his name might suggest, or, in any event, not a born Bostonian or a Federalist.) He went on to point out that the portrait in question was an unauthorized copy, one of several that Winstanley had unsuccessfully tried to sell, even going as far afield as the West Indies—and that had been sold at public auction for the unpaid freight bill. "It is certainly not to the credit of Faneuil Hall," Baston wrote, "to be decorated with a picture, a stolen copy by a foreigner from the celebrated Stewart [sic], who at this time is in this town, and is the only man who ever took a correct likeness of Washington."

To Stuart's satisfaction, public opinion was aroused, and as he later told William Dunlap, the effect was "electrical and spread through the town." A chagrined Samuel Parkman finally asked friends to approach the artist with the request for an original full-length *Washington*. Thoroughly amused and also stimulated by the situation, Stuart readily agreed. He started immediately on an entirely new composition, a heroic representation of Washington at Dorchester Heights, the daring capture of which by the Americans forced the evacuation of the British troops from Boston. Drawing on his collection of engravings and using the Athenaeum head, Stuart painted a variation on a favorite Van Dyck pose and borrowed a horse—very Baroque in spirit—probably from Rubens. Impressing friends to pose for various parts of his subject's anatomy, Stuart painted furiously and effectively. Within ten days he had brought the canvas to the point where he could allow it to have a preliminary showing. To Samuel Parkman's relief and satisfaction, the painting was displayed in triumph at the annual Fourth of July banquet held by the Federalists in the newly restored Faneuil Hall, with Stuart as an honored guest. With his friend Henry Sargent, Stuart was on the committee in charge of decorations for the event. They decked the large interior with paintings and busts of Revolutionary heroes, flags and bunting, and evergreens and flowers. *The Columbian Centinel* described the scene:

> At the head of the Hall was placed the Grand Picture which the celebrated Stuart is painting for Samuel Parkman Esq., and which he intends to present to the town to be permanently fixed in the Hall when finished. The picture is about ten feet by seven, the figures as large as life. The great founder of our Empire is in military dress, represented standing on the heights of Dorchester and anxiously contemplating the cannonade and movements which preceded the evacuation of Boston in 1776. At his side is his favorite white Charger whose expanded nostrils and features tell the story of the picture. In the background are seen a view of Fort Independence and adjacent islands, and a fleet of vessels sailing out of the harbor. The picture is not finished, and we feel grateful for the indulgence of Mr. Stuart in permitting its exhibition on the occasion. The portrait of General Lincoln is from the pencil of Mr. Henry Sargent.

According to an account in *The Boston Repository* shortly after the event, "the thirteenth toast . . . was an allusion to the excellent painting of Washington and a compliment to the talents of Mr. Gilbert Stuart, now a resident in this town, who painted it, and who is at present engaged on several portraits of equal magnitude, to be placed, we understand, in the State House." After the banquet the *Washington* was returned to Stuart's painting rooms for completion. It was permanently installed in Faneuil Hall in the following August. (It is now on permanent loan to the Boston Museum of Fine Arts for security's sake, a copy having replaced it in its historic original position.)

The success of the new *Washington* was an auspicious beginning to a renewed career in Boston. Stuart found a house on Washington Street, where he installed Charlotte and the children. To keep track of his numerous sittings he began to keep an appointment book—probably not for the first time, though none have come down to us—evidence of an attempt at a greater degree of personal organization. He regularized his life in other ways, walking frequently with his younger artist friend, Henry Sargent, on the Mall, "a pleasant promenade, adjoining to Boston Common, consisting of a long walk shaded by trees, about half the length of the Mall, St. James's Park. At one end you have a fine view of the sea." "I became very intimate with him," Sargent later wrote to William Dunlap, "and obtained much useful information from him. In our frequent walks together the conversation, of course, often turned upon the subject of painting. It was his opinion—often expressed—that the art was on the decline. I never argued with him, for he was a vain, proud man, and withal, quick-tempered. I chose rather to preserve his friendship as an artist."

Stuart took up music again. He had acquired a piano, Sully tells us, and played on it and a harpsichord daily. From time to time, he played a small organ and other instruments, sometimes accompanying the singing of his wife and daughters and their friends. Once he even went with the rest of the family to a Sunday service at Trinity Church to hear a sermon by the famous and scholarly Dr. J. S. J. Gardiner, but, to Charlotte's regret, that happened only once. On their return home, as George Mason tells it in his 1869 biography of the painter, Stuart commented that he did not think that he would go to church again.

"Why not?" his daughter Ann asked.

"Oh," he replied, "I do not like the idea of a man getting up in a box and having all the conversation to himself."

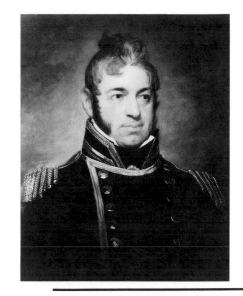

Commodore William Bainbridge

c. 1813. Oil on panel, 29 × 23″
Collection Mrs. John Hay Whitney

A hero of the War of 1812, Bainbridge was for a time captain of the famous frigate U.S.S. Constitution.

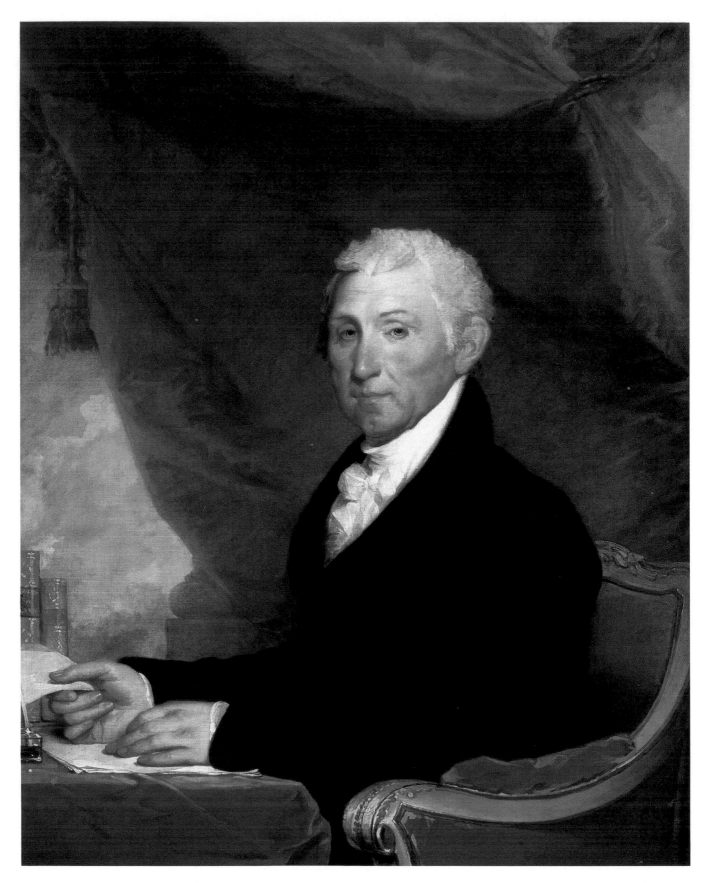

James Monroe

VIII. "The Celebrated Stuart, of Boston"

S TUART OFTEN BEGAN a story for the amusement of his sitters with the opening words "When I was living in the Athens of America." By this he meant Philadelphia, and he was poking some not undeserved fun at the Bostonians who liked to compare their city with the Athens of Pericles, yet were comparatively stingy in their support of the arts. Events in 1816 emphasized the point. In that year the Pennsylvania Academy purchased an important Romantic painting from Washington Allston, an artist whom Boston had adopted as one of her own, for $3,500, a very handsome sum in the currency of the period, and Baltimore followed with a similar acquisition later the same year. So outraged was one Bostonian that he wrote a letter to *The Columbian Centinel* on April 10 upbraiding his fellow townsmen for their parsimony. "What has been done," he inquired, "with the riches which the commerce of half the world has for twenty years thrown into the town? The only answer that can be returned is, they have been consumed in the profusion of the table, and other luxuries equally indicating a gross and depraved taste." As Stuart remembered the bargain *Washington* portrait that Samuel Parkman had intended to present to the town for Faneuil Hall, he must have chuckled in agreement as he read *The Centinel* correspondent's heartfelt and irate protest.

Though Stuart's life was more settled in Boston than it had been in previous years, he was still given to capricious behavior. It became accepted that one could never expect a portrait to be finished until after many months. As Sully pointed out, when Stuart liked a picture, he hated to give it up, and when he did not, he hated to finish it. Yet for all his eccentricities, Boston accepted him. As a contemporary observed, a Boston house was not considered properly furnished without one or more Stuart portraits in it. This did not mean that Bostonians did not patronize other painters, artists who could be relied upon to deliver their works at the agreed time, and who would not fly into a rage if one questioned a detail of costume or asked for a certain color of gown. When that gigantic and genial frontiersman, the painter Chester Harding, visited Boston in 1822, he was flooded with commissions. He had been reluctant to come to Boston because he regarded it as Stuart's domain, and he had the greatest respect for the older artist. But he had come at the invitation of a number of prominent Bostonians, and immediately, as he wrote in his delightful autobiographical sketch, "My room at Boston became a place of fashionable resort, and I painted the enormous number of eighty heads in six months, and I verily believe I had more than twice that num-

James Monroe

1818–20. Oil on canvas, 40½ × 32"
The Metropolitan Museum of Art, New York City
Bequest of Seth Low, 1960

This is the only remaining portrait of the set of the first five presidents commissioned by John Doggett, a Boston framemaker and art dealer. The portraits of the first three presidents were burned in the 1851 Library of Congress fire, and the Madison, *which survived the fire, has been lost for years.*

133

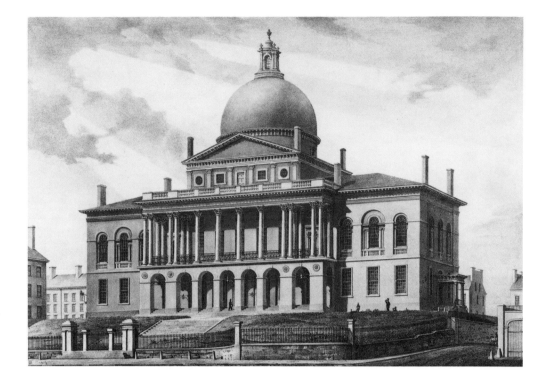

State House, Boston

From an 1828 lithograph by Pendleton
after a drawing by A. J. Davis
Boston Athenaeum

Completed in 1798, the State House marked the beginning of the transformation of Boston by the architecture of Charles Bulfinch into the gracious Federalist city in which Stuart lived and worked for nearly a quarter of a century.

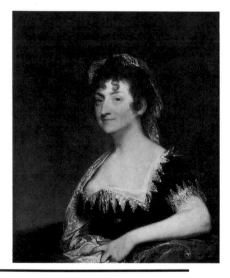

Hepzibah Clark Swan

1806–10. Oil on panel, 32½ × 26½″
Museum of Fine Arts, Boston
Swan Collection. Bequest of
Elizabeth Howard Bartol

The wife of Colonel James Swan, Mrs. Swan lived and entertained lavishly in her handsome Dorchester house, designed by Charles Bulfinch and furnished with objects liberated from the royal collections at the time of the French Revolution. She was renowned for her exotic costumes.

ber of applicants for portraits at that time. Mr. Stuart was too well known to allow of the supposition that my portraits could bear any sort of comparison with his; yet such was the fact that while I had a vast deal more offers than I could execute, Mr. Stuart was allowed to waste half his time in idleness for want of sitters. I can account for this public freak only in the circumstance of my being a backwoodsman, newly caught; then the circumstance of my being self-taught was trumpeted about much to my advantage."

When he met Stuart, Harding took pleasure in informing him that an Irish artist had told him that he owed his own professional career to Stuart's encouragement and to what he had learned from studying his methods. Harding went on from Boston to a triumphal tour of Europe, where he painted royalty and the aristocracy, who were impressed by his immense physique and charmed by his courtly manners as well as by his undoubted abilities as a painter. Before he left Boston, Mrs. Humphrey Devereux prevailed upon him to repaint the costume in Stuart's portrait of her. She had not dared to ask that quick-tempered artist to make the change. In 1825 Harding wrote Stuart from London, addressing him as "Honoured Sir," to let him know that he had not been forgotten. He went on, "This is the place where I think you should have remained, and the place where I think if you were to come now, you would command any price for your labours, and I do not hesitate to say that you would stand ahead of all, unless it be Sir Thomas Lawrence."

Another turning point in Stuart's life came in March of 1813, when his beloved son, Charles Gilbert, died. Stuart had recognized the boy's gifts, but, fearful of interfering with the originality of his talent, he forbore from giving him direct instruction. He saw himself, with all his extravagances and willfulness, in the young man and painfully recognized a basic instability akin to his own. In his

THE CELEBRATED STUART, OF BOSTON

determination to try to make sure that the son did not repeat his own destructive patterns of behavior, he tried to impose standards that he himself had never been able to live up to. The results were inevitable and tragic. Though the son had proved himself a promising landscape painter, having learned from observing his father's pupils that which his father himself had refrained from teaching him, he turned to a life of compulsive dissipation and increasing alcoholism, and he died of consumption, a wasted and fragile figure who appeared decades older than his twenty-six years. He was buried "in Strangers Tomb under the old Trinity Church in Summer Street," which has long since disappeared.

The house seemed haunted by the presence of the departed son, and Stuart packed up and moved the family to Roxbury. There, in a large, somewhat ramshackle old house, with grounds enough for a garden and livestock, he sought to recover himself in the reassuring comforts of a rural life, just as he had at Stillorgan, harking back to what seemed increasingly an idyllic boyhood in Rhode Island, now incredibly remote. It was in this spirit of nostalgia that Stuart finally revisited the scenes of his childhood. But by 1817, he had been driven to move out of the Roxbury house, which had been sold by its owner, and he found another on "Washington Street, formerly the Neck," where he lived for some months before moving to Washington Place in Boston. The house overlooked India Wharf and Boston Harbor from Fort Hill, which is no longer there, having been used as landfill on the shore. In conversations recorded by George Channing, a fellow Rhode Islander and a frequent and welcome visitor during his later years, Stuart confided that he had recently returned to Newport, taking the stage through Walpole to Providence, and then by packet down the river and the bay to Newport. As Channing recorded Stuart's account, he

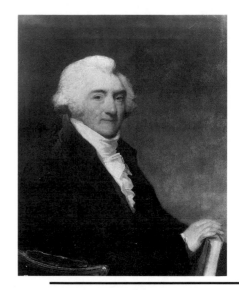

Governor James Sullivan

1807. Oil on panel, 33 × 26½"
Museum of Fine Arts, Boston
Bequest of Alexander Cochrane

In this likeness of a Massachusetts governor, Stuart shows his mastery of essential portraiture, without setting or added detail to detract from the expressive concentration on the head, subtly modeled and vigorously brushed.

landed somewhere near Ferry-wharf Lane, and was directed to respectable lodgings in Broad Street, near to the State House. Next morning I began my search for landmarks and frosted heads. The former were scarce enough, for I could hardly recognize localities once familiar. . . . I strayed to the upper part of the town, gave a look at the graveyard and its headstones with most quaint inscriptions, and made my bow to the Liberty Tree, and then walked at my leisure down Thames Street. . . . I passed along looking eagerly at the signs, hoping that I might read the names of old friends. People stared at me and I at them, but we could not identify one another. Beginning to feel rather blue over the wrecks of time I thought I might while away a portion of my time in the organ loft of Old Trinity Church, and perchance by force of memory and a vivid imagination revive some of the sweet music that used to reach me in my humble pew from one of the best instruments in America, the gift of George Berkeley, Bishop of Cloyne. I then . . . cast a glance at the Redwood Library building and admired its unique architecture, so classical, so refined; examined a few folios and reverently gazed at their pictorial embellishments, . . . and after exploring . . . the State House, I returned to my lodgings to muse over the scenes of my childhood. . . . In the afternoon, having nothing better to do, I made a second visit to the church, examined the ancient tablets, . . . and finally exhausted the daylight in reading familiar names on the monuments in the churchyard.

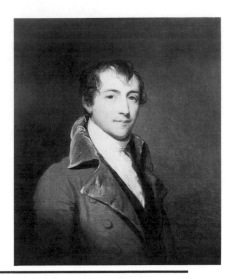

Philip Jeremiah Schuyler

1807. Oil on canvas, 29 × 24″
New-York Historical Society, New York City

Descendant of a patroon family with extensive landholdings in the Hudson River valley, Philip Schuyler was a prominent figure in New York life.

Mrs. Philip Jeremiah Schuyler

1807. Oil on canvas, 29 × 24″
New-York Historical Society, New York City

Born Mary Anna Sawyer, Mrs. Schuyler and her young husband had only recently been married when they sat to Stuart for their portraits.

Mrs. Stephen Salisbury I

c. 1810. Oil on canvas, 32½×26¼″
Worcester Art Museum, Massachusetts
Gift of Stephen Salisbury III

Elizabeth Tuckerman of Boston married Stephen Salisbury in 1797 and moved into the handsome Salisbury house on Lincoln Square in Worcester. In one of his finest female portraits, Stuart recorded his admiration for her intelligence and charm.

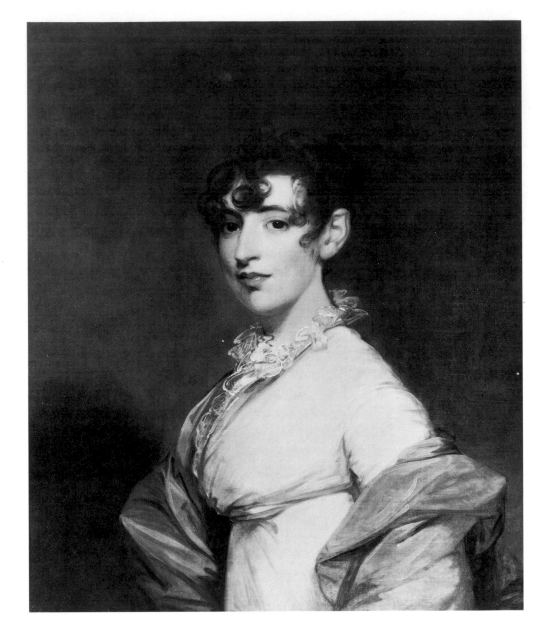

Perhaps ten years later, in 1826, Stuart again returned to Rhode Island, this time to visit the mill on Petaquanset Pond. He hired a carriage in Newport and, taking the ferry across to the western shore of Narragansett Bay, traveled inland. Twenty years later, the then tenant of the mill remembered the visit, how, "in the lifetime of my father, Mr. Stuart came there (a young gentleman accompanied him) and staid about one hour. He viewed the premises with particularity, and observed that the willow below the house, now old and in a state of decay, was quite small when he was a boy. He then requested liberty to view the house, if there were no objection. He viewed it inside, and particularly desired to enter and look at the N. E. bedroom; and when in the room he stated 'In this room my mother always told me that I was born.'"

During Stuart's later years he had many pupils, and there were many more who came to him for advice. Despite his notorious impatience, he was invariably

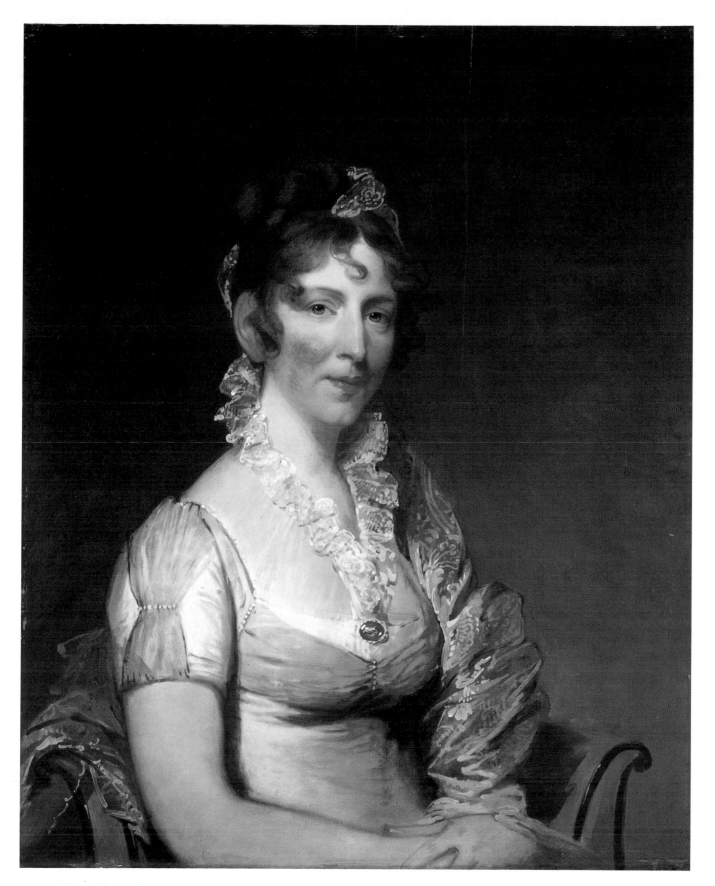

Mrs. Stephen Salisbury I

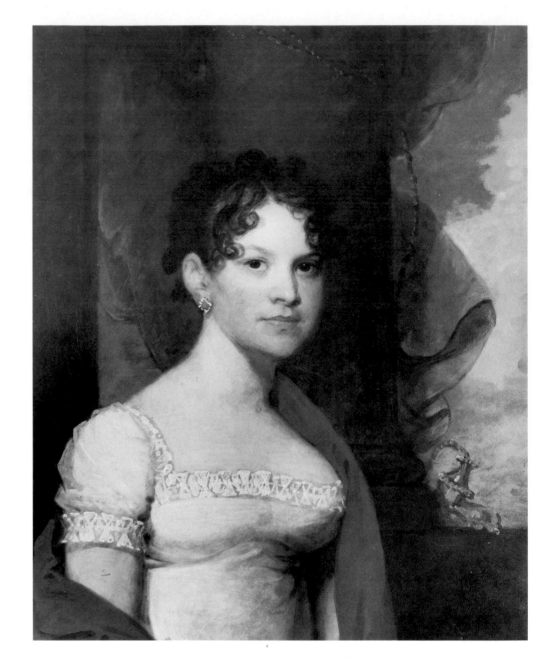

Mrs. Henry Alexander Scammell Dearborn

c. 1812. Oil on panel, 28⅜ × 22⅞″
Bowdoin College Museum of Art, Brunswick,
Maine. Bequest of Miss Mary J. E. Clapp

*Though the Dearborn portraits are a pair,
Stuart followed his familiar formula for
male portraits in concentrating on the
general's head and eliminating accesso-
ries. For Mrs. Dearborn, as was usual in
his American female portraits, he not only
gave attention to her gown and its trim-
mings but also added a Grand Manner
drapery with suggestions of a column and
landscape with sky.*

kind to them, offering counsel, sometimes giving them work as assistants in pre-
paring colors, canvases, or panels, and asking each pupil to produce a painting so
that his level of achievement could be assessed. Stuart's encouragement and his
generosity with his time and knowledge were perhaps increased by his painful
awareness of his failure with his own son. Many of his pupils left accounts of their
studies with him. John Neal, a young man of Quaker background who visited
him about 1817, was somewhat taken aback when Stuart offered him a glass of
"old East India madeira, which he poured from a half-gallon ewer, like cyder in
haying time." He described the artist as "a man of noble type, robust and hearty,
with a large frame and the bearing of a man who might stand before kings." He
was "fresh-looking, old fashioned, reminding you constantly of Washington
himself, or General Knox or Greene."

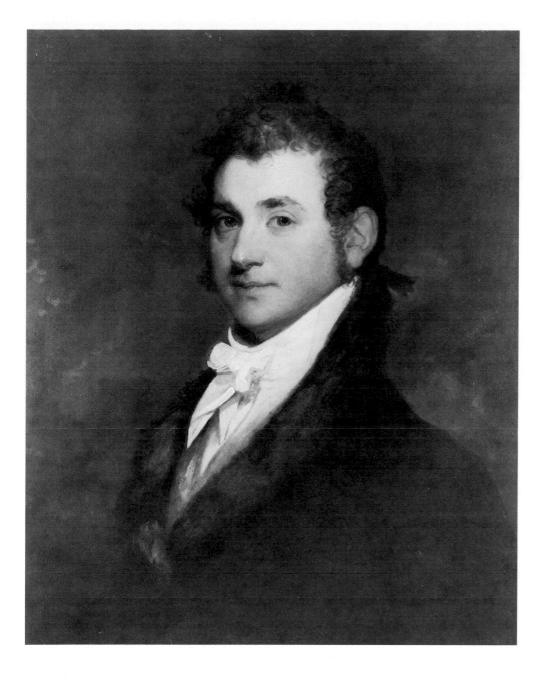

Major-General Henry Alexander Scammell Dearborn

c. 1812. Oil on panel, 22½ × 27¼″
Bowdoin College Museum of Art, Brunswick,
Maine. Bequest of Miss Mary J. E. Clapp

Like his father, the younger Henry Dearborn had a distinguished public career.

Jacob Eichholtz, of a Pennsylvania German family, was another who made the pilgrimage to see "the celebrated Stuart, of Boston." A youthful coppersmith, he brought a portrait he had painted of Nicholas Biddle, president of the United States Bank. "I had a fiery trial to undergo," Eichholtz remembered. "My picture was placed alongside the best of his hand, and that lesson I considered the best I ever received; the comparison was, I thought, enough, and if I had vanity before I went in, it 'all left me' before my return. I must give Stuart justice to say he gave me sound lectures and hope. I did not fail to profit by them."

Two years after he had stood behind Stuart's chair and watched him at work, Thomas Sully returned to spend six months with him. In the meantime he had worked in London, where he had attracted the favorable attention of Benjamin West, but he felt that Stuart could better help him to refine and mature his

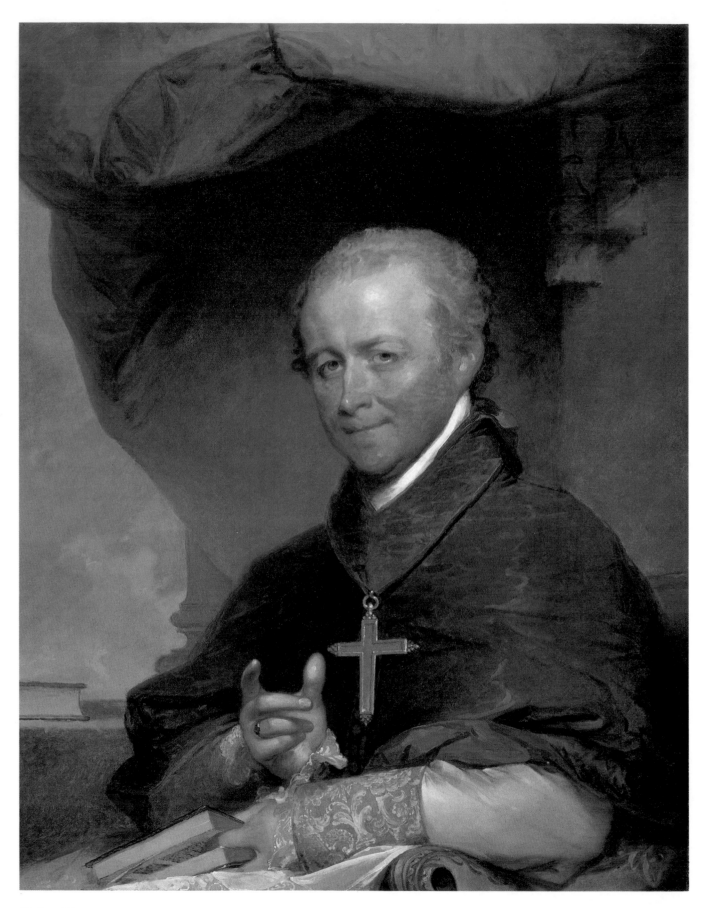

Bishop Cheverus

style. Sully liked to recall the older artist's kindness and tact: When the pupil had painted the portrait of a boy that was greatly admired, Stuart joined the rest in their appreciation, proudly pointing out its strong points. Only when the two were alone did he also point out its weaknesses, analyzing the whole in a manner calculated to give its author as much assistance as possible.

James Frothingham was another. A young man who had served his apprenticeship to a chaisemaker, he walked many miles to see Stuart, taking with him his latest effort at portraiture. When he finally reached Stuart's house, he was at first too shy to knock at the door and took some time to get up his courage. Finally, he hid the portrait and, in a moment of extra daring, knocked on the door. He was immediately shown to the great man's painting room. He stood there for a moment in panic before he could blurt out that he had come to ask for advice about his painting.

"I will tell you anything I know," said Stuart. "Have you brought a specimen of your skill?"

"I brought a portrait, sir. It is out of doors."

"Bring it in, sir. We do not turn pictures out of doors here. Bring it in."

The terrified youth went to fetch it, and Stuart put it on an easel next to one of his own. He proceeded to examine it, using his own picture to illustrate various points of his critique and to explain how he had achieved certain effects. Then he turned to his visitor.

"What is your present employment?" he asked.

"I am a coach painter, sir."

"Stick to it!" Stuart exclaimed. "You had better be a tea-waterman's horse in New York than a portrait painter anywhere." Nevertheless, he gave Frothingham such encouragement that whenever he finished a portrait, he took it to Stuart for criticism, and by the time he had brought around the sixth, the improvement was so great that Stuart exclaimed, "You do not know how well you have done this!"

One of Stuart's favorite pupils was Matthew Jouett, who, like Chester Harding, had been born and brought up on the frontier, in Lexington, Kentucky, so "Kentucky" he became to Stuart. Jouett was a good student who rapidly became a valued assistant and companion. Being a serious young man, he kept careful notes on all that the older artist told him, which provide invaluable insights into Stuart's attitudes toward his art and his technical practice of it. "Be ever jealous about truth in painting, and preserve as far as practicable the round, blunt stroke in preference to the winding, flirting, whispering manner," he told Jouett. "Never be sparing of color, load your pictures, but keep your colors as separate as you can. No blending, 'tis destructive of clear and beautiful effect. It takes the transparency and liquidity of coloring, and renders the flesh the consistency of buckskin.... Flesh is like no other substance under heaven. It has all the gayety of a silk-mercer's shop without its gaudiness of gloss, and all the soberness of old mahogany without its sadness.... Drawing the features distinctly and carefully with chalk is loss of time; all studies should be made with the brush in hand."

John Neagle, to whom we are indebted for a fine portrait of Stuart in his old

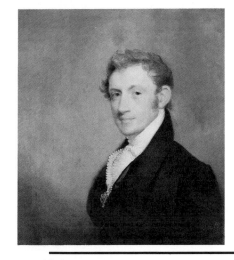

David Sears, Jr.

c. 1815. Oil on canvas, 27¼ × 23½"
The Metropolitan Museum of Art, New York City
Gift of Several Gentlemen, 1881

An off-center composition, often used by Stuart. The subtlety of balance makes the device scarcely noticeable.

Bishop Cheverus

1823. Oil on canvas, 36¼ × 28¾"
Museum of Fine Arts, Boston
Bequest of Mrs. Charlotte Gore Greenough
Hervoches du Quillan, 1921

Jean-Louis Lefebvre Anne-Madelaine de Cheverus, who was respected for his scholarship and admired for his ecumenical spirit, became the first bishop of Boston in 1810. This portrait was commissioned by a Protestant friend just before Cheverus returned to France to assume an archbishopric and a cardinal's hat.

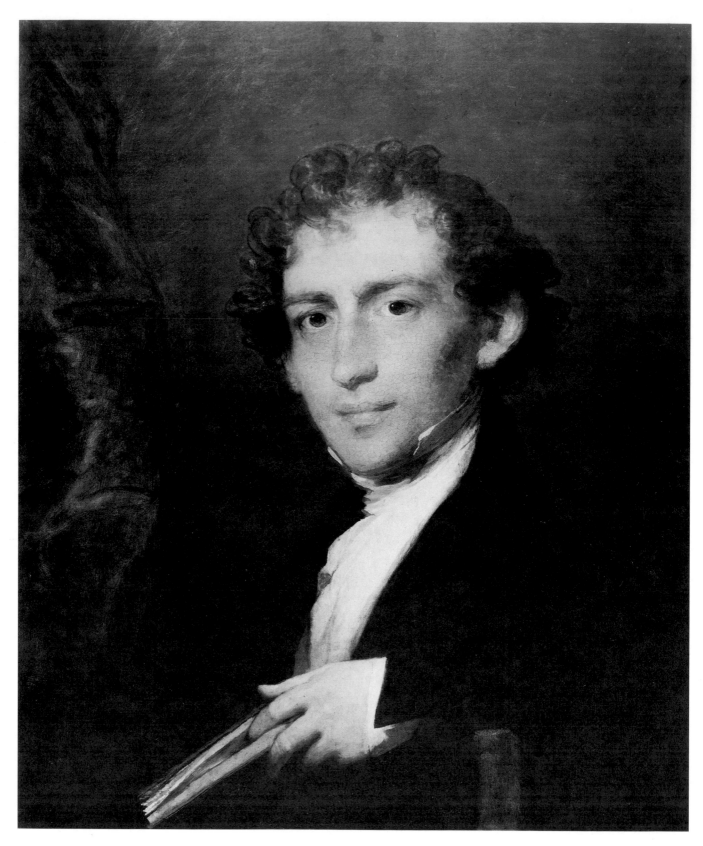

Edward Everett

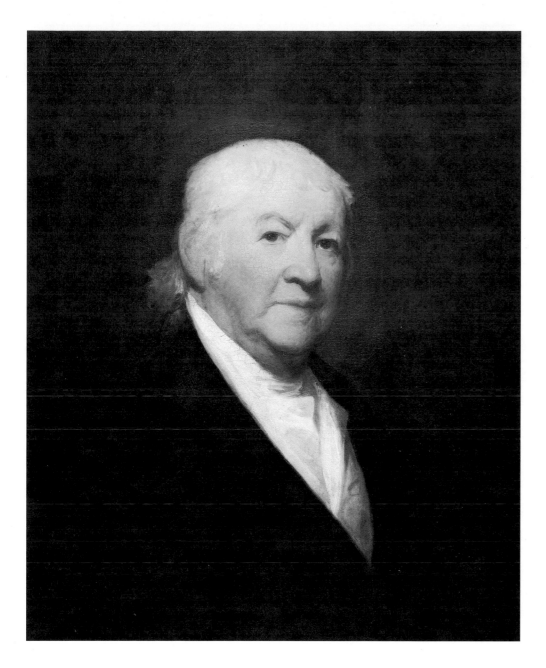

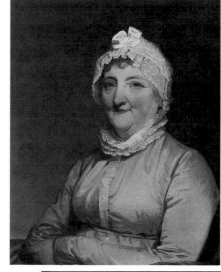

Mrs. Paul Revere

1813. Oil on panel, 28½ × 23¾″
Museum of Fine Arts, Boston. Gift of
Joseph W., William B., and Edward H. R. Revere

Rachel Walker was Paul Revere's second wife.

Paul Revere

1813. Oil on panel, 28½ × 23¾″
Museum of Fine Arts, Boston. Gift of
Joseph W., William B., and Edward H. R. Revere

The patriot as he appeared in his robust old age: goldsmith, bronze-founder, and a leading citizen of Boston.

age, never forgot his remark that "good flesh partook of all colors, not mixed so as to combine in one tint, but shining through each other, like blood through the natural skin." Because Stuart applied the paint in small strokes adjoining or ever so slightly overlapping each other, they are visually mixed by the eye when seen as he intended, from a short distance, but are seen as separate when examined closely. It is for this reason that, when he noticed someone looking at a picture too closely, he would growl, "Well, does it smell good?"

Several portraits that Stuart left unfinished—mostly painted in his later years—reveal much of his unique method of constructing a head. Those of two distinguished historians, Thomas Motley and Jared Sparks, and of the famous author of *The Practical Navigator*, Nathaniel Bowditch, are well-known examples. In each the vivid likeness is there, achieved by laying in the form of the head in

Edward Everett

c. 1815. Oil on panel, 26 × 20″
Harvard University Portrait Collection,
Cambridge, Massachusetts

A youthful portrait of the man who was to become famous as an orator and statesman.

opaque pigment in neutral tones, which were modeled into light with transparent and semitransparent strokes, leaving the eyes until last. There are no lines or outlines whatsoever. All is subtle transition in a soft but clear light that makes the work of most other painters look, as Benjamin West said of an early Copley, "liney." There is a luminance that makes most other portraits appear, on comparison, opaque and enamel-like. None of Stuart's many pupils and followers ever quite caught this particular quality, no matter how assiduously they followed his advice and practice. Yet with all of them he held nothing back and allowed them to watch him work at all stages of the development of a picture. All who had the opportunity of seeing him paint remarked on the quality of his stroke. In spite of the tremor of his hand, which grew to an alarming degree in his later years, so much so that people marveled that he could paint at all, he maintained extraordinary control. "He deliberated," John Sartain remembered in his delightful *Reminiscences of a Very Old Man*, "every time before the well-charged brush went down upon the canvas with an action like cutting into it with a knife. He lifted the brush from the surface at a right angle, carefully avoiding a sliding motion. He always seemed to avoid vexing or tormenting the paint when once it was laid on, and this accounts partly for the purity and freshness . . . of his work." Garments and backgrounds were painted broadly, often sketchily, with loaded lights contrasting with thin, transparent darks.

As Stuart grew older, his work did not deteriorate, but it changed. The emphasis came to be entirely on the face and what it revealed of the person behind it. "I copy the works of God and leave clothes to tailors and mantuamakers," he told a friend. That is why the late, unfinished portraits do not strike us as seriously flawed by their incompleteness. As far as their portrait value is concerned, they are completely realized. As for the missing costume, we can echo Stuart's own comment when someone complained to him that a sitter's family thought the cravat not sufficiently detailed, "What do they think I am, a damned haberdasher?" His portrait of the outstanding American Romantic painter Washington Allston, a quarter century his junior, was left similarly unfinished at Stuart's death. As Allston's brother-in-law, the author Richard Henry Dana, remarked, "It is a mere head, but such a head, and so like the man!" And the art historian Albert Ten-Eyck Gardner observed, "It would be difficult to find a more perfect representation of the early nineteenth-century ideal of romantic genius."

The type of portrait that Stuart developed in his later years, with its concentration on the head, shown against an unspecific background, with details of costume and accessories either suppressed or eliminated, became increasingly popular among the next generation or so of Americans. It reflected the Romantic movement's emphasis on the character of a particular person, regardless of externals, and a democratic society's accentuation of the importance of the individual for his or her own personal qualities alone. There were to be, of course, portraits of sitters in fashionable gowns, academic robes, or uniforms, and there were official portraits with a certain amount of paraphernalia; but the emphasis had fundamentally though subtly changed. No one in America, until Thomas Eakins in the later nineteenth century, was to show the insight into character that Stuart at his best revealed in this way. And no other American came close to Stu-

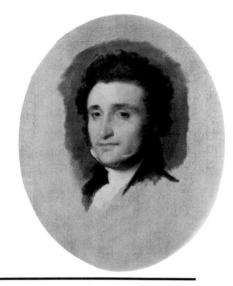

Jared Sparks

c. 1826. Oil on canvas, 25 × 20″
The New Britain Museum of American Art,
Connecticut

This unfinished portrait of the distinguished historian shows Stuart's unique manner of working: modeling the head, without preparatory drawing, by means of small strokes in varying tones that express every necessary nuance of form.

Josiah Quincy

1824. Oil on canvas, 36 × 28″
Museum of Fine Arts, Boston
Gift of Eliza Susan Quincy

Quincy was an effective member of Congress, the most successful and progressive mayor that Boston has ever had, and a brilliant president of Harvard. His extraordinary vigor is caught by the artist, who shows him with the facade of Quincy Market, an important achievement of his mayoralty, in the background.

Josiah Quincy

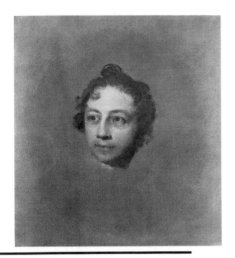

Washington Allston

c. 1827. Oil on canvas, 24 × 21½"
The Metropolitan Museum of Art, New York City
Alfred N. Punnett Fund, 1928

Though unfinished, the portrait is a vivid likeness of one of the leading painters of the Romantic movement. Equally famous on both sides of the Atlantic, Allston was a great admirer of Stuart.

art's fashionable portraiture until James Abbott McNeill Whistler, who was not born until six years after Stuart's death, and John Singer Sargent, a late-nineteenth- and early-twentieth-century member of the same family as Stuart's walking companion on the Mall, Henry Sargent.

About 1818 John Doggett of Roxbury, an expert framemaker and also an art dealer, commissioned from Stuart half-lengths of the first five presidents, "the Virginia dynasty." The first three of the set were destroyed when the Library of Congress burned in 1851. The *Madison* seems to have survived the fire, but it has not been located, and the *Monroe* is in the Metropolitan Museum of Art; the head is a replica of the portrait from life painted when the fifth president visited Boston in 1817. In the firmness of the painting of the head and hands, with their subtlety of modeling, the free and fluid handling of the background, and the decorative elements of the setting, in the sure solidity of the still-life details and the juicy touches of the ruffle and the neckcloth, one can detect no diminution of power nor any evidence of a trembling hand. If the Doggett Portraits, completed about 1820, were all of this quality, they would strongly stand comparison with the earlier presidential series.

Stuart had for some years suffered from gout, but in his later sixties the condition worsened, causing constant pain and making him more cranky than ever. As a result there were fewer sitters, though his artistic reputation remained strong. Nevertheless, in 1822 James Perkins, a friend of Stuart's, was persuaded by his family to have his portrait painted. Perkins was a China-trade merchant and a public-spirited person who was a founder of the Perkins Institute for the Blind and of the Boston Athenaeum. According to the story told to Stuart's early biographer, George C. Mason, by Perkins's grandson, "About the time of my grandfather's death he was sitting to Stuart for his portrait, which was supposed by his brother and the family to be in a forward state, and, indeed, nearly finished. After his death, he having died very suddenly from pneumonia, Colonel Perkins [his brother] called at the studio and was very much disappointed to find that the artist had only a mere sketch on his easel. The fact was, the hours given to sittings had been passed in conversation, for the two were well acquainted, and the result was the faithful memorial of one so dear, which my uncle had counted on seeing, did not exist. . . . The Colonel, being very indignant, left the studio, saying, 'Very well, Mr. Stuart, you have inflicted an irreparable loss by your dilatoriness, and I shall never enter your studio again.' He accordingly left without hearing the artist's explanations. Some weeks passed, when they met by chance one day in the street, and Stuart, who had been busy painting on the portrait from memory, begged the Colonel to reconsider his resolution. . . . My uncle yielded, and, as he told me, 'I entered the studio, and there on the easel I saw the perfect portrait of my dear brother, which (pointing to the picture on the wall) now hangs before you.'"

The following year Stuart moved to a three-story house at 59 Essex Street, nearer the center of things than Fort Hill. Among his sitters in that year was Jean-Louis Lefebvre Anne-Madelaine de Cheverus, the much-admired Roman Catholic bishop of Boston. After a stint as missionary to the Penobscot Indians in

the District of Maine, Cheverus was transferred to Boston, where he rapidly became known for his faithfulness in keeping in touch with his parishioners by walking miles every week to visit their homes. On such an errand he was one day overtaken by the carriage of Josiah Quincy, Congressman, later mayor of Boston and president of Harvard. Quincy remembered "a forlorn foot passenger, . . . drenched and draggled, . . . plodding along the miry road." Though at first he refused Quincy's offer of a ride, the latter prevailed, and the two became lifelong friends. Because of Cheverus's ecumenical spirit, wit, and scholarship, Protestant Boston accepted him, and the first Catholic cathedral was built to plans donated by Charles Bulfinch with funds supplied in generous measure by leading Bostonians, led by John Adams. The wife of a Massachusetts governor, Mrs. Gore, commissioned the portrait just before Cheverus left for France to become Archbishop of Bordeaux and eventually a cardinal. Mrs. Gore hung the portrait beside that of Dr. Gardiner, the equally popular rector of Trinity Church. Though Stuart painted the bishop in full clericals, he caught him as if in the animated conversation that must have taken place during the sittings.

In 1824, at the request of his daughter Eliza, Josiah Quincy sat for another portrait—the first had been done in 1806—to celebrate his election as mayor of Boston. The portrait was well started, with the head and figure near completion, when Stuart suffered a stroke. Though his left arm was partly paralyzed and the right side of his face somewhat immobilized, he continued the sittings. He asked Eliza Quincy to bring him drawings of "the elevation and plan of the New Market as he intends to represent Mr. Quincy as seated in a window of Faneuil Hall, commanding a view of the edifice. When I told him that Allston said the head was worthy of the old masters, he replied with a sharp glance of his piercing eye, 'Am I not an old master, Miss Quincy?' But, he went on, 'You deserve half the credit of the portrait, as you persuaded your father to sit to me a second time. You must always say that we painted that portrait.'" The picture shows not a trace of Stuart's disability. The painting is vigorous and straightforward, reflecting the forthright character of the subject. The glimpse of the granite facade of Quincy Market, designed by Bulfinch's pupil Alexander Parris, is firmly drawn. It is an outstanding portrait; given the circumstances under which it was done, it is a heroic achievement.

In September of 1825, President John Quincy Adams recorded in his diary that he called on Stuart to ask him to go out to Quincy to paint a final portrait of his father, John Adams, who had been persuaded to sit again. Dreading the trip, Stuart finally consented to go, "to paint a picture of affection and of curiosity for future times." John Adams, admirable patriot and able president though he was, had little use for the arts; he wrote in answer to a sculptor's request for permission to sell replicas of a bust of him, "I would not give sixpence for a picture of Raphael or a statue of Phidias." But he confessed to a friend, "Speaking generally, no penance is like having one's picture done. You must sit in a constrained and unnatural position, which is a trial to the temper. But I should like to sit to Stuart from the first of January to the last of December, for he lets me do just what I please, and keeps me constantly amused by his conversation."

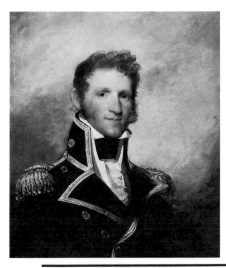

Commodore Thomas Macdonough

c. 1818. Oil on panel, 28½ × 23″
National Gallery of Art, Washington, D.C.
Andrew W. Mellon Collection, 1942

Macdonough became a hero through his decisive defeat of the British on Lake Champlain in the War of 1812; he not only turned back the enemy's counterinvasion but also captured seven British vessels.

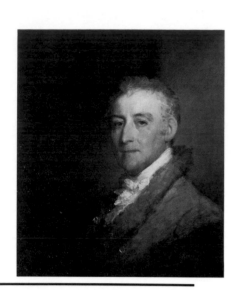

John Trumbull

1818. Oil on panel, 25¹⁵/₁₆ × 21⁷/₁₆″
Yale University Art Gallery, New Haven
Bequest of Herbert L. Pratt

Colonel Trumbull, veteran of the Revolution, friend of Stuart, and his fellow pupil with Benjamin West in London, is best known for his lively, small-scale paintings of crucial events of the Revolution. He gave his collection to Yale College, and he designed its first art gallery.

John Adams

1826. Oil on canvas, 30 × 25⅛″
National Museum of American Art,
Smithsonian Institution, Washington, D.C.
Adams-Clement Collection. Gift of Mary Louisa
Adams Clement in memory of her mother,
Louisa Catherine Adams Clement

In 1825 President John Quincy Adams persuaded Stuart to paint his father once more. The artist, seriously ill, finally consented. The two old men thoroughly enjoyed the experience, and the painting was finished shortly before Adams died at the age of ninety.

Remarking on Stuart's painting of this portrait, Josiah Quincy wrote, "It was his habit to throw his subject off guard, and then by his wonderful powers of conversation he would call up different emotions in the face he was studying. He chose the best, or that which he thought most characteristic, and with the skill of genius used it to animate the picture. And this portrait of John Adams is a remarkable work, for a faithful representation of the extreme age of the subject would have been painful in inferior hands. But Stuart caught a glimpse of the living spirit shining through the feeble and decrepit body. He saw the old man at one of those happy moments when the intelligence lights up the wasted envelope, and what he saw he fixed upon the canvas."

Washington Allston was deeply touched by the portrait of the ninety-year-old ex-president. "Called forth as from its crumbling recesses, the living tenant is there—still ennobling the ruin, and upholding it, as it were, by the strength of his own life. In this venerable ruin will the unbending patriot and the gifted artist speak to posterity of the first glorious century of our Republic." As for Stuart, he must have thoroughly enjoyed his sessions with Adams, who was also known as a good conversationalist with a crisp wit. The stimulation of good talk enabled the painter to rise above the increasing weight of his disability and the constant pain he now suffered. He was satisfied with the result, as were Adams and his family.

The painting was finished early the following year, well before John Adams died in the wing chair beside the fireplace in the parlor of the old Adams mansion, where he had posed for Stuart. He died on the fourth of July, the fiftieth anniversary of independence. When it was learned that on the same day, Thomas Jefferson, his old political opponent and, in later years, friendly correspondent, had passed away at Monticello, far away in Virginia, the event seemed portentous indeed, a coincidence that "so struck the soul with awe and wonder, . . . it is not in the power of words to express, and no American will ever forget." John Quincy Adams was president, but mid-term elections established an anti-administration majority in the House, and Andrew Jackson, frontiersman and Democrat, the hero of New Orleans, was waiting in the wings.

An age was passing. It was Stuart's age also. He had outlived most of his sitters, and more and more he felt himself to be a relic of the past. Yet he kept busy, driven both by pride and by the ever-pressing financial necessity that had dogged his entire life. Increasingly, his daughter Jane filled out the busts and backgrounds after he had completed the heads. Yet in 1826 John Neal could write in the London *Monthly Magazine* that, "old as he is, taking him altogether he has no superior among the portrait painters of our age," and quote Allston's opinion that his latest works were among his best. But his paralysis and attacks of gout increased, and his once-sturdy frame withered. After weeks of growing debility and agonizing pain, which he bore with stoic fortitude but which rendered him bedridden, he died in the house on Essex Street on the ninth of July, 1828, in his seventy-third year, and in the fifty-second of the republic whose founders and heroes he had so magnificently recorded.

John Adams

AFTERWORD
"The Father of American Portraiture"

BECAUSE OF THE FAMILY'S POVERTY there was only a small funeral. On the tenth of July Gilbert Stuart was buried in the ancient cemetery on Boston Common where so many other distinguished figures of American history also lie. Though it has often been written that the site of his grave is unknown, his body was interred in a vault now "underneath the Mall, which runs from Park Square to the Park Street Church," the favorite walk of Stuart and his friend Henry Sargent. It was placed in Tomb Sixty-one, hurriedly purchased for the occasion from George Howland, a carpenter; Lemuel Clark, a housewright; and the heirs of Abijah French, a blacksmith who had died in 1811. According to John Hill Morgan, who wrote the excellent short sketch of the painter's life that appears in Lawrence Park's monumental four-volume work on Stuart, the burial place was reconfirmed when a bronze tablet in the shape of an artist's palette was fastened to the cemetery railing above it, "placed by the Paint and Clay Club, 1897."

Washington Allston wrote a graceful tribute in *The Boston Daily Advertiser*, calling Stuart "not only one of the first painters of his time, but must have been admitted by all who had the opportunity of knowing him, to have been, even out of his art, an extraordinary man; one who would have found distinction easy in any other profession or walk of life. His mind was of a strong and original cast, his perceptions as clear as they were just, . . . his conversation was marked by wisdom and knowledge; while the uncommon precision and eloquence of his language seemed even to receive an additional grace from his manner, which was that of a well-bred gentleman."

The artists of Philadelphia—Sully, Neagle, and others who considered themselves his pupils and heirs—published a testimonial lauding his "genius as a painter, . . . particularly gifted with that power of hand which so admirably counterfeited life upon the canvas, . . . whose pencil was the wand of a magician." They remembered his generosity to all who sought his help and declared him "to have been the *Father of American Portraiture*."

Meanwhile, the Boston Athenaeum was the site of a memorial exhibition of more than two hundred of his works, held *"for the benefit of his family."* Through a public subscription, a committee of trustees of the Athenaeum raised fifteen hundred dollars to purchase the portraits of President and Mrs. Washington, the painter's only legacy to his family. As soon as outstanding bills were finally paid, his widow moved back to Newport with the four remaining daughters: Agnes, who died in 1850; Ann, who died in 1868; Emma, who lived "many years an invalid in Providence"; and Jane, the youngest. They were supported by Jane's art. For more than half a century she continued to paint portraits and to produce copies of her father's famous *Washington* that had been sold to the Athenaeum. A picturesque and legendary figure in Newport—which had become the haunt of

millionaires instead of the home of merchants and shipowners—Jane outlived her sisters by many years. She finally died in 1888, a ghost from a remote and forgotten past.

As we look back at the life and works of Gilbert Stuart from the uneasy vantage point of the waning years of the troubled twentieth century and seek to find the man who was the leading recorder of the personalities of his age, we can look at the few relics of his life besides his paintings. There is the mill on Petaquanset Pond, ancient and picturesque, and lovingly restored. There are the treasured buildings of Newport, including Trinity Church, where he raptly listened to that dry old pedagogue, Herr Knotchell, momentarily come alive when playing the organ. A little bit of Stuart's Boston is still there, lost among the overpowering towers, though almost nothing of old New York remains. Philadelphia has fared a bit better, and the old house in Germantown still stands, though the barn that he used as a studio has long since burned.

In London and Dublin the very streets have changed, though something of the atmosphere of his times may be momentarily recaptured here and there, and something of the personalities of his contemporaries—West and Reynolds and Gainsborough—enlivens their canvases, respectfully enshrined in the museums of the world. Stuart wrote few letters and then only under the stress of some difficulty, usually financial, and few have been preserved. The various older accounts of his life and work are almost all colored by the desire to deify by glossing over or leaving out the more discreditable facts of his career: it seemed only fitting that the greatest portrait painter of his age in America should have led a life of hard work and sober responsibility, or else how was his undoubted achievement possible?

The view from a post-Freudian perspective is a different one. We see a tremendously gifted man with a seriously troubled spirit, constantly overreacting to his personal and profoundly unsure view of what was going on around him, fluctuating between depths of enervating depression that robbed him of a capacity to act and manic periods of bravado. His urge to please and to impress, and equally his compulsion to take offense and to strike out, are both measures of his insecurity. Being very perceptive, though in an instinctive rather than in a cerebral way, he recognized much of the nature of the problem within himself, and his lack of the control to avoid or to solve it. Yet he was the wittiest of men, bright, with a retentive memory and a fertile, often extravagant, imagination. He was attractive in appearance, charming in manner, and showed infinite kindness to those less fortunate and to younger artists. All his life, from his brash, unsure youth through his dandified early manhood, his contumacious middle years, and the picturesque ruin of his old age, he was a formidable presence. From today's vantage point, the problems of his personality merely emphasize the heroism of his artistic achievement and enable us to see more clearly how, again and again, his own vital but flawed humanity enabled him to penetrate deeper into the character of his sitters and to create, for as long as his images remain, the most complete visual record that exists of the pageant of personalities that enlivened a rich and vigorous age.

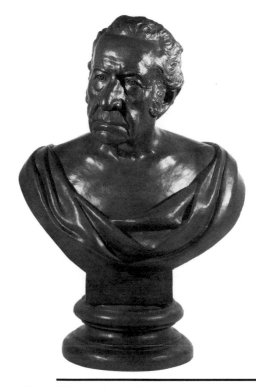

Jean Henri Isaac Browere
Portrait of Gilbert Stuart

New York State Historical Association, Cooperstown

Browere (1792?–1834), an upstate New Yorker, "conceived the idea of making likenesses of all the outstanding Americans of the day" by means of life masks and thus produced a series of toga-draped busts. That of Stuart dates from about 1825. The original plaster is in the Redwood Library, Newport; the bronze, illustrated here, was cast in the twentieth century and is one of the series of Browere's busts in the New York State Historical Association, Cooperstown.

Chronology

1777	*Becomes pupil of Benjamin West; moves to Villiers Street*
	Washington at Valley Forge; Gates victorious at Saratoga, John Paul Jones at sea; Articles of Confederation
1778	*Paints* Self-Portrait in a Rubens Hat
	Copley paints *Watson and the Shark*; Count d'Estaing and a French fleet arrive off the Delaware capes
1780	*Major assistant to West*
	Trumbull imprisoned in London; French General Rochambeau arrives at Newport; Benedict Arnold's treason exposed
1781	*Shows* Dr. John Fothergill *and other portraits at the Royal Academy to favorable reviews*
	Cornwallis surrenders at Yorktown; West and Copley triumph in history painting
1782	The Skater *acclaimed at Royal Academy exhibition; moves to his own painting rooms on Newman Street*
	Shelburne and the Whigs replace Tories; The Netherlands recognizes American independence
1783	Treaty of Paris ends the Revolution; ministry of Pitt the Younger; Loyalists sail from New York
1784	*With a growing practice, moves again, to New Burlington Street; portraits of Reynolds, Copley, and others for Alderman Boydell*
	The Empress of China sails from New York to Canton to initiate the China Trade; New York is temporary capital
1786	*Marries Charlotte Coates of Reading, Berkshire; paints John Philip Kemble as Macbeth*
	Shays's Rebellion
1787	*Completes* Northumberland *portraits; flees London for Dublin to escape creditors*
	Constitutional Convention in Philadelphia; death of the duke of Rutland, viceroy of Ireland
1788	*Settles in Pill Lane, Dublin; portrait of Lord Chancellor Fitzgibbon*
	Constitution ratified; temporary insanity of George III; death of Gainsborough
1789	First U.S. Congress, New York; Washington inaugurated as first president; the French Revolution begins
1790	*Moves to farm at Stillorgan, near Dublin*
1791	*Portrait of the Right Honorable John Foster; incapacitated with broken arm*
1792	Sir Joshua Reynolds dies
1793	*Sails for New York, arriving in April;* Pollock *and* Yates *portraits; portrait of John Jay*
	Washington, starting his second term, lays cornerstone of the U.S. Capitol
1794	Jay's Treaty with Britain
1795	*Moves to Philadelphia; paints first* Washington *portrait*
1796	*Moves to Germantown, near Philadelphia; full-lengths of Washington*
	Washington's Farewell Address; John Adams elected president, Thomas Jefferson vice-president
1797	Lansdowne Washington *acclaimed in London*
1799	Washington dies at Mount Vernon; Napoleon Bonaparte becomes first consul in France
1800	*Portraits of John and Abigail Adams, Jefferson, and others*
	U.S. capital established at Washington
1801	Jefferson president, Aaron Burr vice-president; war with Tripoli
1802	*Portraits of Sarah Morton*

1803	*Moves to Washington; family in Bordentown, New Jersey* The Louisiana Purchase; the Lewis and Clark expedition
1804	*Portraits of the Madisons, Thorntons, etc.; the Peales' portrait of Stuart* Burr kills Hamilton in a duel
1805	*Moves to Boston via Philadelphia and Bordentown* Jefferson begins second term
1806	*Paints* Washington at Dorchester Heights
1809	James Madison president
1811	Harrison defeats Tecumseh at Battle of Tippecanoe
1812	U.S. declares war on Great Britain
1813	*Death of the artist's son, Charles Gilbert; moves to Roxbury* British burn the Capitol; Dolley Madison saves Stuart's *Washington*
1814	Treaty of Ghent ends the War of 1812
1815	Andrew Jackson defeats British at New Orleans; Copley dies in London
1816	*Revisits Newport; moves to Washington Street, Boston* First protective tariff enacted
1817	*Moves to Washington Place on Fort Hill, Boston* James Monroe president
1820	*Completes Doggett set of presidential portraits; only the Monroe remains* Benjamin West dies in London
1823	*Moves to Essex Street, Boston;* Cheverus *portrait* Monroe Doctrine proclaimed
1824	*Second portrait of Josiah Quincy; suffers stroke*
1825	*Ailing, paints last portrait of President John Adams* John Quincy Adams president
1826	*Revisits his birthplace in North Kingston* John Adams and Thomas Jefferson die on July 4
1828	*Dies July 9; buried the next day in Boston Common Cemetery* Andrew Jackson elected president; Audubon publishes the first volume of *Birds of America*, Webster, *The American Dictionary*

Photograph Credits

The author and the publisher wish to thank the museums, galleries, libraries, and private collectors who permitted the reproduction of works of art in their possession and supplied the necessary photographs. Photographs from other sources (listed by page number) are gratefully acknowledged below.

Henry Beville, Annapolis, Md.: 54, 100, 101, 120; E. Irving Blomstrann, New Britain, Conn.: 99; A. C. Cooper, London: 59, 60; Courtauld Institute of Art, London: 23; Frick Art Reference Library, New York: 33; John C. Hopf, Newport: 12, 23, 24, 42; Otto Nelson, New York: 102; Jackson Smith, Winston Salem, N.C.: 69.

Bibliography

RECENT PUBLICATIONS

FLEXNER, JAMES THOMAS. *Gilbert Stuart: A Great Life in Brief*. New York, 1955. Brief and breezy; an interesting account.

MORGAN, JOHN HILL. *Gilbert Stuart and His Pupils*. New York, 1939. Includes all of Matthew Jouett's careful notes on Stuart's teaching and methods, and much more.

MOUNT, CHARLES MERRILL. *Gilbert Stuart: A Biography*. New York, 1964. The most recent and complete; an exhaustive biography, including results of extensive research, especially in Ireland.

WHITLEY, WILLIAM T. *Gilbert Stuart*. Cambridge, Mass., 1932. Contains much material from contemporary periodicals and records, as in his invaluable *Artists and Their Friends in England, 1700–1799* (2 vols. London and Boston, 1928). Excellent background for this period.

EARLIER WORKS

DUNLAP, WILLIAM. *History of the Rise and Progress of the Arts of Design in the United States*. New York, 1834; new edition, edited by Frank W. Bayley and Charles E. Goodspeed. 3 vols. Boston, 1918. Contains the author's account, Dr. Waterhouse's essential essay, and recollections of others who knew Stuart.

KNAPP, SAMUEL L. *The Treasury of Knowledge and Library of Reference*. New York, 1855; vol. 3, *American Biography*, contains a sketch of Stuart's life by a friend who knew him well.

MASON, GEORGE C. *The Life and Works of Gilbert Stuart*. New York, 1879; reprinted 1972. Contains material supplied by the artist's daughters.

PARK, LAWRENCE. *Gilbert Stuart: An Illustrated Descriptive List of His Works*. 4 vols. New York, 1926. Has a good biographical sketch by John Hill Morgan; a landmark work that later scholarship has corrected in many details.

STUART, ANN. A sketch of her father's life in Wilkin Updike's *History of the Episcopal Church in Narragansett*. 3 vols. Boston, 1907. Cites important church records.

STUART, JANE. *Scribner's Monthly* XII (1876): 367–74; XIII (1876–77): 640–46; XIV (1877): 376–82. Recollections of the painter's youngest child, whose versions of events that took place before her birth are often inaccurate.

IMPORTANT ARTICLES

SAWITZKY, WILLIAM. In *Art in America* XXI (1932–33): 15–27, 39–48, 81–96. In *New York Times Magazine*, 12 August 1928. Corrects wrong attributions and identifies lost works.

SWAN, MABEL M. In *Antiques Magazine* XIX (1931): 278–81; XXIX (1936): 65–67; XXXIV (1934): 308–9. On Stuart's Boston career. In *Art in America* XXXXI, no. 2 (1953): 88–91. On Dr. Waterhouse's biography.

EXHIBITION CATALOGUES

Gilbert Stuart: Portraitist to the Young Republic. National Gallery of Art, 1967. Fine introductory essay by Edgar P. Richardson and much good information.

Copley/West/Stuart in America and England. Museum of Fine Arts, Boston, 1976.

OTHER PUBLICATIONS

HERBERT, J. D. *Irish Varieties of the Last Fifty Years*. London, 1836. Written under a pseudonym by James Dowling, an Irish painter who was Stuart's friend and assistant. The major source of entertaining information on Stuart's Dublin period.

KIMBALL, FISKE. *The Life Portraits of Jefferson and Their Replicas*. Philadelphia, 1931.

MORGAN, JOHN HILL, and MANTLE FIELDING. *The Life Portraits of Washington and Their Replicas*. Philadelphia, 1939.

TRUMBULL, JOHN. *Autobiography*. New York, 1841; new ed. edited by Theodore Sizer, New Haven, 1953. Lively account of an artistic career by a friend and contemporary of Stuart's.

Index

Page numbers printed in *italic* refer to the illustrations.